Teach Yourself VISUALLY

Photoshop® Elements

by Lisa A. Bucki

Visual
A Wiley Brand

About the Author

An author, trainer, and content expert, **Lisa A. Bucki** has been educating others about computers, software, business, and personal growth topics since 1990. She has written and contributed to dozens of books and multimedia works, in addition to providing marketing and training services to her clients and writing online tutorials. Bucki is cofounder of 1x1 Media, LLC (www.1x1media.com), an independent publisher of books and courses focused on how-to topics for entrepreneurs, startup founders, makers, and other business professionals.

About the Technical Editor

Doug Sahlin is a professional photographer, instructor, and author living on the west coast of Florida. He has photographed weddings, events, lawyers, doctors, and other professionals who need portraits for their websites, business cards, and documents. Sahlin also teaches Adobe Photoshop, Adobe Photoshop Elements, and Adobe Photoshop Lightroom online and in person. Doug has written over twenty how-to books in Wiley's "For Dummies" series, many of them about cameras and photography. In addition, he has published three Yale Larsson PI murder mysteries, which are available in paperback or Kindle format at Amazon. Doug has many image galleries at his website. To view his fine art photography, visit: https://dasdesigns.net/fine-art.

Author's Acknowledgments

My journey on this book began when Associate Publisher Jim Minatel asked me to take on the project. Thank you, Jim, for giving me another opportunity to be part of a Wiley team creating compelling content for readers. I appreciate the guidance and contributions received from Managing Editor Christine O'Connor, Project Manager Tracy Brown Hamilton, and Senior Managing Editor Pete Gaughan. They kept me on track through all the complexities of producing the pages that follow.

I also would like to thank additional team members for their excellent work on this project, including Technical Editor Doug Sahlin, Copy Editor Kim Wimpsett, Proofreader Evelyn Wellborn, Content Refinement Specialist Magesh Elangovan, Editorial Assistant Melissa Burlock, and all the other Wiley employees or partners who had a direct or indirect role in this undertaking.

My gratitude also flows to my supportive and patient husband, Steve Poland, and all of our beloved furry dog children.

Author's Note

I've written the steps and captured screens based on the Photoshop Elements 2023 version. If you're using a different version, you may notice small differences.

How to Use This Book

Who This Book Is For

This book is for readers who have never used this particular technology or software application, as well as for readers who want to expand their knowledge.

The Conventions in This Book

1 Steps

This book uses a step-by-step format to guide you easily through each task. Numbered steps are actions you must do; bulleted steps clarify a point, step, or optional feature; and indented steps give you the result.

2 Notes

Notes give additional information — special conditions that may occur during an operation, a situation that you want to avoid, or a cross-reference to a related area of the book.

3 Icons and Buttons

Icons and buttons show you exactly what you need to click to perform a step.

4 Tips

Tips offer additional information, including warnings and shortcuts.

5 Bold

Bold type shows command names, options, and text or numbers you must type.

6 Italics

Italic type introduces and defines a new term.

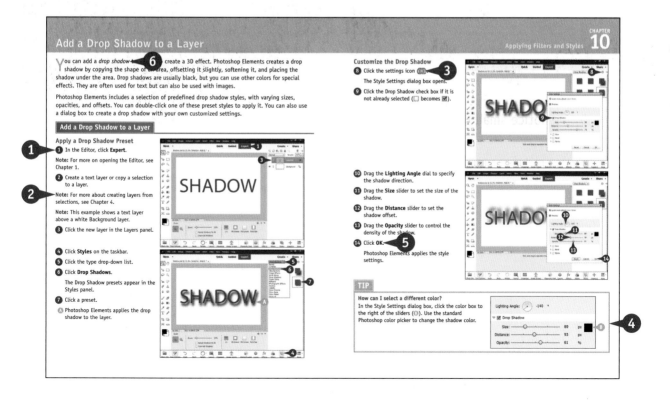

Table of Contents

Chapter 3 — Applying Basic Image Edits

Chapter 4 — Using Layers

Table of Contents

Chapter 7 Enhancing Lighting, Color, and Sharpness

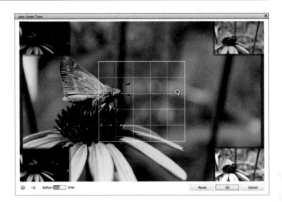

Chapter 8 Applying Quick and Guided Edits

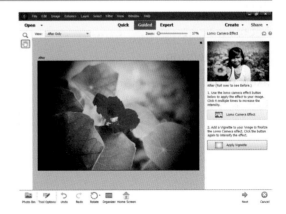

Table of Contents

CHAPTER 1

Getting Started

Do you want to improve or transform your photos and digital images? Are you interested in creating projects that combine images, text, and more? This chapter introduces Adobe Photoshop Elements 2023, a popular photo editor and organizer.

Introducing Photoshop Elements 2023

You can use Photoshop Elements to edit, improve, and organize digital images. The program is split into two parts: the *Organizer* and the *Editor*. Use the Organizer to collect photos into albums, tag them, and search for specific photos. Use the Editor to improve the color and exposure of your photos, apply corrections, crop them, and transform them with creative effects. For example, you can add a virtual frame, make a photo look like a painting, add captions and other text, and decorate your photo with shapes and objects. The Editor supports layers, which make it easy to combine multiple images into a collage and experiment with changes without having to alter your original image. When you are finished editing your images in Photoshop Elements, you can print them and more.

Fix Photos

The Editor is packed with features you can use to make simple and quick improvements to your photos. You can apply one-click fixes for color and contrast, correct color and exposure manually, and stretch and shrink your photos in many different ways to correct perspective. You can crop photos to remove unwanted content and improve the composition. As you gain more experience, you can begin to select objects in your photos — including people — and move them within the photo or even delete them completely. You also can combine photos to create group shots and panoramas.

Retouch and Repair

You can use Photoshop Elements to edit new photos to make them look their best as well as retouch and repair scans of older photo prints. For example, you can restore a faded photo by using color saturation controls to make it more vibrant, or you can use the Clone Stamp tool to repair a tear or stain. You also can use the program's exposure and lighting commands to correct tone problems as well as using the Eraser and other tools to edit out unwanted objects.

Add Decoration

The painting and drawing tools in Photoshop Elements make the program a formidable illustration tool as well as a photo editor. You can apply colors or patterns to your images with a variety of brush styles. And you also can add text, captions, speech or thought bubbles, and frames and other shapes.

Create a Digital Collage

You can combine parts of different images in Photoshop Elements to create a collage. Your compositions can include photos, scanned art, text, and anything else you can save on your computer as a digital image. By placing elements on separate layers, you can move, place, and edit them independently.

Organize and Catalog

As you bring photos into Photoshop Elements, the Organizer keeps track of them. You can preview photos from one convenient window, group photos into theme-specific albums, tag photos with keywords, and search for photos based on time and date, location, and any tags you added. You can even find photos that are visually similar and put names to faces in your photos.

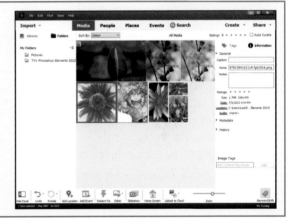

Put Your Photos to Work

After you edit your photographs, you can print them using your own printer or even order prints and other special projects online. While it is not covered in detail in this book, you also can share your images online to social media such as Facebook or Twitter directly from the Editor. In the Organizer, you also can share via email or create slideshows.

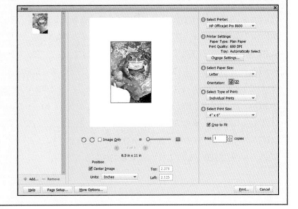

Understanding Digital Images

Digital images are made of millions of tiny squares called *pixels*. When you take a photo with a digital camera or scan a photo with a scanner, the hardware converts the scene or the source image into a grid of pixels. This section introduces you to some important basics about how computers store images in digital form.

Acquire Photos

You can acquire photographic images to use in Photoshop Elements from a number of sources. You can transfer photos to Photoshop Elements from a digital camera, a memory card, a photo CD, or, in some cases, your smartphone. You can import photographs, slides, or artwork by scanning the images directly into the Organizer. You also can bring in photos that you have downloaded from the web or received via email. You also can open images from any disk in the Editor.

Understanding Pixels

Each pixel is a single color. If you zoom in on your photo or image, you can see the pixels as a colored grid. An image with too few pixels (or low *resolution*) looks small on the screen and appears blurry or jagged when printed. Photos with too many pixels take up a lot of disk space when saved and require ample computer memory as you edit them. (Modern hardware typically includes generous disk storage and memory.) Photoshop Elements in part works its magic by rearranging and recoloring these pixels. You can edit specific pixels or groups of pixels by selecting the area of the image you want to edit.

Bitmap Images

Images composed of pixels are known as *bitmap images* or *raster images*. Arranged in a rectangular grid, each pixel includes information about its color and position. For most of your work in Photoshop Elements, you will be working with bitmap content such as your digital photos, as well as shapes and objects you may draw.

Vector Graphics

Photoshop creates *vector graphics*, such as text and shapes, using mathematical formulas that define lines, points, curves, and shapes. You can stretch or shrink vector graphics as much as you want without losing sharpness, meaning the graphics are scalable. You can add text by typing, and you can resize text and shapes using your mouse. Photoshop Elements hides all the math that makes this possible.

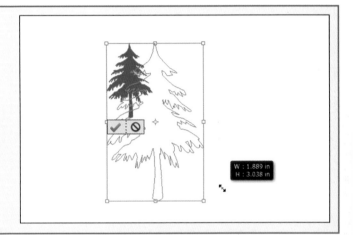

Supported File Formats

Photoshop Elements supports a variety of files, including BMP, TIFF, JPEG, GIF, PDF, PNG, and PSD, which stands for Photoshop Document. The PSD, TIFF, and PDF formats can include layers. Other formats cannot. The most common formats for images published on the Internet are JPEG and PNG. Photoshop Elements also supports a variety of camera raw file formats.

Photoshop (*.PSD;*.PDD)
BMP (*.BMP;*.RLE;*.DIB)
CompuServe GIF (*.GIF)
Photo Project Format (*.PSE)
GIF (*.GIF)
JPEG (*.JPG;*.JPEG;*.JPE)
Photoshop PDF (*.PDF;*.PDP)
Pixar (*.PXR)
PNG (*.PNG;*.PNS)
TIFF (*.TIF;*.TIFF)

File Size

Image file formats differ from one another in the amount of storage they take up on your computer. Formats such as PSD and TIFF take more space because they save a perfect copy of a photo. They also can include multiple layers. PNG files are perfect copies of a photo but do not include separate layers. JPEG and GIF use compression, sacrificing some quality for a smaller file size. Typically you can save

Ratings: ☆ ☆ ☆ ☆ ☆
Size: 3MB 3264x2448
Date: 9/10/2014 7:55 PM
Location: C:\Users\Lisa\Pictures\
Audio: <none>

your work as a PSD file while editing or printing and then save a separate copy as a JPEG or a PNG when you want to share the file online. When you save to the JPEG format, you also can specify a Quality setting that affects file size.

Start Photoshop Elements

You can install Photoshop Elements from a download or a copy of the installer software stored on a USB drive or other media. After installation, you can launch Photoshop Elements in the usual ways. The method you use will depend on the type of computer you have and its operating system version.

On a PC, you can use a desktop shortcut icon or click the **Adobe Photoshop Elements 2023** choice in the All apps list on the Start menu. On a Mac, you can search for it in the Finder or through Launchpad, or add the Adobe Photoshop Elements 2023 icon to the Dock.

Start Photoshop Elements

1 Double-click the **Adobe Photoshop Elements 2023** shortcut icon on the Windows desktop.

The Photoshop Elements Home Screen opens.

You can open the Organizer or the Editor from the Home Screen.

Note: In Windows 11, you can click the **Start** button on the taskbar, click **All apps**, and then click **Adobe Photoshop Elements 2023** in the list of apps to start Photoshop Elements. On a Mac, click the **Launchpad** icon on the Dock, start typing **Photoshop Elements** in the Search box at the top, and then click the **Adobe Photoshop Elements 2023** icon when it appears.

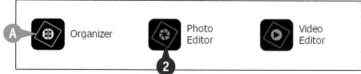

2 Click **Photo Editor**.

The Photoshop Elements Editor opens.

A You can click **Organizer** to open the Organizer.

Note: To exit Photoshop Elements 2023 completely, click the window **Close** button (❎) at the upper right for all open windows: Home Screen, Editor, and Organizer. On a Mac, the Close button is a red circle with an x in it at upper left.

Explore the Editor Workspace

To open the Editor, click **Photo Editor** on the Home Screen. You can then use its tools, menu commands, and panel-based features to edit your digital photos and other images. You can select Quick, Guided, and Expert editing modes to reveal different editing options. The main area of the Editor displays the photo(s) you are editing.

Ⓐ Active Image Area

This displays the photo you are editing.

Ⓑ Image Tabs

These tabs switch between open images in the Editor.

Ⓒ Organizer Button

This button opens or switches to the Organizer, where you can catalog your photos.

Ⓓ Mode Buttons

These buttons switch among the three editing modes. (Expert mode is shown.)

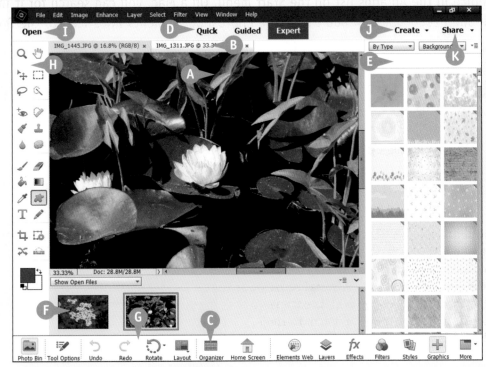

Ⓔ Panel Bin

This is an area for panels, which display information about layers, effects, graphics, and editing options.

Ⓕ Photo Bin

This lists the open photos you can edit.

Ⓖ Taskbar

These buttons select panels and various options. They also include important editing commands, including Undo.

Ⓗ Toolbox

These icons are the main editing tools in Photoshop Elements.

Ⓘ Open Button

Click this button to select and open a photo for editing.

Ⓙ Create Button

Click this button to create various photo-based projects such as calendars, CD/DVD jackets, and collages.

Ⓚ Share Button

Click this button to share photographs on a photo website and select social media networks.

Tour the Organizer Workspace

In the Photoshop Elements Organizer, you can catalog, view, and sort your growing library of digital photos and other images. The main Organizer pane, which displays the Media view by default, shows miniature versions of the photos in your catalog. To open the Organizer, click **Organizer** on the Home Screen.

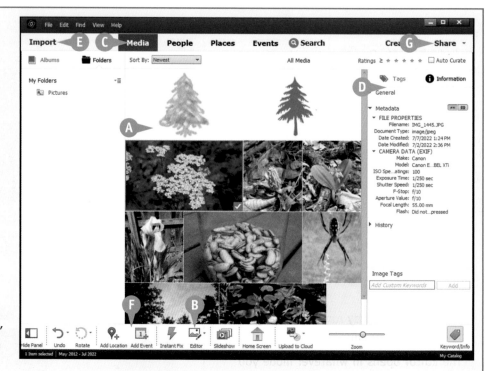

Ⓐ Media View

This displays miniature versions, or *thumbnails*, of the photos and other media in your catalog.

Ⓑ Editor Button

This button opens or switches to the Editor workspace, where you can edit your photos.

Ⓒ View Buttons

These buttons switch between views in the Organizer.

Ⓓ Panel Bin

This is an area for panels, which display quick fix, tagging, or photo information.

Ⓔ Import Button

Click this button to import photos and other images from a folder on an internal or external drive, camera or card reader, or scanner.

Ⓕ Taskbar

These buttons select panels and various options. They also include important editing commands, including Undo.

Ⓖ Share Button

Click this button to share your photo by email, on social media, and more.

Switch Between the Organizer and the Editor

Photoshop Elements has two main workspaces: the Organizer and the Editor. The Organizer lets you browse, sort, share, and categorize photos in your collection, and the Editor enables you to modify, combine, and optimize your photos. You can easily switch between the two environments.

You can use the Organizer to review your photos to find images for your projects. After you select your photos in the Organizer, you can open the Editor to adjust the colors, lighting, and other aspects of the photos, and then switch back to the Organizer to choose more photos to edit.

Switch Between the Organizer and the Editor

1 Start the Photoshop Elements Organizer.

Note: See the section "Start Photoshop Elements" for more on starting the program.

You can browse and sort your photos in the Organizer.

Note: For more about adding photos to the Organizer, see Chapter 2.

2 Click a photo to select it.

3 Click **Editor**.

The photo opens in the Editor. If the Editor is not already running, it may take a few moments to launch.

A The Editor opens in whatever mode you last used.

B You can click **Organizer** to return to the Organizer.

Introducing the Photoshop Elements Tools

In the Editor, Photoshop Elements offers a variety of specialized tools that enable you to manipulate your image. You can select tools by clicking icons on the left side of the workspace or by pressing a keyboard shortcut key. Keyboard shortcut keys are shown in parentheses. Many tools create *selections* — areas you can edit. Each editing mode displays different tools. Expert mode displays all the tools, as shown here.

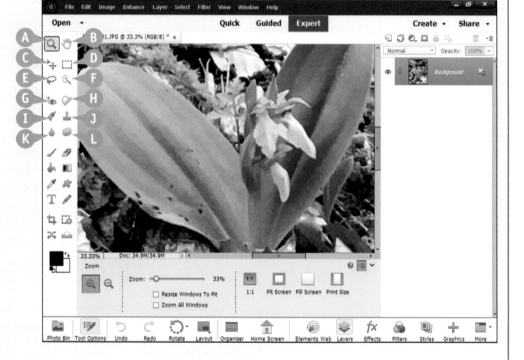

Ⓐ Zoom (Z)

Expand/shrink the image in the preview area.

Ⓑ Hand (H)

Drag the image when it is too big to display fully in the active image area.

Ⓒ Move (V)

Move a selection.

Ⓓ Marquee (M)

Create a rectangular or oval selection.

Ⓔ Lasso (L)

Draw a free-form selection shape with your mouse.

Ⓕ Quick Selection (A)

Create a selection by looking for similar colors or contrasting edges.

Ⓖ Eye (Y)

Correct red eye problems.

Ⓗ Spot-Healing Brush (J)

Repair imperfections by copying nearby pixels.

Ⓘ Smart Brush (F)

Select and apply a "quick fix" collection of effects.

Ⓙ Clone Stamp (S)

Paint pixels from one area to another.

Ⓚ Blur (R)

Blur a selection.

Ⓛ Sponge (O)

Increase or decrease color *saturation* (intensity).

The toolbox doesn't have room to display all the tools at once, so some tools share a location. To toggle through the available variations of a tool, you can press its shortcut key or Alt+click (Option+click on a Mac) the tool until you see the one you want to use. Or click the desired variation at the left side of the Tool Options panel.

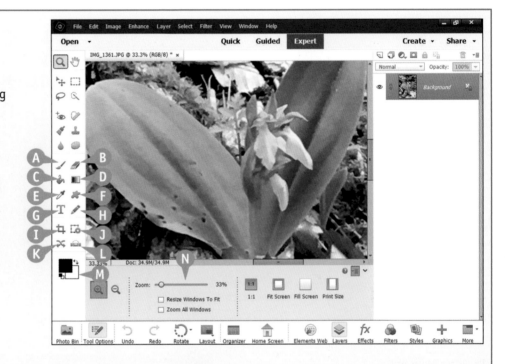

A Brush (B)
Paint on the image.

B Eraser (E)
Erase pixels by replacing them with the background color or making them transparent.

C Paint Bucket (K)
Fill a selection with a single color.

D Gradient (G)
Fill a selection with a blend of colors.

E Color Picker (I)
Copy a color from the image.

F Shape or Custom Shape (U)
Draw various shapes.

G Type (T)
Add text to an image.

H Pencil (N)
Draw hard-edged lines.

I Crop (C)
Remove unwanted parts of an image to improve it.

J Recompose (W)
Intelligently change the size of a photo while keeping elements intact.

K Content-Aware Move Tool (Q)
Move a selection and fill its old location with textures from the surrounding area.

L Straighten (P)
Straighten a crooked image or rotate it for special effects.

M Foreground and Background Color
Set the foreground and background colors used by the paint, draw, text, shape, and fill tools.

N Tool Options Panel
Display settings and options for the current tool.

Switch Editing Modes

The Photoshop Elements Editor has three modes: Quick, Guided, and Expert. Use Quick mode for simple, easy edits. This mode is perfect for beginners who are new to photo editing.

Guided mode offers step-by-step instructions for more complex edits and effects. Use it to experiment with what Photoshop Elements can do. Expert mode gives you full access to all the features in Photoshop Elements. Use it when you have more experience with the tools and feel more confident about working with them.

Switch Editing Modes

1 Open a photo in the Editor.

Note: See Chapter 2 for information about opening photos.

2 Click **Quick**.

Quick mode appears.

Ⓐ Click the toolbox to select a tool.

Note: For more about tools, see the next section, "Work with Tools."

Ⓑ Click here to select and apply one of the built-in quick adjustments and fixes.

3 Click a menu.

Photoshop Elements displays the menu commands.

4 Click or move the mouse pointer over a command with a triangle (▶) to display a submenu if needed.

Ⓒ In Quick and Guided modes, some commands are grayed out and you cannot use them.

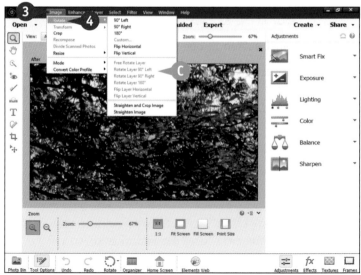

5 Click **Guided**.

Guided mode appears.

6 Click one of the six categories across the top.

The guided edits offered in the selected category appear.

Note: Rather than clicking a category, you can click **Search** at upper right, type a word or phrase in the text box that appears, and then press Enter or Return.

7 Click a guided edit choice.

The file and Panel Bin reappear. Follow the prompts in the Panel Bin to perform the edits.

Note: Very few tools are available in Guided mode, but the step-by-step editing suggestions include tools and settings of their own.

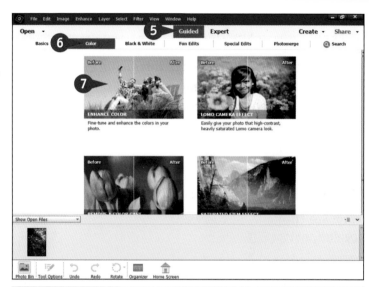

8 Click **Expert**.

Expert mode appears.

D Click a tool in the toolbox to select it.

E Click a panel button to open its panel.

Note: See the section "Work with Panels" for more information.

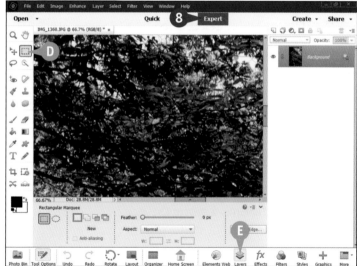

Work with Tools

You can use the tools in Photoshop Elements to make changes to an image. After you select a tool, the Tool Options panel displays controls and settings for the tool. For example, if you select the Rectangular Marquee tool, you can set the width and height of the selection area.

Some tools display a tiny mark in the upper-right corner when you position the mouse pointer over them. This means you can select related tools by clicking a tool icon at the left side of the Tool Options panel. For example, you can click the Lasso tool icon to select two further tools: Polygonal Lasso and Magnetic Lasso.

Work with Tools

Select a Tool

1 Click an editing mode tab.

2 Position the mouse pointer over a tool.

A A tool tip displays the tool name and shortcut key.

3 Click the tool to select it.

B The Tool Options panel shows settings and options for the current tool.

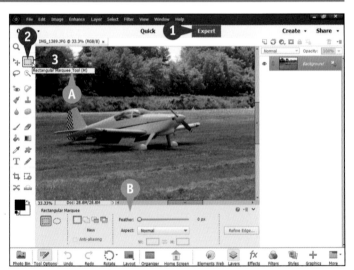

Select a Related Tool

1 Click a tool that has a ◥ in the upper-right corner when you point to it.

Photoshop Elements displays the tool and any related tools in the Tool Options panel.

2 Click one of the related tools.

You also can press a tool's shortcut key or Alt +click (Option +click on a Mac) repeatedly to cycle through the related tools.

Close the Tool Options Panel

You can close the Tool Options panel to give you more space to view and edit your photos.

1 Click **Tool Options**.

The Tool Options panel closes.

A You can click **Tool Options** again to reopen the Tool Options panel.

How can I keep the Tool Options panel hidden?
In the Tool Options panel, click the panel menu (▾≣) icon. By default, Auto Show Tool Options is selected, and the panel is shown when a tool is clicked. Click **Auto Show Tool Options** to deselect the option and keep the panel hidden.

How can I reset a tool to its default settings?
With a tool selected, click the panel menu (▾≣) icon in the Tool Options panel and then click **Reset Tool**. You can click **Reset All Tools** to reset all the Photoshop Elements tools to their default settings.

Work with Panels

In the Photoshop Elements Editor, you can open *panels* to access different Photoshop Elements features. In Expert mode, shown in this example, most panels open in the Panel Bin at the right side of the workspace. Other panels may open in a tabbed window. You can drag this window to another position, click the tabs to select different panels, and resize the window in some cases.

For example, the Layers panel shows the layers in your image, including the standard background layer available in all images. The Graphics panel displays clip art and graphics you can add to your photos.

Work with Panels

Using the Main Panels

1 Open the Photoshop Elements Editor and an image file.

Note: For more on opening the Editor, see the section "Start Photoshop Elements." For more on opening a file, see Chapter 2.

2 Click one of the panel buttons on the taskbar.

Note: You also can open panels using the **Window** menu.

A The clicked panel opens in the Panel Bin.

B Many panels have tabs, menus, and controls for specifying further suboptions.

3 Click the panel button again.

The panel closes.

C Closing the panel increases the empty space in the active image area, so you could zoom the image to a larger size if desired.

Open More Panels

1 Click **More**.

A window opens with tabbed panels.

2 Click any tab to display a panel.

Ⓐ You can drag the panel header to move the window.

Ⓑ You can click ⊠ to close the panel window.

Resize Panels

1 To resize the panel window, drag the corner or edges. Not all panels in the panel window are resizable.

The panels resize.

What do the tabs in the floating panel do?
Info shows color information for the pixel under the mouse pointer. **Navigator** is a combined zoom and drag tool. **Favorites** shows favorite effects. **History** shows a list of edits. **Histogram** graphs tonal ranges by color channel. **Color Swatches** shows color presets, known as *swatches*. **Action** shows a list of ready-made edit operations.

How do I reset my panels?
Click **Window** and then **Reset Panels**. This resets the size of the panels and, in Expert mode, shows Layers panel in the Panel Bin.

Set Program Preferences

You can use the Photoshop Elements Preferences dialog box to change various settings. For example, you can change image measurements from inches to centimeters or pixels, set how much memory is being used, control how many steps of Undo are remembered, and so on. You can make these changes from both the Editor and the Organizer.

Preferences are always saved to disk. Changes remain in effect even if you quit and restart Photoshop Elements. In the Organizer, you can restore all preferences to their original state by clicking **Restore Default Settings** in the General preferences.

Set Program Preferences

In the Editor

1 In the Editor, click **Edit**. (On a Mac, click **Adobe Photoshop Elements 2023 Editor**.)

Note: For more on opening the Editor, see the section "Explore the Editor Workspace."

2 Click **Preferences**.

3 Click **General**.

As an alternative, you can press Ctrl+K (⌘+K on a Mac).

The Preferences dialog box opens and displays General options.

4 Select any settings you want to change.

A For example, you can click the ▾ to specify the shortcut keys for stepping backward and forward through your commands.

B You can click this option (☐ changes to ☑) to open images in floating windows instead of tabbed windows.

5 Click any of the items in this list to select a different preference category.

C You also can click **Prev** and **Next** to move back and forth between categories.

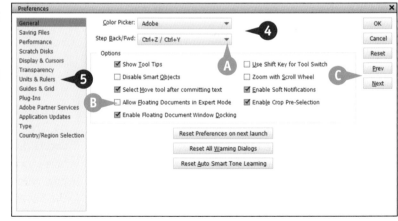

20

This example shows the Units & Rulers preferences.

6 Select any settings you want to change.

7 Click **OK**.

Photoshop Elements sets the preferences.

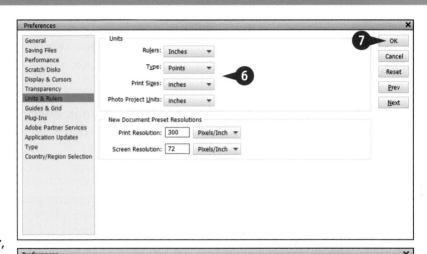

In the Organizer

1 In the Organizer, repeat steps **1** to **4** in the subsection "In the Editor." On a Mac, click **Elements Organizer**, and then click **Preferences**. Or press Ctrl+K (⌘+K on a Mac).

Note: For more on opening the Organizer, see the section "Tour the Organizer Workspace."

The Preferences dialog box opens.

2 Select any of the preference groups.

Note: The groups and the settings are not the same as the Editor preferences.

3 Click and change any of the settings.

4 Click **OK**.

Photoshop Elements sets the preferences.

TIPS

What type of measurement units should I use in Photoshop Elements?
Typically, you use the units that match the output you want to produce. For web designs, use pixels. For print, use inches, centimeters, or millimeters. Percentage units are useful for general editing.

How do I give Photoshop Elements more memory so I can open work on more photos at once?
The Performance preferences in the Editor show how much memory, or *RAM*, you have available and how much of it Photoshop Elements is using. Use the Scratch Disks preferences to use disk space instead of RAM.

View Rulers and Guides

In Expert mode, you can turn on rulers and guides. Use rulers to measure widths and heights in your image. To change the units of measurement, see the previous section, "Set Program Preferences."

Guides are horizontal or vertical lines. You can add them in the Editor active image area to help you line up elements in your image. You can see guides only as you edit. They do not appear in printed images or in images saved for sharing.

View Rulers and Guides

Show Rulers

1. Click **Expert**.

2. Click **View**.

3. Click **Rulers**.

 You also can press Shift+Ctrl+R (Shift+⌘+R on a Mac).

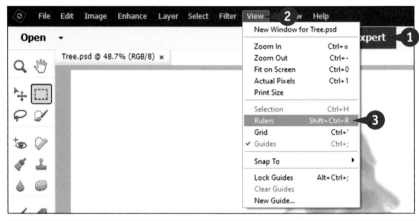

A Photoshop Elements adds rulers to the top and left edges of the active image area.

Note: The left and top of the image always line up with 0 on the rulers.

Create a Guide

1 Move the mouse pointer over one of the rulers, and drag the mouse pointer into the window (⏳ changes to ↔).

Drag from the top ruler down to create a horizontal guide.

Drag from the left ruler to the right to create a vertical guide.

B A thin, colored line appears.

You also can click **View** and then **New Guide** to add a guide at a precise position.

Move a Guide

1 Click the **Move** tool (⊹).

2 Position the mouse pointer over a guide (⏳ changes to ↔), and then drag.

Photoshop Elements shows the guide position from the top or left of the image as you drag.

You also can press Ctrl +' (⌘ +' on a Mac) to display a grid on your image. The lines of the grid can help you align objects in your image.

TIPS

How do I make objects in my images "snap to" my guides when I move those objects?
The "snap to" feature is useful for aligning elements. Click **View**, **Snap To**, and then **Guides**. When you move an object near a guide, Photoshop Elements snaps it — pulls it — to the guide. Select **Document Bounds** to snap elements to the edges of a photo, and select **Layers** to snap to layer positions. Turn the "snap to" choices off if you want to place elements by hand without automatic alignment.

Do guides work across layers?
Guides are for display only. They do not change an image or a layer. If you are working with layers, guides remain visible on top of the layer stack. For more about layers, see Chapter 4.

Importing and Opening Digital Images

Before you can start working with a photo, you must import or open it. This chapter shows you how to import photos into the Organizer and open them in the Editor, along with how to perform other file tasks.

Get Photos for Your Projects

Photoshop Elements can accept images from various sources, including digital cameras and smartphones, scanners, and photo-sharing sites. Before you can organize and edit your images, you must import them. Photoshop Elements imports different sources in different ways.

Digital Cameras and Smartphones

Photoshop Elements enables you to import or open photos from smartphones, mid-range point-and-click enthusiast cameras, and full-featured digital SLR (Single Lens Reflex) cameras. Some cameras support a direct USB connection, while others save files to a memory card accessed using a USB-connected *memory card reader* device. The process for smartphones will vary depending on the type of phone and your computer's operating system. Photoshop Elements reads all the standard digital photo file types, including the high-quality raw formats available on many cameras.

Scanned Photos and Art

You can use the Windows version of Photoshop Elements to scan photos and hand-drawn or painted art into your computer using an external scanner. Some scanners support transparency (slide) scanning, and you can use Photoshop Elements to crop, tidy up, and repair images from old slides. Note that scanning is not available on the Mac version, but you can use external scanning software to scan images and then import them manually as files.

Web Images

If you have photos or art stored on the Web, you can save those image files to your computer and then open them in Photoshop Elements. In Microsoft Edge in Windows, you can save a web image by right-clicking it and clicking **Save Image As** (Control+click and then click **Save Image As** in Safari on a Mac). Inexpensive stock photo websites, such as iStock (formerly iStockphoto), offer professional-grade images for download. On photo-sharing sites such as Flickr, contributors often allow noncommercial use of their photos.

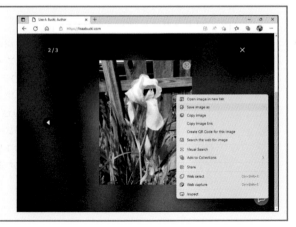

Start from Scratch

You also can create a Photoshop Elements image from scratch by opening a blank canvas in the active image area. Then apply colors and patterns with the tools in Photoshop Elements, or cut and paste parts of other images to create a composite. This example uses a background copied from part of another image, with text and shapes added. See the section "Create a Blank Image" for more on opening a blank canvas.

Film Photos

Although most photography is now digital, cheap waterproof film cameras are still popular for vacation and sports photography. Some serious photographers continue to prefer the look of film or slides. If you use a commercial film developing service, you can usually ask to receive your images pre-scanned to files on a DVD or USB drive or made available via web download. You can import these images into the Photoshop Elements Organizer or open them in the Editor.

Working with Imported Photos

When you import images into the Photoshop Elements Organizer, you can browse miniature versions of your photos, called *thumbnails*; group them into albums; display photo details; and assign keyword tags to them. You can edit your photos by opening them in the Photoshop Elements Editor. You can open them in the Editor from the Organizer or open them directly from folders on your computer. See Chapter 1 for more on the Editor and the Organizer workspaces.

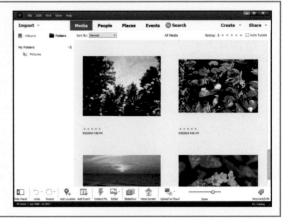

Import Photos from a Digital Camera or Card Reader

You can import photos into Photoshop Elements from a digital camera or from a memory card. To read from a camera (and some smartphones), connect it to a USB port and power it on. To read from a card, connect a card reader — a small device with slots for different memory cards — to a USB port and then plug the card into a compatible slot on the reader. Some computers have a built-in card reader. (Some newer Mac models may require an adapter to connect standard USB devices.)

Every camera and card reader works differently. For example, you may need to set a special USB mode on your camera before you can read photos from it. Check your camera's manual for instructions.

Import Photos from a Digital Camera or Card Reader

1 If the Photo Downloader doesn't open automatically in the Organizer when you connect your camera or card reader to the USB port, click **File**.

2 Click **Get Photos and Videos**.

Note: Instead of steps **1** and **2**, you could click the **Import** button at the upper left to see the import command choices.

3 Click **From Camera or Card Reader**.

The Photo Downloader dialog box opens.

4 Click ∨ to choose your camera or memory card from the Get Photos from menu.

A You can click **Browse** (**Choose** on a Mac) to set the import destination.

By default, Photoshop Elements downloads your photos into subfolders inside your Pictures folder in both Windows and Mac. Each folder name includes the date of the photos.

B You can click ∨ to select a different naming scheme for subfolders.

Note: You can name subfolders with the shoot date in a variety of formats, the import date, and a custom name.

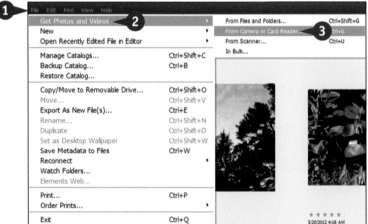

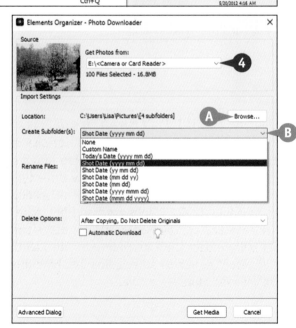

28

Ⓒ Click ⌄ to set a naming scheme for your files.

Ⓓ Click ⌄ to choose whether to keep your photos on the device or delete them after downloading.

Note: Keeping the photos on the device provides a good backup and is the best practice.

Ⓔ On Windows only, you can click this option to set up Photoshop Elements to download your photos automatically using the current settings whenever a photo device is connected to your computer (☐ changes to ☑).

❺ Click **Get Media**.

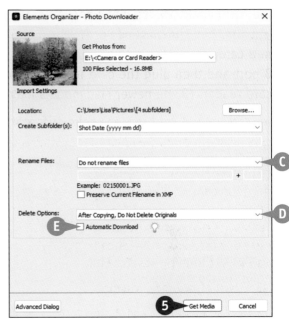

Ⓕ Photoshop Elements downloads the photos from the device.

Ⓖ You can click **Stop** to abort the download.

After downloading the photos, Photoshop Elements adds them to the current Organizer catalog.

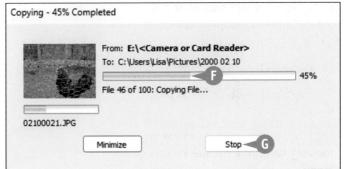

TIPS

What can I do if I don't have a free USB port?
One option is to buy a *USB hub*. This optional extra provides additional USB ports that plug into a single USB port on your computer. There are three types. USB 1.0 hubs are cheap but too slow for speedy downloading. USB 2.0 hubs are faster but more expensive and are the best option for occasional photo downloads. USB 3.0 hubs work with all the most recent accessories, including fast hard drives, but are even more expensive.

How do I import files from another disk or folder location?
If you have files saved to another storage location — such as a USB drive or a folder on an external or network-connected drive — click **File**, click **Get Photos and Videos**, and then click **From Files and Folders**. The Get Photos and Videos from Files and Folders dialog box appears. Navigate to and select a photo to import; then click **Open**.

Import Photos from a Scanner

You can import a digital version of a hard-copy photo into Photoshop Elements using a scanner attached to your computer in Windows. The photo appears in the Organizer Media view after importing. On a Mac, you can use the Image Capture application to scan photos and then import them. Some scanners include slide or film attachments that enable you to digitize slides or film.

Every scanner works differently. Consult the documentation that came with your scanner for more information.

Import Photos from a Scanner

1 In the Organizer, click **File**.

2 Click **Get Photos and Videos.**

Note: Instead of steps **1** and **2**, you could click the **Import** button at the upper left to see the import command choices.

3 Click **From Scanner**.

The Get Photos from Scanner dialog box opens.

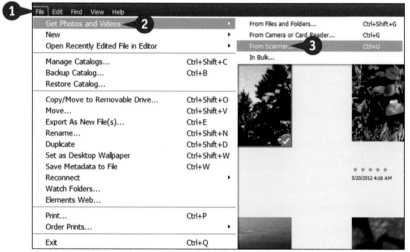

4 If your scanner does not appear here, click ▼ to select it.

By default in Windows, Photoshop Elements saves scanned photos in the Adobe folder inside your Pictures folder.

Ⓐ You can click **Browse** to choose another location.

5 Click ▼ to choose a file format.

Note: PNG is a good choice because it does not reduce image quality.

6 Click **OK.**

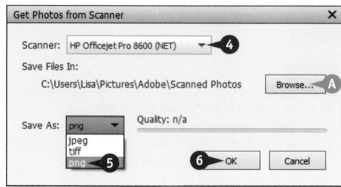

The software associated with your scanner opens. Different scanners have different software, so you may not see the options shown here.

7 Change your scanning settings as needed. You may need to specify whether you want the scanned (output) photo to be color or grayscale. You may also get to preview the scan.

8 If your software includes a Preview button, click it to see a preview.

B The preview may include a box around the photo, as shown here. If the box doesn't snap to the edges of the photo, you can usually drag the corners of the preview box to adjust the scan area.

9 Click your scanner software's **Scan** button to scan the photo.

C Photoshop Elements scans the photo.

After scanning, the photo appears in the Organizer.

Note: Scanned photos often need to be cropped and/or rotated. For details, see Chapter 3.

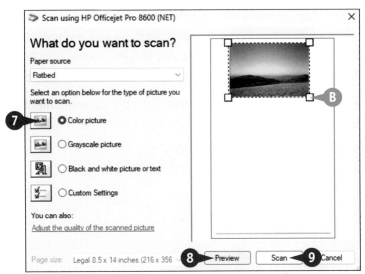

TIPS

How can I adjust the default settings for scanning photos?
Click **Edit**, click **Preferences**, and then click **Scanner**. In the Scanner Preferences dialog box that opens, you can adjust the default settings. The **Quality** slider is disabled when the TIFF or PNG format is selected. Click **OK** to save the settings. Photoshop Elements displays the updated settings the next time you scan a photo.

What resolution should I use while scanning?
Even many consumer-grade scanners can create digital images with resolutions of 2400 dpi and up. Scanning at an excessive resolution wastes disk space, however. If you are scanning a photo to have it professionally reprinted or restored, many service providers recommend scanning at 600 dpi. Use a higher dpi for enlarged prints. In the dialog box example at the top of this page, you would click **Adjust the quality of the scanned picture** to change the dpi.

Open a Photo

You can open a photo or other image file in the Editor to modify it or to use it in a project. After you open the file, you can adjust its color and lighting, add special effects, and move selections in the photo or image to separate layers. You also can select and open a photo from the Organizer for editing in the Editor.

You can open more than one photo at a time in the Editor. You can switch between photos using the window tabs. Open images also appear in the Photo Bin.

Open a Photo

Open a Photo in the Editor

1 In the Editor, click **File**.

2 Click **Open**.

You also can press Ctrl + O (⌘ + O on a Mac).

Note: In the Windows version, the Editor also can directly import images from cameras and phones that support WIA (Windows Image Acquisition) image transfer. Connect and power on the device; then click **File**, click **Import**, and click **WIA Support** to begin.

Note: A camera raw format file opens in the Camera Raw dialog box. To open other file types in the Camera Raw dialog box, use the **Open in Camera Raw** command on the **File** menu.

The Open dialog box appears.

3 Use your preferred method to navigate to the folder containing the file you want to open.

4 Click the photo you want to open.

A If you don't see preview icons, you can click here and then click another view.

5 Click **Open**.

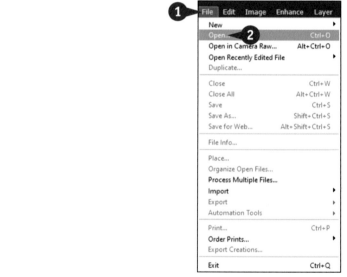

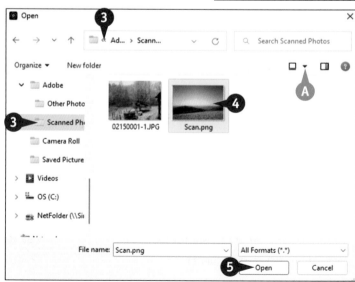

Photoshop Elements opens the image.

Ⓑ The file name and zoom (preview magnification) setting appear in the tab.

Note: Depending on your preferences, the image may appear in a floating window instead of a tab.

Ⓒ If the Photo Bin is open in the Editor, the image also appears in the Photo Bin.

Ⓓ You can click **Window** to view a list of open files at the bottom of the menu.

Open a Photo in the Organizer

1 In the Organizer, click the photo you want to edit.

2 Click **Editor**.

Ⓐ You also can right-click the image and select **Edit with Photoshop Elements Editor**.

Photoshop Elements opens the photo in the Editor.

TIP

What types of files can Photoshop Elements open?
Photoshop Elements can open most of the image file formats in common use today. Here's a partial list.

File Type	Description
BMP (Bitmap)	The standard Windows image format
TIFF (Tagged Image File Format)	A format for print
JPEG (Joint Photographic Experts Group)	A format for web images
PNG (Portable Network Graphics)	An alternative web format to GIF and JPEG
PSD (Photoshop Document)	Photoshop's native file format

Create a Blank Image

You can start a Photoshop Elements project by creating a blank image and then adding photo content, text, shapes, and more. When you create a blank image, you specify the dimensions and the resolution. Photoshop Elements offers a number of useful preset sizes, including common paper sizes and web browser dimensions.

You can add content from other images to your blank image as separate layers. For more on layers, see Chapter 4. Chapter 9 explains how you also can use the Brush tool, shape tools, and other tools to add image content.

Create a Blank Image

1 In the Editor, click **File**.

2 Click **New**.

3 Click **Blank File**.

You also can press Ctrl+N (⌘+N on a Mac).

Note: If you copy an image or selection before creating a new image, Photoshop Elements automatically copies its dimensions into the New dialog box. You can select a different size.

The New dialog box opens.

4 Type a name for the new image if desired.

A Click here to change the size units for the image.

Note: Changing the units for one dimension also changes the units for the other dimension.

5 Type the desired image width.

6 Type the desired image height.

7 Type the resolution for the new image.

Note: Use the default RGB color mode for color images.

B If you choose a preset Document Type such as Photo, you can then click the **Size** drop-down list and click one of the available sizes for the selected Document Type.

C You can click the **Background Contents** drop-down list to change the image background.

Note: By default, Photoshop Elements makes the background white. You can instead choose to use the background color selected in the swatch at the bottom of the toolbox or a transparent background.

8 Click **OK**.

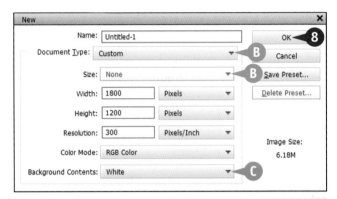

Photoshop Elements creates a new blank image with the dimensions you selected.

Note: After you create a new image, you can resize the image canvas or resample the image to change its size and/or resolution. Chapter 3 covers these important tasks.

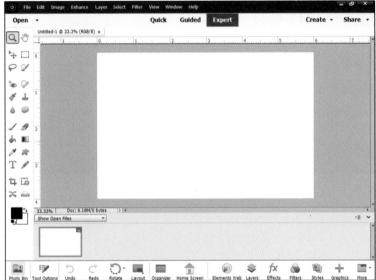

TIP

What should I choose as a resolution for a new image?

Resolution indicates the level of detail in a photo based on the pixels it holds, usually stated in pixels per inch (ppi) or dots per inch (dpi). Images with higher resolutions have more detail. For web images, select 72 pixels/inch, the standard resolution for onscreen images. To output images on a typical inkjet printer, use a resolution of 300 pixels/inch. You may need to use a much higher resolution for images to be included in video projects or to be printed professionally in large format sizes.

Save an Image

You can preserve the changes you make to an image file by saving it. Photoshop Elements enables you to save files in a number of formats. The default format when you save a new file is PSD. This includes useful project information, but it can be read only by a limited collection of Adobe-compatible applications.

You can resave a PSD file to PNG for most situations and to JPEG if you need very small files and can afford to lose some image quality. You can save multiple versions of the same image as a *version set* in the Organizer.

Save an Image

Save a New Image

1 In the Editor, click **File**.

2 Click **Save As**.

Note: You also can use the **Save As** command when you want to rename the file or save it in a different file format. "Open a Photo" mentions some of the supported file formats.

Note: For photos that you have previously saved, you can click **File** and then **Save**. Or press Ctrl + S (⌘ + S on a Mac). This command saves recent file changes and keeps the current file type. Repeatedly saving a JPEG file can degrade image quality. To avoid this, save as a PSD file, make edits, and then resave the final image back to JPEG.

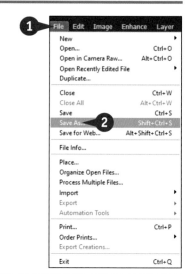

The Save As dialog box opens.

3 If you need to change the name, type it here.

A Use your preferred method to navigate to and choose another disk and/or folder to store the saved file.

B Click the **Save As Type** drop-down list (**Format** drop-down list on a Mac) to choose a different file format.

Note: Photoshop Elements adds the correct file extension automatically to the filename.

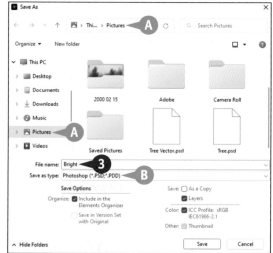

Ⓒ This option adds the file to the current Organizer catalog when checked (the default).

Ⓓ Click this option to save the file as part of a version set with other versions (☐ changes to ☑).

You can use this option only if a version set for the image already exists and you are using Save As to save it under a new name.

④ Click **Save**.

Photoshop Elements saves the image file.

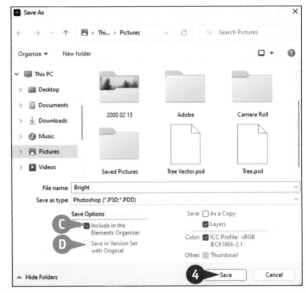

View a Version Set in the Organizer

① In the Organizer, scroll to find a thumbnail with a version set icon (🖼).

You can use the scroll bar to browse your photos.

② Click ▶ to expand the version set so you can view all the photos in that set.

Note: File details must be displayed (click **View** and then **Details**) to see the icons for expanding version sets.

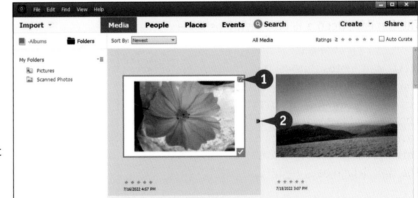

TIP

How can I save my open photos as an album in the Organizer?
In the Photo Bin, click the bin menu (▾≡). Click **Save Bin as an Album**. In the Save Photo Bin dialog box, type a name for the album and click **OK**. The photos are saved as a new album in the Organizer.

Print Photos

You can print your photos and images on a standard desktop printer or even a specialty photo printer. Many printers are compatible with high-quality photo paper, so you can make photo prints at home.

The print feature in the Organizer includes a number of hidden options. You can print single images, a contact sheet with thumbnails of many images, or a picture package with a selection of layout and labeling options. Note that on the Mac, you can select photos for printing in the Organizer, but the print dialog appears in the Editor.

Print Photos

1 In the Organizer, click the photo to print.

Note: Use Ctrl+click (⌘+click on a Mac) to select multiple photos For more on using the Organizer, see Chapter 1.

2 Click **File**.

3 Click **Print**.

You also can print by pressing Ctrl+P (⌘+P on a Mac).

Note: In the Editor, Ctrl+click (⌘+click on a Mac) the files to print in the Photo Bin. Click **File**, click **Print**, choose settings in the Print dialog box, and then click **Print**.

The **Prints** dialog box opens.

A Click this drop-down list to select a printer.

B Click this drop-down list to select a paper size.

Note: Select the size you have loaded into your printer, as in this example.

C Click this drop-down list to select Individual Prints, Contact Sheet, or Picture Package modes.

D Click this drop-down list to select a print size.

4 If this option is available, click here to change your printer settings.

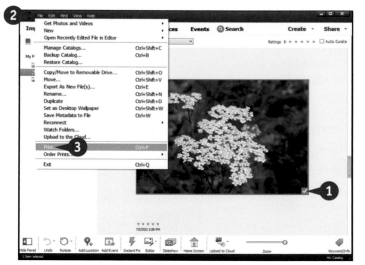

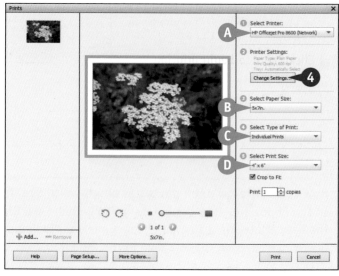

A printer settings dialog box appears.

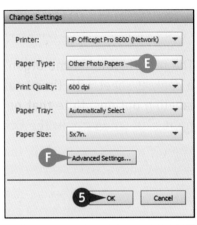

E If you are using special photo-quality paper, you can select it with this menu.

F You can click **Advanced Settings** to access color control and other settings. The settings you see depend on your printer and your operating system.

5 Click **OK** to close the dialog box.

6 Click **More Options** to show further settings.

The More Options dialog box appears.

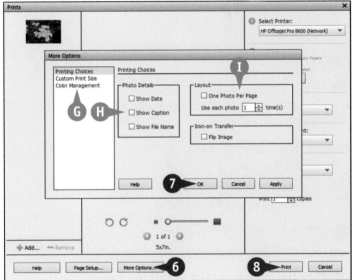

G Click items in the list to show further options.

This example shows the Printing Choices options.

H Click check boxes as desired to print the date, caption, and filename of the photo.

I Click the check box and type or specify a number to print more than one copy of each photo.

7 Click **OK** to close the dialog box.

8 Click **Print** to begin printing.

TIPS

What is a contact sheet?
Contact sheets were formerly used by professional photographers to preview thumbnails from a shoot. In Photoshop Elements, you can select photos in the Organizer and print preview copies in one to nine columns. You can include details such as the filename and caption under each image. Some photographers use this option to create printed catalogs that they can show or refer to away from the computer.

What is a picture package?
You can use a picture package to create print layouts that use paper efficiently. For example, you can create two horizontal prints on a single sheet of paper in landscape format. This can be more efficient than printing a separate sheet for each photo. You also can print the same photo at different sizes. This option can be useful for creating prints after events such as proms, parties, or weddings. For details, see the online help.

Create a Photo Panorama

You can use the Photomerge Panorama feature to stitch several separate digital photos together into a new, single panoramic image. Photoshop Elements can find the common features in the photos, arrange them in order, and paste them into a single wide image. Use this feature — found in Guided mode — to create wide landscapes or unusually detailed location shots.

You can specify how the images are merged, or you can leave Photoshop Elements to guess the best option for you. Optionally, you can fill any space left at the edges of the panorama with other content.

Create a Photo Panorama

① Before starting, copy the image files you want to combine into a separate folder on your system's hard disk or a USB drive.

Note: This step simplifies the process of finding the files to use.

② In the Editor with the Photo Bin displayed, open each of the image files.

See "Open a Photo" earlier in the chapter.

③ Click the thumbnail for the first image to use in the Photo Bin.

④ Ctrl +click (⌘+click on a Mac) the thumbnail for each additional image to use.

⑤ Click **Guided**.

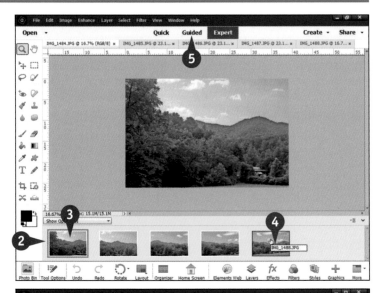

⑥ Click the **Photomerge** category.

⑦ Click **Photomerge Panorama**.

Note: Scroll down first if you don't see that choice.

The Photomerge Panorama panel opens and displays Panorama Settings.

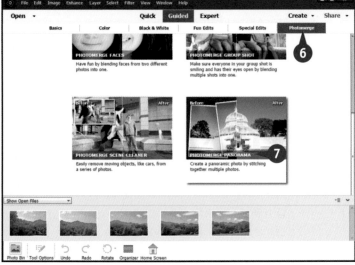

8 If desired, click here to select a different layout.

Note: Auto Panorama, the default, is a good first choice. You can experiment with the other options if Auto Panorama does not give a good result.

Note: The "After" preview may not show the finished panorama.

9 Click here to explore and change additional settings, if desired.

10 Click **Create Panorama** to build the panoramic image.

Photoshop Elements merges the images into a panorama.

Note: The process goes through various stages and can take some time. The images are combined into layers and masks. For more about layers and masks, see Chapter 4.

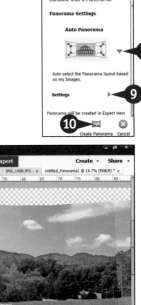

A The stitching process can leave empty areas around the panorama.

B In the Clean Edges dialog box that appears, you can click **Yes** to have Photomerge Panorama automatically fill in the edges.

Note: Alternatively, you can click **No** to continue the process and crop the panorama to a rectangle later.

11 Click **Done** at lower right.

You can then return to Expert mode to further edit and save the panorama file.

Done

TIP

How can I create photos that merge successfully?
To merge photos successfully, you need to align and overlap the photos as you shoot them. Some hints:
- You do not need to use a tripod, but try to take all your photos at roughly the same height. Shoot photos with 15 to 30 percent overlap.
- Do not use lenses that distort your photos, such as fisheye, and do not change zoom settings.
- Check the lighting in the middle of the scene, adjust the camera exposure settings as needed, and then use the same settings for all the photos. Avoiding shooting into light, shadow, or varying light (such as passing clouds).
- Experiment with the different layout modes in the Photomerge Panorama panel.

Duplicate a Photo

In the Editor, you can duplicate a photo or image to keep an unedited "safe" version before you begin making changes. When you make a duplicate, Photoshop Elements creates a new image tab or window for it. You can then save the duplicate image file and make your changes in it, leaving the original file as a clean backup. See the earlier section, "Save a Photo," for more details. Note that creating a duplicate automatically creates a version set.

The Editor's Quick mode includes a **View** drop-down list above the active image area. Use it to choose a view for comparing the original (Before) and edited (After) versions of a photo. For more about working with different views and layouts, see Chapter 3.

Duplicate a Photo

1 In the Editor, click **File**.

2 Click **Duplicate**.

The Duplicate Image dialog box opens.

A Type here to change the name of the duplicate, if desired.

Note: By default, Photoshop Elements adds "copy" to the original filename.

3 Click **OK**.

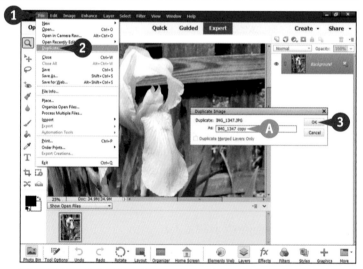

B Photoshop Elements opens a duplicate of the photo on another file tab.

C A thumbnail for the duplicate file also appears in the Photo Bin, if displayed.

Note: The **File** menu in the Editor also includes the **Save for Web** and **Order Prints** commands that you can use to do more with images. Click the **Share** button at the upper right in the Organizer or the Editor to see choices for sharing an image to social media and more.

Close a Photo

You can close a photo or other image file after you finish editing it. Although you can have more than one photo open at a time, closing photos can free up memory and make your computer work faster. It also reduces workspace clutter.

If you try to close an edited photo without saving it first, Photoshop Elements asks if you want to save it so you do not lose the changes. When you exit Photoshop Elements, it closes all open images and also warns you about unsaved changes.

Close a Photo

1 In the Editor, click **File**.

2 Click **Close**.

You also can press Ctrl+W (⌘+W on a Mac).

A You also can click ✕ to close a photo.

B If you have edited but not saved your photo or image, Photoshop Elements asks if you want to save it before closing. See the "Save an Image" section for more about saving files.

C Click **Yes** to save your work or **No** to lose your changes.

Photoshop Elements closes the photo.

Note: If you open the Editor by selecting a photo in the Organizer and clicking the **Editor** button, closing the file also switches back to the Organizer.

CHAPTER 3

Applying Basic Image Edits

Are you ready to start working with images? This chapter shows you how to take charge of how images appear in the active image area in the workspace. You also learn how to resize an image, crop an image to remove unwanted content, and make speedy edits in Quick mode, among other fundamental image editing tasks.

Manage Open Images

By default, each image you open in Photoshop Elements appears in its own tabbed window. This arrangement gives you the maximum space for editing, while enabling you to have multiple images open at once to compare them or copy content between them.

In Expert mode, you can use the window tabs above the active image area to switch between images. Each tab lists the name of the image file, the current zoom percentage, and the image mode. You also can use the Photo Bin or Window menu to switch between open images in Quick and Expert editing modes.

Manage Open Images

Using Tabs

1 In the Editor, click **Expert**.

2 Open two or more images.

Note: For more on opening the Editor, see Chapter 1. For more on opening image files, see Chapter 2.

Ⓐ The Editor active image area shows the currently selected image ready for editing.

Ⓑ Tabs for each image appear here and show the filename and zoom (image magnification).

3 Click a tab to select a different image.

The photo appears in the active image area.

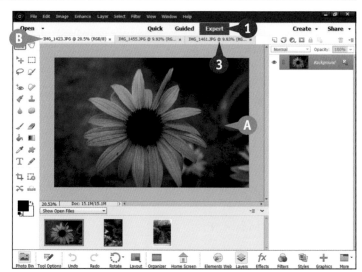

Using the Photo Bin

The Photo Bin usually displays thumbnails (small versions) of all the images open in the Editor.

Ⓐ If the Photo Bin is closed, you can click **Photo Bin** on the taskbar to open it.

1 Click an image thumbnail.

The image file becomes active.

Using the Window Menu

1 Click **Window**.

2 Click an image filename.

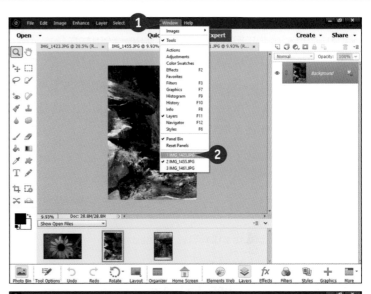

A The image file becomes active.

B You can click **✕** to close a tab.

Closing a tab closes its image file in the Editor.

Note: If you loaded the files from the Organizer, closing all open tabs closes the Editor. If you open files directly in the Editor, it remains open.

Using Layouts

Y ou can use a *layout* to view more than one image at a time in the Editor. Layouts can arrange images in columns, rows, or a grid. You can use this feature to compare images or to select and copy content between them.

When you've chosen a layout to display multiple images, only one of the tabbed windows is active. Choose the active image by clicking its tab, clicking the image itself, or selecting the image in the Photo Bin or the Window menu.

Using Layouts

① With multiple image files open, click **Layout**.

Photoshop Elements displays a menu of layouts.

② Click a layout in the menu.

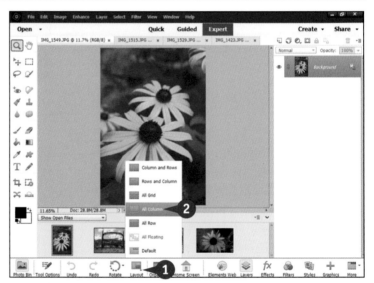

Photoshop Elements arranges the open images in tabbed windows.

This example shows the **All Column** option.

③ Click an image or a tab to select it.

Ⓐ You can use the scroll bars to display a different area of an image in its window.

Note: You also can change the image zoom and move it with the Zoom (🔍) and Hand (✋) tools in the toolbox. For details, see the next two tasks.

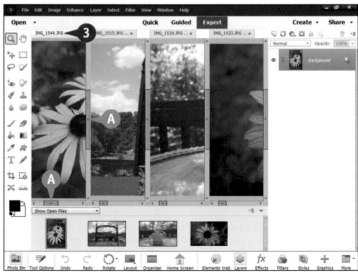

④ Click **Layout**.

Ⓑ You can click **Column and Rows** or **Rows and Column** to display three images at a time. Additional open image files will not initially appear in the layout.

⑤ Click one of the combined row/column layouts.

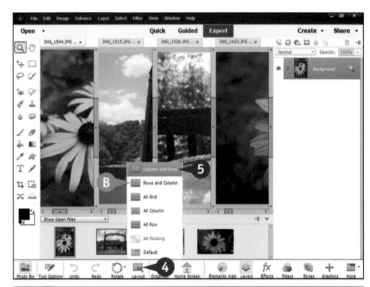

Photoshop Elements displays a split layout.

Ⓒ When a layout area displays multiple tabs, you can click the tabs to select the image that appears in the layout area.

Ⓓ Alternately, you can click the double-arrow button and then click the name of the image file to display in the layout area.

Why is the All Floating option grayed out?
Click **Edit**, click **Preferences**, and then click **General** (click **Adobe Photoshop Elements 2023 Editor**, click **Preferences**, and then click **General** on the Mac). Click the **Allow Floating Documents in Expert Mode** check box to check it (☐ changes to ✔). You can now select the **All Floating** layout and move/float/resize windows independently. Note that if you subsequently open a file from the Organizer, it appears in a floating window and ignores the current layout.

Can I control how Photoshop Elements arranges photos in a layout?
No. Photoshop Elements makes its own decisions about how best to place the photos in a layout. You cannot prioritize or group the photos differently.

Using the Zoom Tool

You can use the Zoom tool to change the image magnification in the active image area in Photoshop Elements. You can zoom in to view and edit fine details or zoom out to see the complete image. You can use the Zoom tool to zoom in or out, or you can set an exact zoom by typing a percentage into the Zoom text box.

Zooming changes the magnification in the Editor active image area. It does not resize the image file or add or remove pixels.

Using the Zoom Tool

Increase the Zoom (Zoom In)

1 In the Editor, click the **Zoom** tool (🔍).

You also can press Z.

Note: For more on opening the Editor, see Chapter 1.

2 Click the image as many times as needed to reach the desired zoom.

You also can press Ctrl + = (⌘ + = on a Mac) to zoom in.

By default, the Zoom tool zooms in to a higher zoom percentage each time you click the image.

The current zoom percentage appears in the image window tab and the Tool Options panel (when in Expert mode).

Ⓐ You can change the zoom by dragging the **Zoom** slider in the Tool Options panel.

Ⓑ You can change the zoom by double-clicking the Zoom text box, typing a new value, and pressing Enter.

Decrease the Zoom (Zoom Out)

1 Click the **Zoom Out** button (🔍) in the Tool Options panel.

You can instead press and hold **Alt** (**Option** on a Mac) while clicking on the image as instructed in step **2**.

2 Click the image as many times as needed to reach the desired zoom.

You also can press **Ctrl**+**-** (**⌘**+**-** on a Mac) to zoom out.

Photoshop Elements zooms out to a lower zoom percentage each time you click the image.

Magnify a Detail

1 Click the **Zoom In** button (🔍) in the Tool Options panel if needed.

2 Drag with the mouse pointer to select an area.

The image zooms in to show the selected area.

The more you zoom in, the larger the pixels may appear and the less you see of the image's content. When zooming in on a high-resolution image like those produced by modern cameras and smartphones, pixel size is less of a concern.

TIPS

What is the quickest way to reset the zoom to 100%?
Double-click the **Zoom** tool or press **Ctrl**+**1** (**⌘**+**1** on a Mac). But you may find the Fit Screen option more useful. Click the **Fit Screen** button in the Tool Options panel after clicking the **Zoom** tool or press **Ctrl**+**0** (**⌘**+**0** on a Mac).

Why do lines and details vary at different zooms?
The fast calculations Photoshop Elements uses to resize the image onscreen are not as sophisticated as the slower math used to resize the dimensions or canvas in the image file. If an image has fine lines or text, they can vanish or double in thickness if the zoom percentage is not 100 percent. Set the zoom to 100 percent to check whether the problem disappears.

Pan the Image

When an image is too big to fit into the Editor active image area or current window, you can use the Hand tool to drag another part of the image into view. You also can use scroll bars to move the image left and right or up and down. This is called *panning* the image.

Use the Hand tool to display different areas and details in an image at a high zoom percentage or on a small monitor.

Pan the Image

Using the Hand Tool

1 In the Editor, click **Expert**.

Note: For more on opening the Editor, see Chapter 1.

2 Click the **Hand** tool (🖐).

You also can press **H**.

Note: The Hand tool is available only if the image is zoomed to a size where it does not fully fit in the active image area.

3 Move the mouse pointer over the image and drag in the desired direction.

The image shifts inside the window so that a different part of the image becomes visible onscreen.

Note: When using any tool, you can press and hold **Spacebar** to switch to the Hand tool. Drag the image as needed, then release the **Spacebar** to revert to the prior tool.

Using the Scroll Bars

1 Drag the scroll box on the horizontal scroll bar to move the image left or right.

2 Drag the scroll box on the vertical scroll bar to move the image up and down.

Resetting the View

1 Click Fit Screen in the Tool Options panel.

You also can press Ctrl + 0 (⌘ + 0 on a Mac).

Photoshop Elements resets the zoom to fit the entire image in the Editor active image area.

Dragging with the Hand tool does not have any effect at this zoom percentage.

TIP

What does the Scroll All Windows check box do?

When you have multiple windows open in a layout, you can check this option so that dragging with the Hand tool moves all the photos at the same time. If all the images have the same dimensions and zoom, corresponding areas appear in all the windows. This can make it easier to compare the images and copy and paste content between them. If the zoom percentages are not the same, the photos scroll at different rates.

Change the Canvas Size

You can change the canvas size to crop an image or add a one-color frame — sometimes called a *mat* or *matte (mount* in the United Kingdom) — around it. Changing the canvas size is like making a photo smaller by cutting off the edges with scissors or making it bigger by gluing a card around it. The photo content is not stretched or squashed.

Making the canvas smaller than the photo crops it by cutting away some area around the edges. Photoshop Elements displays a warning so you can confirm the deletion. Making the canvas bigger adds colored space around it. The default color is white, but you can select some other color.

Change the Canvas Size

1 In the Editor, click **Image**.

2 Click **Resize**.

3 Click **Canvas Size**.

Note: For more on opening the Editor, see Chapter 1.

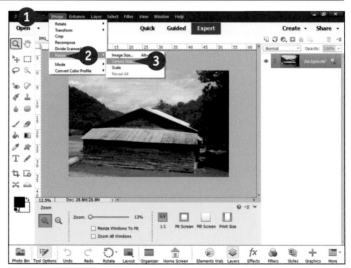

The Canvas Size dialog box opens.

Ⓐ You can see the current photo/canvas dimensions here.

Ⓑ You can click these drop-down lists to change the units of measurement.

Ⓒ Check this box (☐ changes to ☑) to specify relative instead of absolute dimensions for the new canvas.

Note: In relative mode, you can specify how much you want the dimensions to change; Photoshop Elements works out the new image size for you. Negative numbers crop the canvas.

4 Type the new canvas dimensions.

This example uses relative mode to expand the canvas by 3 inches in width and height.

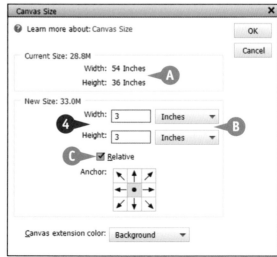

D You can click the arrows in these boxes to position the image on the resized canvas.

Note: For example, the top-left arrow moves the image to the top left of the canvas. If cropping, this removes the content at the bottom and right of the photo.

Note: If you do not change the default, Photoshop Elements leaves the image in the center of the canvas.

E You can click this drop-down list to choose a new border color. Click Other in the list to open a color picker.

Note: This option works only when you increase the canvas size.

Note: For more about using a color picker, see Chapter 9.

5 Click **OK**.

Note: If you decrease a dimension, Photoshop Elements displays a dialog box asking whether you want to proceed. Click **Proceed**.

Photoshop Elements changes the image's canvas size.

In this example, the canvas is resized to add a symmetrical border around the image.

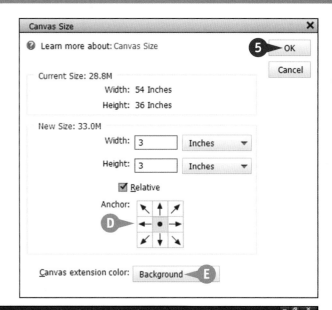

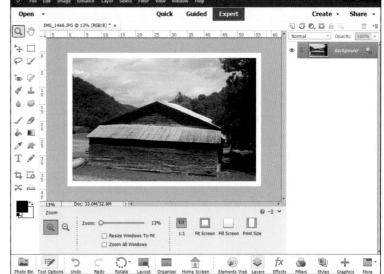

TIP

When should I use percentages and dimensions, and relative or absolute changes?
Use absolute dimensions when you need a specific image size and percentages to crop with less precision. Use the **Relative** setting unless you have a good reason not to, because you can specify an exact size change without calculating the new image size. Resizing may not be simple. For example, it can be a challenge to fit a photo taken with one aspect ratio onto printer paper with another aspect ratio and leave an even border. Sometimes you need to crop and resize in two separate actions.

Resize an Image by Resampling

You can *resample* an image when resizing it for a specific purpose — for example, to save a version of a large photo optimized for a web page or to make a large high-quality print.

Resampling enables you to change the image size but retain the same resolution. Without resampling, making the image width and height smaller would increase the resolution, and vice versa. Resampling can cause a loss of detail. If you expand or shrink an image by more than a factor of two, sharp features become soft.

Resize an Image by Resampling

1 In the Editor, click **Image**.

2 Click **Resize**.

3 Click **Image Size**.

Note: For more on opening the Editor, see Chapter 1.

The Image Size dialog box opens.

A You can see the current image dimensions here.

B You can click these drop-down lists to change the width and height units.

4 To resize by a certain percentage, click the drop-down list and click **Percent**.

5 Make sure **Resample Image** is checked (☑).

C You can uncheck **Constrain Proportions** (☑ changes to ☐) if you want to change the width and height by different amounts.

Note: It's rare to need to change the image proportions, however.

6 Type a percentage here.

Note: An entry of 50% halves the width and height, and an entry of 200% doubles the width and height.

Note: When **Constrain Proportions** is checked (☑), typing a number into the Width text box copies it to the Height text box, and vice versa.

D Photoshop Elements calculates the new dimensions and shows them here.

7 Click **OK**.

Photoshop Elements resizes the image.

In this example, the image has been resampled to half its original size.

Note: If you zoom in on the image, you will likely see that it is less sharp than the original, especially if you increased the image size.

TIP

What does the drop-down list at the bottom of the Image Size dialog box do?
Use the drop-down list to specify the method Photoshop Elements uses to resample the image. The best option depends on photo content, and starting with a quality photo gives the best outcome. Try each of the methods and see which result looks best to you. Nearest Neighbor works well for text and graphics where you want to preserve clean edges.

Crop an Image

You can use the Crop tool to remove unwanted content or clutter around the edges of an image. You also can use it to reposition a subject in the photo frame or make the image square rather than rectangular.

When you use the Crop tool, it suggests possible cropping options. You can accept these suggestions or set up a crop manually. Note that cropping a photo cuts off content around the sides of the image and shrinks the canvas size.

Crop an Image

1 In the Editor, click **Expert**.

Note: For more on opening the Editor, see Chapter 1.

2 Click the **Crop** tool (⛶).

A If the Layers panel is in the way, click **Layers** on the taskbar.

Note: If a crop preview grid appears, you can skip ahead to "Fine-Tune the Crop" or press Esc to dismiss it and crop by hand.

Crop by Hand

B You can drag the mouse pointer on the image to select a crop area.

C Photoshop Elements shows the selected area as you drag.

D Photoshop Elements shows the dimensions of the area.

When you release the mouse, the crop preview grid appears.

Select a Crop Suggestion

Ⓔ You can click the drop-down list and then click an aspect (height/width) ratio for the crop suggestions.

Note: The ratios match popular photo formats and standard print sizes.

Note: With No Restriction selected, you can type values into the W (Width) and H (Height) boxes.

Ⓕ Click one of the Crop Suggestions to show it in the preview area.

Fine-Tune the Crop

Ⓖ You can drag the corner handles of the preview to fine-tune the crop. Hover the mouse pointer over a corner handle and then drag when the two-headed rotation pointer appears to rotate the crop.

Ⓗ You can drag the crop area to reposition it on the photo.

Ⓘ Click one of these buttons to select a different preview grid to help you position and resize the crop.

③ Click the ✔ button to crop the photo.

Photoshop Elements crops the image, reducing the photo to the boundary you specified.

TIP

What does the Cookie Cutter tool do?
Click the **Cookie Cutter** tool (Ⓐ), click the drop-down list arrow (Ⓑ), and then click a shape. Drag on the image to crop it to the shape. You can drag the shape to position it over the photo before you confirm the crop.

Straighten an Image

You can use the Straighten tool to fix a slanted horizon. The Crop tool includes a similar feature, but the Straighten tool is easier to work with. You can straighten an image and then crop it to match an aspect ratio.

To use the tool, select it and draw a line along the horizon or some other horizontal feature in a photo. Note that some photos need extra editing to correct for curves introduced by the lens or perspective distortions.

Straighten an Image

1 In the Editor, click **Expert**.

Note: For more on opening the Editor, see Chapter 1.

2 Click the **Straighten** tool (▦).

3 Click the **Crop to Remove Background** button in the Tool Options panel.

Note: You also can click **Crop to Original Size** and click the **AutoFill Edges** check box (☐ changes to ☑).

4 Drag along a line or other feature that you want to align to the horizon or image bottom.

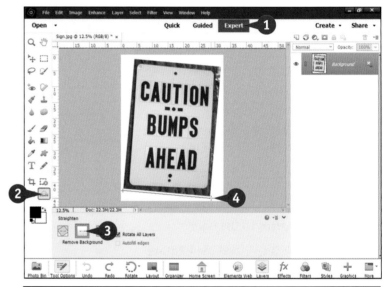

Photoshop Elements rotates the image and crops the corners.

If you selected **AutoFill Edges**, Photoshop Elements fills in extra content at the edges to avoid white space.

Note: Some photos have multiple conflicting horizontals and verticals. You may need to try straightening along different angles to see which works best.

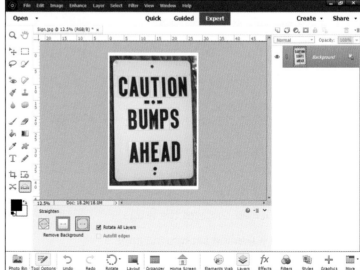

Rotate an Image

You can use a selection of tools and options to rotate an image. The simplest option rotates your photo by 90 degrees left or right. You can use this method to correct the orientation of smartphone shots.

You also can use the **Rotate** submenu of the **Image** menu to select a range of options. You can rotate an image by 180 degrees, flip it horizontally or vertically, or display a dialog box to rotate an image by any number of degrees.

Rotate an Image

To Rotate or Flip

1 In the Editor, click **Expert**.

Note: For more on opening the Editor, see Chapter 1.

2 Choose the desired rotation.

Ⓐ You can click the **Rotate** button to rotate an image 90 degrees to the left.

Ⓑ You can click the **Rotate** button drop-down list arrow (▼) and click the **Rotate Right** option to rotate the image 90 degrees to the right.

Ⓒ You can click **Image** and then **Rotate** and then click one of the available commands.

To Rotate by a Custom Amount

1 Click **Image**.

2 Click **Rotate**.

3 Click **Custom**.

4 Type a rotation angle into the dialog box.

5 Click an option button to select **Right** or **Left** rotation.

6 Click **OK**.

Photoshop Elements rotates the image.

Note: To remove unwanted background around a rotated image, use the Crop tool (🔲).

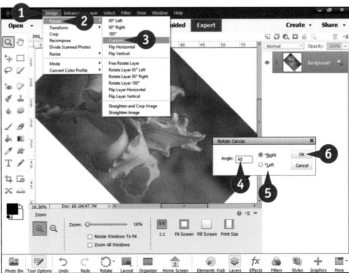

Work in Quick Mode

In Quick mode, you can enhance your photos using a simple interface that includes all the most useful tools. Use the Zoom and Hand tools to see details in your photo, and use the Quick Selection tool to select an area for editing.

Quick Mode includes a selection of quick editing tools in the panel at the right, with one-click presets and useful settings. For finer control, use Expert mode, which is described throughout the rest of this book.

Work in Quick Mode

Pan and Zoom a Photo

1 In the Editor, click **Quick**.

Note: For more on opening the Editor, see Chapter 1.

2 Click the **Zoom** tool (Q).

Note: For more about the Zoom tool, see the section "Using the Zoom Tool."

3 Drag around an object or detail to zoom in.

Photoshop Elements zooms the image and enlarges the detail.

A After zooming, you can click the **Hand** tool (🖐) to move your image within the image window.

Select an Area for Editing

1 Click the **Quick Selection** tool (🖌).

A You can set the brush size by dragging with the Size slider.

2 Drag over an object in your image.

This tool works best when the object has strong edges and contrasting color against the background.

3 Repeat step **2** until the entire object is selected.

B Photoshop Elements selects the object.

Note: For more about making selections, see Chapter 5.

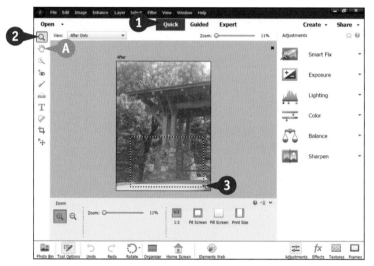

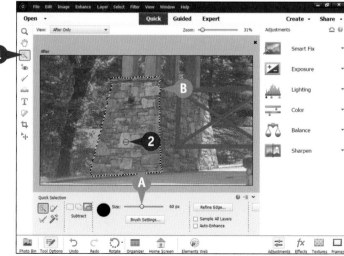

Make an Adjustment

1 Click a tool in the Adjustments panel.

The tool displays settings for adjusting a photo.

A Some tools include tabs you can click to select additional adjustments.

2 Use the choices for the tool to make the adjustment.

B Move the mouse pointer over a preset to preview how it changes the image and click the preview to apply the change.

C You can drag a slider to make more precise changes.

If you have selected an object, the adjustments change only the object, not the background.

Photoshop Elements applies the changes.

D This example shows the Saturation and Hue tab sliders used to exaggerate colors in the selected object.

E You can reset all adjustments and undo the change by clicking the **Reset** button ().

Note: To save your changes, see Chapter 2.

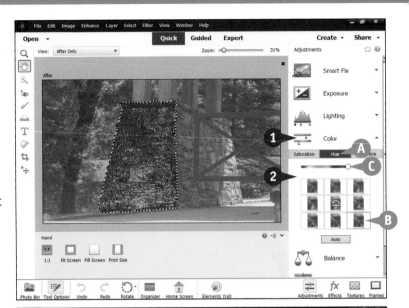

TIP

What do the adjustments do?

Use **Smart Fix** to apply combined one-click edits that improve the color, tone, and contrast. **Exposure** makes the image brighter or darker. **Lighting** works like three different **Exposure** adjustments with separate control over shadows, midtones, and highlights. **Color** can shift colors, make them stronger or weaker, or add color punch (vibrance). **Balance** adjusts blue/red and pink/green balance for improving flesh tones and warming the color in portraits. **Sharpen** sharpens details and emphasizes textures.

Apply an Effect in Quick Mode

You can apply a selection of preset effects in Quick mode. The effects change the tone and color of a photo to add atmosphere and character. Similar effects are very popular on social networking sites.

To use the effects, click the **Effects** button on the taskbar. Click either the Artistic or Classic tab to see a list of effects. Clicking an effect on the Classic tab displays previews of possible variations. Click a variation to apply it to your photo.

Apply an Effect in Quick Mode

1 In the Editor, click **Quick**.

Note: For more on opening the Editor, see Chapter 1.

2 Click **Effects** on the taskbar.

Ⓐ The Effects panel opens.

3 Click either **Artistic** or **Classic**.

Note: You can use the panel scroll bar to see more effects.

4 Click an effect.

Note: Photoshop Elements immediately applies effects on the Artistic tab.

Ⓑ Preset variations appear for effects on the Classic tab.

5 Click a variation.

Photoshop Elements applies the effect to your image.

Ⓒ Click the **Reset** button (⌂) to remove the effect.

64

Add a Frame in Quick Mode

You can add surrounding decoration to a photo by adding a frame. Quick mode offers a variety of frame styles to add elegance or whimsy to your project.

The frame effects are applied to the image as separate layers. If you switch to Expert mode and view the Layers panel after adding a frame, you can temporarily turn off the frame by hiding the frame layer. For more about layers, see Chapter 4.

Add a Frame in Quick Mode

1 In the Editor, click **Quick**.

Note: For more on opening the Editor, see Chapter 1.

2 Click **Frames** on the taskbar.

The Frames panel opens with a collection of border graphics.

3 Click a frame.

Photoshop Elements applies the frame to your image.

Note: You can drag the photo within the frame to position it. You also can drag the edges to stretch it or shrink it.

Ⓐ To remove the frame, click the **Reset** button (⌂).

Apply Automatic Enhancements

All of the standard Photoshop Elements enhancement tools are available in Quick mode. The tools have **Auto** versions that can apply easy one-click fixes.

To use the enhancements, click the **Enhance** item in the main menu and select one of the options. This section introduces a couple of the more useful enhancements. The more complex adjustable enhancements are described in later chapters.

Apply Automatic Enhancements

Auto Smart Fix

1 In the Editor, click **Quick**.

Note: For more on opening the Editor, see Chapter 1.

2 Click **Enhance**.

3 Click **Auto Smart Fix**.

Photoshop Elements automatically fixes the exposure and color.

Note: To adjust the effect, click **Enhance** and then click **Adjust Smart Fix**. Drag the slider in the Adjust Smart Fix dialog box to modify the result. Click **OK** to apply the enhancement.

Auto Levels

1 In the Editor, click **Quick**.

Note: For more on opening the Editor, see Chapter 1.

2 Click **Enhance**.

3 Click **Auto Levels**.

Photoshop Elements adjusts the exposure to make dark areas as dark as possible and bright areas as bright as possible.

Note: Try this tool when Auto Smart Fix makes the midtones too bright and washes out the photo. In this example, the enhancement subtly lifts some of the colors.

Note: To adjust the effect, click **Enhance**, click **Adjust Lighting**, and then click **Levels**. For details, see Chapter 7.

Note: To save your changes, see Chapter 2.

TIP

What do the other enhancements do?
Use **Auto Smart Tone** to adjust brightness and contrast in two dimensions. **Auto Contrast** tries to fix contrast issues. Auto Smart Fix and Auto Levels are more complex effects and better at fixing problems with exposure. **Auto Color Correction** can remove color casts. For details, see Chapter 7. **Auto Sharpen** subtly sharpens the image to bring out the textures. **Auto Red Eye Fix** attempts to fix red eye — the effect that sometimes appears when you take a face-on photo of a model or pet using a flash. It is not as effective as the Eye tool (Red Eye Removal) in the toolbox ().

Add a Texture

You can use the Quick mode textures to add character to a photo. Photoshop Elements blends the textures with photo content to add depth and atmosphere. Use textures for creative effects. They are not intended for corrective adjustments.

To add a texture, click the Textures button on the taskbar and click a texture to apply it. Different textures work well with different photos. You may need to try them all to find the one that creates the best result.

Add a Texture

1 In the Editor, click **Quick**.

Note: For more on opening the Editor, see Chapter 1.

2 Click **Textures** on the taskbar.

The Textures panel appears.

3 Click a texture to apply it.

Ⓐ Photoshop Elements blends the texture with the photo, changing the color, tone, and mood.

Note: This example, Cracked Paint, applies a texture with more shadows and highlights.

④ Click a different texture.

Ⓑ Photoshop Elements removes the old texture and applies the new one.

Note: This example, Sun Burst, applies alternating greenish tints from a center point out.

Note: Different patterns may be more prominent in differing parts of the image. This pattern tints the area that appeared white in the prior example.

TIP

Can I use my own textures?
You cannot add textures to the Textures panel. However, you can use the Layers tools described in Chapter 4 to create your own version of the Texture effect. When you use layers, you can apply any photo as a texture. But you must turn down a setting called *opacity* — which sets transparency — to blend two layers to create the effect. You also can change a layer's blending mode. For details, see Chapter 4. Texture and layer blending can create an almost infinite range of creative effects that enhance atmosphere and impact.

Undo Edits

You can undo edits in Photoshop Elements in two ways. The simple option is to type Ctrl + Z (⌘ + Z on the Mac), click the **Undo** button on the taskbar, or click the **Edit** menu and then click **Undo**. This option reverses the last edit. You can repeat it to step back through the last 50 edits.

You also can use **History Window** to see the last 50 edits, displayed as a list. Click any item in the list to return your photo to that edit. You can use this option to skip back over mistakes or to experiment with new edits.

Undo Edits

1 In the Editor, click **Expert**.

Note: For more on opening the Editor, see Chapter 1.

Note: You can use the History window only in Expert mode.

2 Apply a series of edits.

3 Click **Window**.

4 Click **History**.

Note: You can press F10 in place of steps **3** and **4**.

A The History window opens, showing your edits.

5 Click any item in the edit list.

B Photoshop Elements restores the photo to that edit state.

C Later edits are grayed out to show they are not applied.

D You can click a later edit to move forward to that state.

Note: If you make a new edit, Photoshop Elements updates the list and deletes any grayed-out items because they are no longer available.

Note: You can change the maximum number of edits stored in the History in the Preferences in the Performance category. See Chapter 1.

Revert an Image

In a situation where you do not like your edits, you can revert a photo. The **Revert** command reloads the file from disk. If you have not saved the file since you made changes, it restores the original unedited content. If you have already saved the file, it reloads the last saved version.

Revert an Image

1 Open a file in the Editor, and make some changes to it.

Note: For more on opening the Editor, see Chapter 1.

2 Click **Edit**.

3 Click **Revert**.

Note: You do not need to have the History window open to use the revert option. This example includes the History window so you can see its contents.

Note: Revert counts as an edit operation. You can undo it.

Photoshop Elements reloads the image from disk.

A You can click Undo to un-revert the image.

B You also can click an earlier item in the History list.

Note: The History list is available until you close a photo. You can even use it to restore a photo to an edit state before your last save.

Using Layers

Use layers in Photoshop Elements to work independently with different parts of an image and create a more complex composition. You can copy or cut content on one image layer and then paste the content onto different layers. Move layers independently, apply filters to them separately, and transform their contents without changing what's on other layers in the image. You can change the order in which layers stack to control how the content on one layer overlaps the content of lower layers in the stack. And you can merge layers back into a single layer. Create, rename, and select layers as needed. Some types of content you add to an image — such as text — even automatically appear on a new layer.

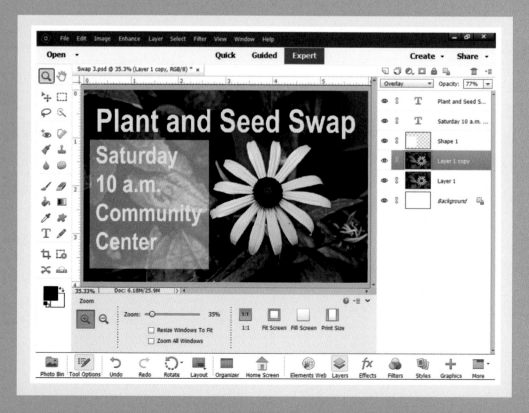

Introducing Layers

A Photoshop Elements image can include multiple layers, each holding different objects, adjustments, or color fills. You can use layers to create content in separate parts. You can then work with the layer parts independently to try different edits and ideas without changing other layer content or the original image. Save a file in a format that supports separate layers so you can continue making changes later.

When you open a digital camera or smartphone image file (or any other single-layer file) in Photoshop Elements, the content appears in a single layer named *Background*. You can copy or cut items on the Background layer and paste them onto new layers, and you can edit the new layers to modify the image without changing it permanently.

Layer Independence

Layers are like image content glued to pieces of transparent plastic. Each layer has its own pixels or vector content. You can select, move, and edit each layer independently. A layer can include a small object or one that's bigger than the canvas. Complex images can include tens or even hundreds of separate layers. The illustration here shows three simple layers and how they stack.

Apply Commands to Layers

Most Photoshop Elements commands and tool actions affect only the layers that you select in the Layers panel. You can move, rotate, and transform each layer independently. Layers are a good way to isolate effects. For example, if you copy an object onto a layer, you can recolor it without changing the rest of the image. You also can create multiple versions of the object on different layers. In this example, the original flower is at upper left, and the copies on separate layers have been recolored, resized, and moved.

Work with Layers in the Layers Panel

You can add, duplicate, hide and unhide, reorder, and combine (*merge*) layers in an image. You also can link selected layers so they move in unison, or you can blend content from different layers in creative ways. You manage all of this in the Layers panel, shown here.

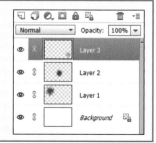

Transparency

A layer can have transparent areas, where the contents of the layers below it (in the Layers panel list) show through. When you cut or erase layer content, the affected pixels become transparent. You also can make a layer partially transparent by decreasing its opacity. Here, the layers with the blue and green flowers are partially transparent.

Fill and Adjustment Layers

Fill layers enable you to add a color, gradient, or pattern into an image. A fill layer hides the content on layers below it in the Layers panel, so you might typically use a fill layer to create a background for the image. Adjustment layers are special layers that contain information about color or tonal adjustments. An adjustment layer affects the appearance of the content in all the layers below it. You can increase or decrease an adjustment layer's intensity to get precisely the effect you want. This example shows a subtle blue and white pattern fill layer.

Save Layered Files

You can save files with layers using the PSD, PDF, and TIFF file formats. Other formats *flatten* layers back into the Background layer, combining all the layer content so that you no longer can work with individual layer content. You also can flatten layers to reduce file size or prepare an image for use on the Web or in a document.

File name: Flowers with Background .psd

Save as type: Photoshop (*.PSD;*.PDD)

Save Options

Organize: ☑ Include in the Elements Organizer

☐ Save in Version Set with Original

Save: ☐ As a Copy

☑ Layers

Color: ☑ ICC Profile: sRGB IEC61966-2.1

Other: ☑ Thumbnail

Create and Add Content to a Layer

To keep each element in your image independent from others, you can create a separate layer and add an object to it. Typically, you copy and paste selected content from one part of your image or from a different image and then paste the copy to place it into the new layer.

When you create a new layer, the layer appears in the list in the Layers panel. The layer content in the image stacks up from bottom to top, meaning that content on layers higher in the list can cover layers lower in the list. To rearrange layers that you have created, see the section "Reorder Layers." To get rid of layers in your image, see the section "Delete a Layer."

Create and Add Content to a Layer

Create a Layer

1 In the Editor, click **Expert**.

2 Click **Layers** on the taskbar to open the Layers panel.

Note: For more on opening the Editor or panels, see Chapter 1.

3 Click a layer.

Note: Clicking a layer tells Photoshop Elements that you want to create the new layer immediately above it in the layer list.

Note: If you have not yet created any new layers in a digital photo file, the Layers panel lists a single layer named *Background*.

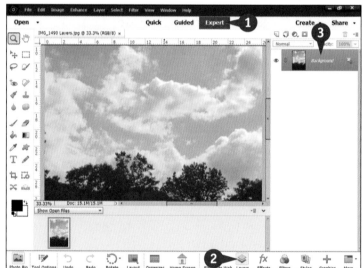

4 In the Layers panel, click the **Create a New Layer** icon (⬜).

Note: Alternatively, you can click **Layer**, click **New**, and then click **Layer**. Type a layer name into the **Name** text box of the New Layer dialog box, and then click **OK**.

A Photoshop Elements creates a new, transparent layer.

Note: To change the name of a layer, see the section "Rename a Layer."

5 Leave the image file open so that you can add content from another image to the new layer.

Copy Content into a Layer

1 Open a different image.

2 Select an area using any selection tool.

Note: See Chapter 2 for more on opening an image. See Chapter 5 for more on selection tools.

Note: This example uses the **Magic Wand** tool (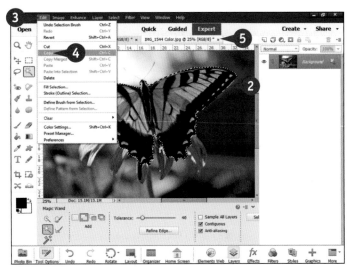) and others to select the butterfly.

3 Click **Edit**.

4 Click **Copy**.

5 Click the image's window tab close button (**×**).

Note: If prompted to save the image, click **Yes** or **No** as desired and rename the image if prompted.

6 Back in the prior image file, click the blank layer if needed.

7 Click **Edit**.

8 Click **Paste**.

Ⓐ The copied selection appears on the previously blank layer.

Note: Press Ctrl+C (⌘+C on a Mac) to copy and Ctrl+V (⌘+V on a Mac) to paste.

Note: Remember to use the **Save As** command on the **File** menu to save the file in a format that supports layers.

Note: To copy a selection to a new layer within the same image, right-click (Control+click on a Mac) the image and then click **Layer Via Copy**.

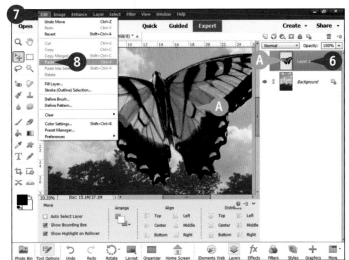

TIPS

What is the Background layer?
The Background layer is the default bottom layer. Photoshop Elements creates it automatically. A Background layer cannot contain transparent pixels and cannot be moved. If you want to move it or delete parts of it, copy it to a regular layer.

How do I make a copy of the Background layer that I can edit?
Select the Background layer. Click **Layer**, click **New**, and then click **Layer from Background**. You also can press Ctrl+J (⌘+J on a Mac) to create an editable copy of the Background layer.

Hide a Layer

You can hide a layer to make its contents disappear temporarily. Use this technique when you want to view or edit the content on layers below it or to check the alignment of objects. Hidden layers remain invisible when you print an image or use the Save for Web command.

You can remove a layer permanently by deleting it. See the section "Delete a Layer" for details. Hiding a layer is different from deleting a layer because you can make a hidden layer visible again.

Hide a Layer

1 In the Editor, click **Expert**.

2 Click **Layers** on the taskbar to open the Layers panel.

Note: For more on opening the Editor or panels, see Chapter 1.

3 Click the visibility icon (👁) for a layer.

Note: You do not need to select the layer first.

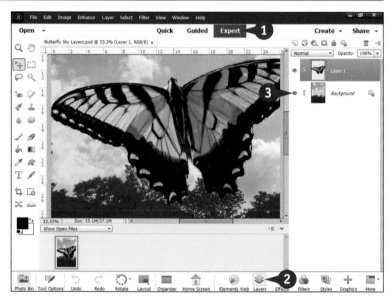

The icon changes to 👁, and Photoshop Elements hides the layer.

Ⓐ The layer remains in the Layer list.

Ⓑ Its content disappears from the active image area.

To show one layer and hide all the others, press Alt (Option on a Mac) and click the visibility icon (👁) for the layer you want to show.

Note: Click 👁 to unhide a layer.

Move a Layer

You can use the Move tool to move a layer. Select a layer, select the Move tool, and drag the layer to a new location. No other layers move.

If you make a selection with a selection tool before using the Move tool, Photoshop Elements moves only the selection. The rest of the layer stays where it is. Moving the selection might create transparent areas in the layer. For more on selection tools, see Chapter 5. To undo a move, click **Undo** or press Ctrl+Z (⌘+Z on a Mac) immediately. For more on using Undo, see Chapter 3.

Move a Layer

1 In the Editor, click **Expert**.

2 Click **Layers** on the taskbar to open the Layers panel.

Note: For more on opening the Editor or panels, see Chapter 1.

3 Click a layer in the Layers panel to select it.

Note: You can Ctrl+click (⌘+click on a Mac) in the Layer list to select multiple layers and move them together.

4 Click the **Move** tool (✥).

5 Drag the layer you selected in the active image area.

Content in the selected layer moves. In this example, moving the top layer reveals a different part of the Background layer.

Note: You must drag from within the layer content or any selection box that appears rather than outside the blank around it.

Ⓐ Select two or more layers to enable the **Align** choices and three or more to enable the **Distribute** choices.

Duplicate a Layer

You can duplicate a layer when you want to move its content to a different location within the image. You also can create duplicates to experiment with filtering or transforming a layer without losing the original layer content. You can make as many duplicates as you want and delete no longer needed duplicates.

When you duplicate a layer, it covers identical content in the original layer until you move, resize, or otherwise edit or transform it. The duplicate appears in the Layers panel list with *copy* appended to the layer name by default.

Duplicate a Layer

1 In the Editor, click **Expert**.

2 Click **Layers** to open the Layers panel.

Note: For more on opening the Editor or panels, see Chapter 1.

3 Right-click (Control+click on a Mac) a layer in the Layers panel.

4 Click **Duplicate Layer**.

Ⓐ You can type a new name for the layer here.

5 Click **OK**.

You also can press Ctrl+J (⌘+J on a Mac) or click **Layer** and then **Duplicate Layer** to duplicate a layer after selecting it.

Ⓑ Photoshop Elements duplicates the selected layer. The duplicate appears in the Layers panel list but does not change the view in the active image area unless you move, resize, edit, or otherwise transform it.

You can now move the layer contents to a new location. See the previous section "Move a Layer" for details.

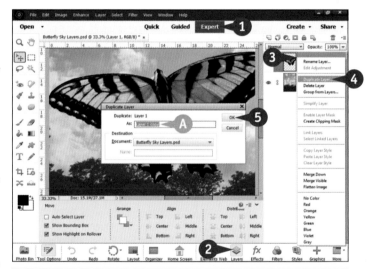

Delete a Layer

You can delete a layer to remove it from your image file or project. Deleting it removes it from the Layers panel list. Its content disappears from the active image area in the image window. To undo the deletion, you can click **Undo** in the taskbar immediately or press Ctrl+Z (⌘+Z on a Mac).

If you want to make the layer disappear temporarily, you can hide it instead of deleting it. For more details, see the section "Hide a Layer" in this chapter.

Delete a Layer

1 In the Editor, click **Expert.**

2 Click **Layers** to open the Layers panel.

Note: For more on opening the Editor or panels, see Chapter 1.

3 Click the layer to delete in the Layers panel.

4 Click the Delete Layer (trash can) icon (🗑) at the top right of the panel.

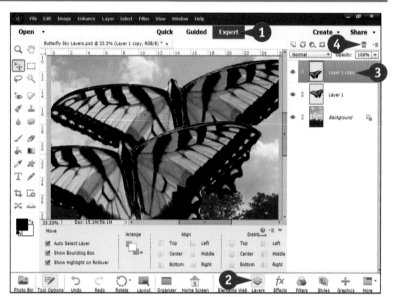

Note: Alternatively, you can click **Layer** in the menu bar and then click **Delete Layer**; you can drag a layer and over the Delete Layer (trash can) icon (🗑); or you can right-click the layer in the Layers panel and click **Delete Layer**.

5 Click **Yes** to confirm the deletion.

Note: Click **Don't Show Again** to check it and turn off the confirmation.

Ⓐ Photoshop Elements deletes the selected layer, and the content in the layer disappears from the active image area.

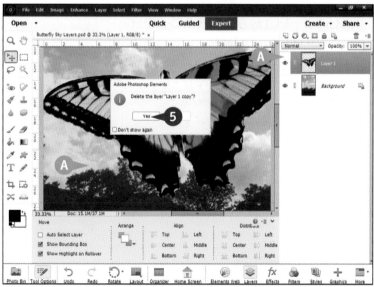

Reorder Layers

You can change the order of layers in the Layers panel to control how layer contents overlap. Think of the list as a stack, where Photoshop Elements draws the bottom layer first and works up to the top. Layers higher in the list may cover content on those lower down. Reordering layers changes the order they are drawn in but not layer content positioning in the active image area. To change a layer's position in the list, drag it up or down.

You can drag any layer, including content layers and adjustment layers. Only the Background layer is locked and stays at the bottom of the list to ensure it serves as the image background.

Reorder Layers

Using the Layers Panel

1 In the Editor, click **Expert**.

2 Click **Layers** on the taskbar to open the Layers panel.

Note: For more on opening the Editor or panels, see Chapter 1.

3 Drag the desired layer to change its position in the list.

Note: It is not necessary to click the layer first to select it, but doing so can help ensure that you move the correct layer.

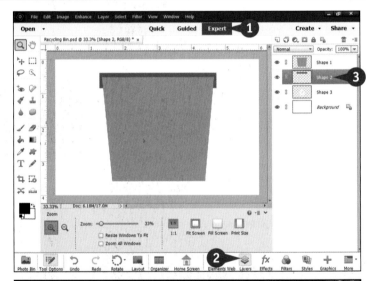

A The layer moves up (or down) the list.

B In this example, the Shape 2 layer is now above the others, so it appears in front of (on top of) the other layers' content in the active image area.

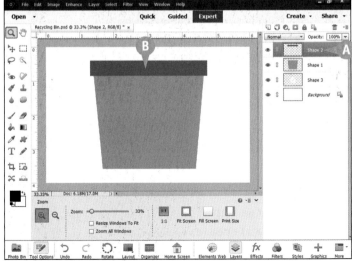

Using the Arrange Commands

1 Click the layer that you want to move to the top of the Layers panel list.

2 Click **Layer**.

3 Click **Arrange**.

4 Click **Bring To Front**.

Ⓐ The layer moves to the top of the list.

Ⓑ It appears in front of the other layers.

You can choose Bring to Front, Bring Forward, Send Backward, Send to Back, or Reverse. Depending on the layer position, some options are grayed out.

Note: You can use **Reverse** only when you select more than one layer with Ctrl+click (⌘+click on a Mac) in the Layer list.

Note: You cannot move a layer below the Background layer. To create the same result, duplicate the Background layer, hide the original, and move the new layer behind the duplicate.

TIP

Can I use keyboard shortcuts to reorder a selected layer?
You can use the shortcut keys in this table. For Mac, replace Ctrl with ⌘.

Move	Shortcut (Windows)	Move	Shortcut (Windows)
Forward (up) one step	Ctrl+]	To the front (top)	Shift+Ctrl+]
Backward (down) one step	Ctrl+[To the back (bottom)	Shift+Ctrl+[

Change the Opacity of a Layer

Adjust the opacity of a layer to allow the layers below it to show through. Opacity is the opposite of transparency — decreasing the opacity of a layer increases its transparency.

You can set a layer's opacity to between 0 and 100 percent. A layer with 0 percent opacity is completely transparent (not visible) in the active image area. A layer with 100 percent opacity is completely opaque (fully visible) and hides the content under it.

Change the Opacity of a Layer

1 In the Editor, click **Expert**.

2 Click **Layers** on the taskbar to open the Layers panel.

Note: For more on opening the Editor or panels, see Chapter 1.

3 Click the layer whose opacity you want to change.

Note: You cannot change the opacity of the Background layer.

The default opacity is 100%.

4 Click the **Opacity** drop-down list arrow (⏷).

5 Drag the slider and then press `Enter` (`Return` on a Mac).

A You also can type a new value in the **Opacity** text box.

B The layer opacity changes and appears more or less transparent.

With layer blending, changing the opacity may not modify the transparency in a simple way. For details, see the "Blend Layers" section in this chapter.

Link Layers

You can link layers if you want to move or edit them together in Photoshop Elements. Use the link icons in the Layers panel to link and unlink layers. You can transform linked layers together to change their dimensions or to rotate them. You also can apply some filters or enhancements.

Linking is temporary. You can unlink layers at any time to edit or move them separately. To link layers permanently, you can merge them. See the next section, "Merge Layers," for details.

Link Layers

① In the Editor, click **Expert**.

② Click **Layers** on the taskbar to open the Layers panel.

Note: For more on opening the Editor or panels, see Chapter 1.

③ Click a layer you want to link.

④ Click the **Link/Unlink Layers** icon (⬚) in a different layer to link them.

Note: You can repeat step **4** to link further layers.

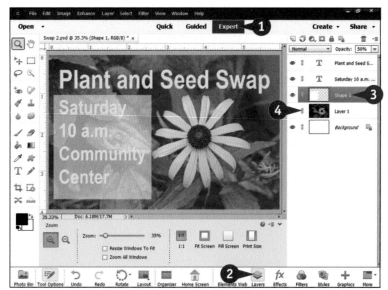

Ⓐ The Link/Unlink Layers icon on each linked layer turns orange (⬚).

Ⓑ If you select the **Move** tool (⬚) and drag any linked layer, the other layers move with it.

To unlink a layer, click the orange Link/Unlink Layers icon (⬚).

Note: You can link layers to the Background layer, but this locks them in place.

Note: Grouping layers also enables you to work with them together in some situations. Collapse the group to free up space in the Layers panel list or expand it to work with an individual layer in the group.

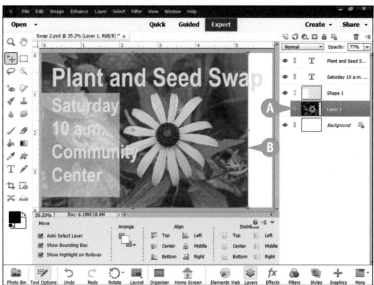

Merge Layers

Photoshop Elements enables you to merge layers to combine them into a single layer, meaning the merged layers are no longer independent. A merged layer appears as a single layer in the Layers panel list. There are three merge options. **Merge Down** (or **Merge Layers**) merges selected layers. **Merge Visible** merges visible (not hidden) layers. **Flatten Image** merges all layers. Flattening an image reduces the file size for faster printing, among other benefits.

Save a safety copy of your project file before merging layers. Merging layers often speeds up editing. However, if you make a mistake, you can open the safety copy with the unmerged layers and try again.

Merge Layers

1 In the Editor, click **Expert**.

2 Click **Layers** on the taskbar to open the Layers panel.

3 Ctrl +click (⌘+click on the Mac) to select two or more layers.

4 Right-click (Control +click on the Mac) a selected layer.

5 Click **Merge Layers**.

Note: Layers with 0 percent opacity disappear after merging.

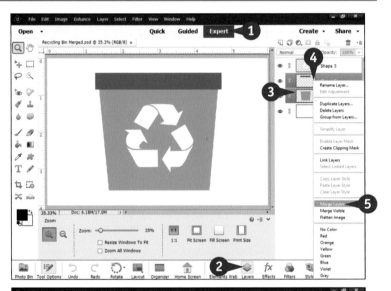

Photoshop Elements merges the layers.

Ⓐ The merged layer keeps the top layer's name and list position.

Note: Reorder layers before merging to avoid stacking problems.

Press Shift + Ctrl + E (Shift + ⌘ + E on a Mac) to merge all visible layers, or Shift + Ctrl + Alt + E (Shift + ⌘ + Option + E on a Mac) to merge the visible layers into a new layer without deleting the existing layers.

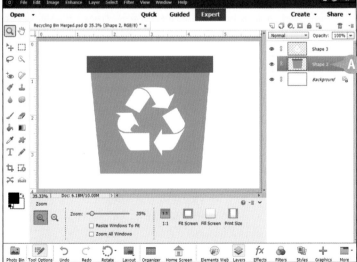

Rename a Layer

When you create a new layer in the Layers panel, Photoshop Elements gives it a generic name such as *Layer 1*. When you duplicate a layer, the duplicate layer has the same name as the original layer with *copy* added. Text layers use the text content of the layer as the layer name.

You can rename a layer to give it a name that better describes its contents. For example, in an image that combines flowers on different layers, you could name one layer *red rose* and another *white lily*.

Rename a Layer

1 In the Editor, click **Expert**.

2 Click **Layers** on the taskbar to open the Layers panel.

Note: For more on opening the Editor or panels, see Chapter 1.

3 Double-click a layer name.

A A small text box opens.

4 Type a new name for the layer.

5 Press `Enter` (`Return` on a Mac).

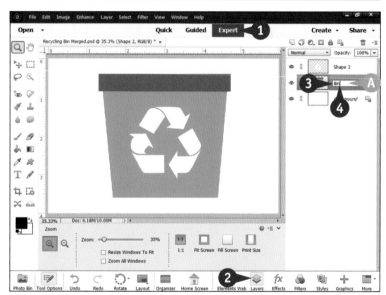

B The layer name changes in the Layers panel.

Note: In this example, two layers were merged before they were renamed. You can use merging and renaming to create readily identifiable "building blocks" as you create a more complex image file.

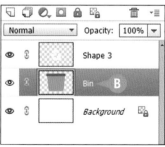

Create a Fill Layer

You can use a fill layer to add a solid color layer to your image, such as creating a color background. When you create a solid color fill layer, you select its color using a Color Picker dialog box. You also can add a *gradient* fill layer with simple color shadings or a *pattern* fill layer with a repeating texture.

You can move fill layers up and down in the Layers panel list, which can create very dramatic changes. Moving a fill layer to the top of the list hides the content on other layers, displaying a solid color.

Create a Fill Layer

1 In the Editor, click **Expert**.

2 Click **Layers** on the taskbar to open the Layers panel.

Note: For more on opening the Editor or panels, see Chapter 1.

3 Click the layer above which you want the solid color layer to appear.

This example adds a new color layer.

4 Click **Layer**.

5 Click **New Fill Layer**.

6 Click **Solid Color**.

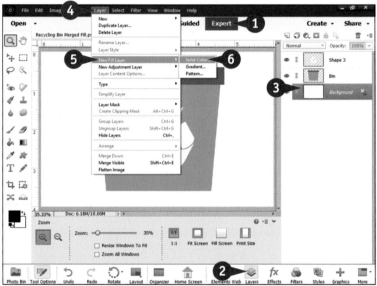

The New Layer dialog box opens.

Ⓐ You can type a name for the layer here, or leave this name unchanged to use the default.

Ⓑ You can click this drop-down list to select a blending mode.

Ⓒ You can click this drop-down list to change the opacity.

Note: See the "Blend Layers" or "Change the Opacity of a Layer" section for details.

7 Click **OK**.

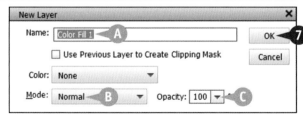

A Color Picker dialog box opens.

8 To change the base color, drag the slider up or down.

9 To set the lightness and saturation, click in this box.

D If the layer is visible, you can preview the color in the active image area.

10 Click **OK**.

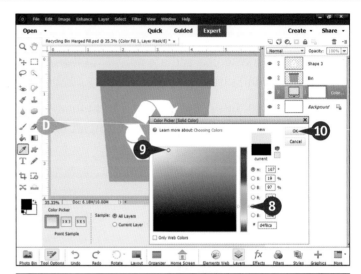

E Photoshop Elements creates a new layer filled with a solid color.

F In this example, a pale green layer covers the original white Background layer.

Note: "Draw a Simple Shape" in Chapter 9 explains how to draw a filled shape to cover part of a layer.

Note: You can change the opacity and blending mode of a fill layer to apply interesting effects to content on lower layers.

TIPS

How do I add or adjust and delete a fill layer?
Fill layers have two parts: a color or fill control for the layer thumbnail and a white *mask* that controls the opacity of the fill. To selectively edit the mask to remove the fill, set the foreground color to black or gray, click the white mask, and then paint or otherwise edit the mask. (See Chapter 9 for more.) To delete the fill layer, you must click the layer thumbnail first.

Are there other special layer types?
Insert an *adjustment layer* to make a correction such as fixing brightness or contrast. Underlying layer content remains intact, so you can hide or move the adjustment layer or change its settings. Click **Layer** and then **New Adjustment Layer** to see the available choices. Chapter 7 describes how to work with similar features directly on a content layer.

Blend Layers

You can use the blending modes in Photoshop Elements to blend layers in creative ways. The range of effects is almost infinite, from subtle enhancements to exotic visual effects. To learn more, experiment with the different modes using many different images and layers. If you use many layers and many blending modes, the results can be difficult to predict.

When you create a new layer, the default blending mode is Normal, which simply covers one layer with another. You can switch back to Normal mode at any time to turn off blending effects.

Blend Layers

Pop Colors with an Overlay Blend

1 In the Editor, click **Expert**.

2 Open a photo or image file.

Note: For more on opening the Editor or panels, see Chapter 1.

For more about opening a file, see Chapter 2.

3 Duplicate the layer with the content that you want to blend with or select the layer above the layer to blend with.

See the "Duplicate a Layer" section for details.

4 Click the blending mode drop-down list.

5 Click **Overlay**.

A The Overlay blend pops the colors.

B If the effect is too exaggerated, you can turn down the **Opacity** to tame it.

Note: When you change the blending mode for a layer, it affects all layers lower in the Layers panel list.

Create Unusual Colors with a Difference Blend

1 In the Editor, click **Expert**.

2 Open any photo or image file and click the layer to blend with.

3 Create a single color fill layer.

See the "Create a Fill Layer" section for details. This example uses a cool blue fill layer.

4 Click the blending mode drop-down list.

5 Click **Difference**.

A Photoshop Elements subtracts the fill layer color from the colors in the original image file, creating a brightly colored artistic interpretation of the source image.

Note: Double-click the left layer thumbnail icon on the layer in the Layers panel to adjust the fill color and try possible color combinations. You can tone the effect down by lowering the fill layer's opacity.

Note: Some photo and fill color combinations are more successful than others.

TIP

What are the most useful blending modes?
- **Multiply:** Darkens the colors where the selected layer overlaps layers below it.
- **Screen:** Lightens colors where layers overlap.
- **Color:** Takes the selected layer's colors and blends them with the light and dark details in the layers below it.
- **Luminosity:** Takes the light and dark details and mixes them with colors from the layers below.

Making Selections

Do you want to edit some parts of an image but leave other parts unchanged or delete, copy, or move content? Then you need to make a selection first. This chapter explains how you can use the selection tools in Photoshop Elements Expert mode to select objects, areas, shapes, colors, and other image features. You can even save a selection and reload it later.

Select an Area with the Marquee

*Y*ou can select an area on an image layer by using the *marquee* — a tool that creates selections using simple shapes. After selecting an area, you can edit it with the Photoshop Elements editing tools, delete it, move it, copy and paste it to another location, and so on.

Two marquee shapes are available. Use the Rectangular Marquee to select rectangular areas, including squares. Use the Elliptical Marquee to select elliptical areas, including circles. To use either tool, select Expert mode, click the layer that has the content to select in the Layers panel, select the tool, and drag diagonally on the layer. You can use the Tool Options panel to set the selection's dimensions or width/height ratio.

Select an Area with the Marquee

Select with the Rectangular Marquee

1 In the Editor, click **Expert**.

Note: For more on opening the Editor, see Chapter 1.

2 Click the layer that has the content to select in the Layers panel.

3 Click the **Rectangular Marquee** tool (▢).

Note: If the Elliptical Marquee tool (◯) appears instead, press M.

4 Drag diagonally in the active image area.

You can press and hold Shift while dragging to select a square area.

A The dimensions of the selection area appear as you drag.

B Photoshop Elements selects the specified rectangular area.

You can reposition a selection marquee by pressing the arrow keys: ⬇, ⬅, ⬆, ➡. You also can drag the selection marquee while a marquee tool is active.

To deselect a selection, click **Select** and then **Deselect**, press Ctrl+D (⌘+D on a Mac), or click outside the selection.

Select with the Elliptical Marquee

1 Click the **Elliptical Marquee** tool (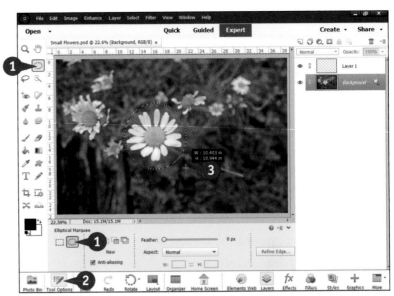).

Note: Pressing M toggles between the Elliptical and Rectangular Marquee tools.

2 Click **Tool Options** on the taskbar to open the Tool Options panel.

3 With the desired layer selected in the Layers panel, drag diagonally inside the active image area.

You can press and hold Shift while dragging to select a perfect circle. Press and hold Shift + Alt (Shift + Option on a Mac) to expand the selection from the center; this technique works with the Rectangular Marquee tool, too.

A Photoshop Elements selects the specified elliptical area.

You can reposition a selection marquee by pressing the arrow keys: ↓, ←, ↑, →. You also can drag the selection while a marquee tool is active.

To deselect a selection, click **Select** and then **Deselect**, press Ctrl + D (⌘ + D on a Mac), or click outside the selection.

TIP

What do the marquee tool options do?
You can set options for how the marquee tools work by using the choices in the Tool Options panel.

- **Feather:** Dragging the slider softens the edges of the selection when you apply an edit.
- **Aspect:** Select **Normal** (no restrictions), **Fixed Ratio**, or **Fixed Size** from this drop-down list to refine the tool operation. Make **W** (width) and **H** (height) text box entries for the latter two choices.
- **New:** Click a choice here to determine whether the tool will make a new selection, add to the current selection, subtract from the current selection, or select an intersecting area.

Select an Area with the Lasso

You can use the Lasso tools in Photoshop Elements to select areas with irregular outlines. Use the regular Lasso to draw a freehand selection area with the mouse. Use the Polygonal Lasso to select an area using line segments. Both these tools require a steady hand and plenty of concentration.

You can use the Magnetic Lasso to select edges automatically, based on the contrast between different colors and textures near the mouse pointer. This not only improves selection accuracy but makes it easier to use than the other Lasso tools.

Select an Area with the Lasso

Select with the Regular Lasso

1. In the Editor, click **Expert**.

Note: For more on opening the Editor, see Chapter 1.

2. Click the layer that has the content to select in the Layers panel.

3. Click the **Lasso** tool (⊘).

Note: If the Polygonal Lasso (⊬) or Magnetic Lasso (🧲) tool appears instead, press Ⓛ until the Lasso appears.

4. Drag the mouse pointer to make a selection.

Note: To better see a complicated edge for accurate selection, zoom in on the image with the Zoom tool (🔍). See Chapter 3 for more on the Zoom tool.

5. Drag to the beginning point, and then release the mouse button.

Ⓐ Photoshop Elements completes the selection.

Note: If you release the mouse button before completing the selection, Photoshop Elements completes the selection for you with a straight line.

Note: If you don't like the final selection, click outside it and try again.

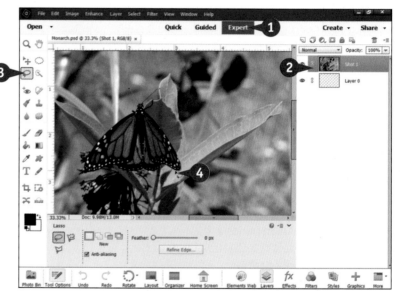

Select with the Polygonal Lasso

1 Click the **Polygonal Lasso** tool (🔾).

Note: If the Lasso (🔾) or Magnetic Lasso (🔾) appears instead, press 🅛 until the Polygonal Lasso appears.

2 With the desired layer selected in the Layers panel, click along the border and at any corners of the area you want to select.

Note: Before completing the selection, you can press Backspace (Delete on a Mac) to undo the last segment you created.

Note: This selection tool works best for selecting an object with straight edges and corners, like the building shown in this example.

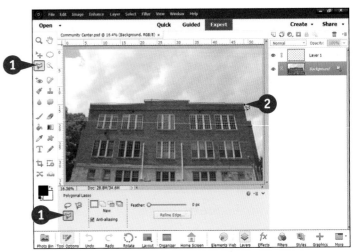

3 To complete the selection, click the starting point.

You also can double-click anywhere in the image.

Ⓐ Photoshop Elements adds a final straight line that connects to the starting point, completing the selection.

Note: After making any selection, you can copy and paste it to another location. See "Copy and Paste a Selection" in Chapter 6 to learn more.

TIPS

How do I select all the pixels in my image?
You can use the Select All command to select all the contents in a single-layer image or selected layer. Click **Select**, and then click **All**. Or press Ctrl+A (⌘+A on a Mac). Note that you must select all pixels before you can copy an image. You do not need to select all pixels before adjusting or editing the image.

What if my selection is not as precise as I want it to be?
Professional artists often use a *graphics tablet* — a device with a pen-shaped stylus that is easier to draw with than a mouse. You can try again by clicking **Select** and then **Deselect**. Or try switching to the Magnetic Lasso tool (🔾). You also can add to or subtract from a selection or refine a selection. For details, see Chapter 6.

continued ▶

You can quickly and easily select elements of your image that have well-defined edges using the Magnetic Lasso tool. The Magnetic Lasso looks for color and tone contrast to find edges. For best results, use this tool to select a subject with well-defined edges and strong contrast from the surrounding image content or background.

As you drag the Magnetic Lasso along an edge, Photoshop Elements places *anchor points* on the edge to define the selection outline. Lines join the anchor points along the selection outline. You can press Backspace (Delete on a Mac) to remove unwanted anchor points as you draw the selection.

Select an Area with the Lasso (continued)

Select with the Magnetic Lasso

1 Click the **Magnetic Lasso** tool (🖐).

Note: If the Lasso (🖐) or Polygonal Lasso (🖐) appears instead, press **L** until the Magnetic Lasso appears.

2 If the Tool Options panel is not open, click **Tool Options** on the taskbar to open it.

3 With the desired layer selected in the Layers panel, click the edge of the object you want to select.

This creates the first anchor point on the selection outline.

4 Drag the mouse pointer along the edge of the object.

The Magnetic Lasso's anchor points and lines snap to the edge of the object as you drag.

5 To help guide the lasso, you can click to add anchor points as you go along the edge.

Note: For good results, add a point at every corner.

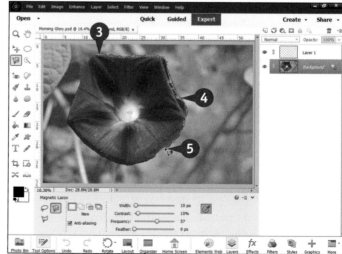

6 Keep following the edge of the object or area, adding points until you get close to the first anchor point.

7 To complete the selection, click the first anchor point.

Note: Double-clicking elsewhere finishes the selection with a straight line to the first anchor point.

The object is selected.

Note: Even though the Magnetic Lasso is easier to use than the other lasso tools, you may still need to refine the selection. For details, see Chapter 6.

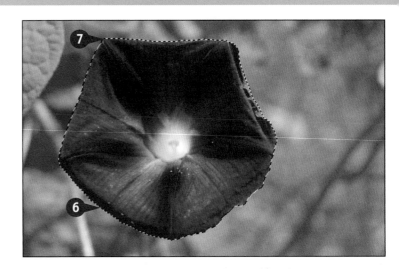

Adjust the Precision of the Magnetic Lasso Tool

You can adjust the Magnetic Lasso tool's precision with different settings.

Note: Adjust the settings before using the tool to make a selection.

Ⓐ Width sets the width of the area (in pixels) the tool looks at when finding edges.

Ⓑ Contrast sets the minimum contrast needed to find an edge.

Ⓒ Frequency determines how often anchor points appear.

Ⓓ Feather softens the selection edges.

> **TIP**
>
> **How can I get a more accurate selection?**
> When using the Magnetic Lasso, adjust the precision carefully. The **Contrast** and **Width** settings are critical, and small changes can have a big effect. However, you also can add and remove areas from an existing selection. If you "sculpt" the selection in stages, you do not have to worry about getting it right the first time, and you can make extremely precise selections that do not rely on luck and a steady mouse. For details, see Chapter 6.

Select an Area with the Magic Wand

You can use the Magic Wand tool to automatically select areas with a color similar to the pixel you click. This useful tool can help you to remove an object from a background, for example. The Magic Wand is especially good at making selections in photos that feature the sky, the sea, a lawn, or a sandy beach.

You can control the accuracy of the selection by adjusting the **Tolerance** value, from 0 to 255. A smaller value constrains Photoshop Elements to select a smaller range of colors. A larger value selects an area with a wider range of colors. Experiment with different **Tolerance** values to select the area you want.

Select an Area with the Magic Wand

1 Click the **Magic Wand** tool (![icon]).

Note: If ![icon], ![icon], ![icon], or ![icon] appears instead, press A until the Magic Wand appears.

Note: The rest of this chapter assumes you are working in Expert mode, as Quick mode has limited selection tools and Guided mode doesn't include the toolbox.

2 If the Tool Options panel is not open, click **Tool Options** on the taskbar to open it.

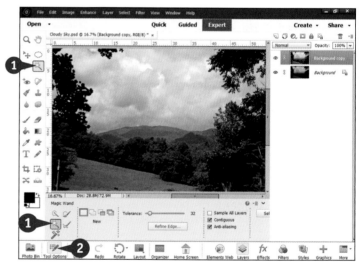

3 Optionally, drag the **Tolerance** slider to select a value from 0 to 255.

4 You also can double-click the value and type a number. The default value of 32 often produces good results.

To select a narrow range of colors, select or enter a small number; for less precision, select or enter a large number.

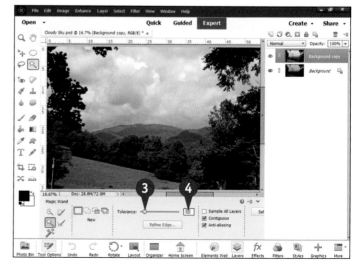

5 With the desired layer selected in the Layers panel, click the area you want to select in the active image area.

A Photoshop Elements selects the pixel you clicked and all the pixels with similar colors around it.

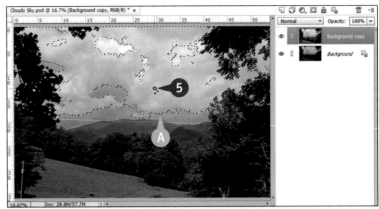

6 To add to your selection, Shift +click elsewhere in the image.

B Photoshop Elements adds to the selection. The new selection does not have to connect with the previous area.

Note: You do not have to select the same colors every time you Shift +click. For example, you can select similar colors at different brightness levels.

Note: For more details on editing selections, see Chapter 6.

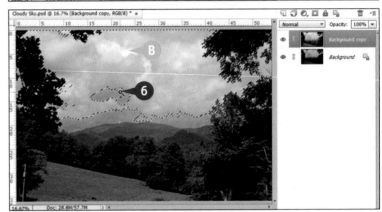

TIPS

How can I select the same color across an image?
You can deselect **Contiguous** (☑ changes to ☐) in the Tool Options panel to make the Magic Wand tool find all similar colors in the image, even if they are not close or adjacent to each other. This can be useful when selecting scattered objects in an image.

What is anti-aliasing?
If you leave the **Anti-aliasing** choice selected, Photoshop Elements applies subtle smoothing to the edges of the selection. This helps avoid jagged edges when the selection edge changes by whole pixels. Leave anti-aliasing on for most selections. If you want to make the edges of a selection look crisp or rough as a special effect, deselect it.

101

Select an Area with the Quick Selection Tool

You can paint a selection in an image with the Quick Selection tool. This "smart" tool looks for areas of similar color and expands the selection to the edges around them. If your image has areas of contrasting color with clean edges, the Quick Selection tool can make accurate selections with very little effort.

You can control the size of the tool and the softness of the selection edges. Start by using a large brush to "paint" an area. You can then subtract unwanted areas with a smaller brush. You also can add additional new areas to the selection.

Select an Area with the Quick Selection Tool

1 Click the **Quick Selection** tool ().

Note: If , , , or appears instead, press A until the Quick Selection tool appears.

Note: The Quick Selection tool () and the , , and tools are the only selection tools in Quick mode.

Note: The Auto Selection tool () works like a combination of the Quick Selection tool and Lasso, Polygonal Lasso, Rectangle, or Oval selection tools.

2 If the Tool Options panel is not open, click **Tool Options** on the taskbar to open it.

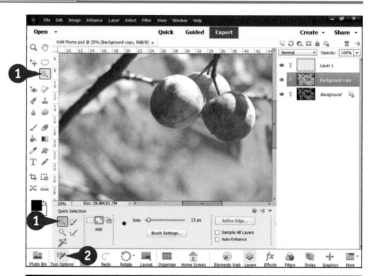

3 Drag the slider to set the brush **Size**. Start with a brush around a quarter to half the size of your object.

You also can change the brush size by pressing and .

4 With the desired layer selected, click the object you want to select.

A Photoshop Elements selects all or part of the object based on its coloring and the edge contrast.

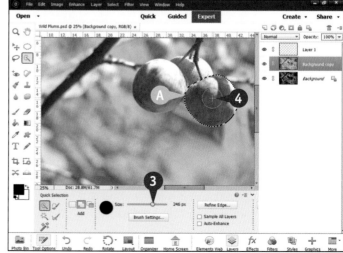

5 After you make an initial selection, you can click the **Add to Selection** (▢) or **Subtract from Selection** button (▢) to fine-tune the selection.

6 Optionally, select a smaller brush **Size** for finer control.

Note: You also can click **Select** and then **Subject** or press Alt + Ctrl + S (Option + ⌘ + S on a Mac) to automatically select the main subject(s) in the image layer. (You may need to close the Layers panel to see a **Select Subject** button in Tool Options.)

7 Click or drag on additional areas to "sculpt" your selection, adding and removing further areas as needed.

Photoshop Elements modifies the selection.

Note: This example shows the plums and stems selected.

Note: The Quick Selection tool is also available in Quick mode.

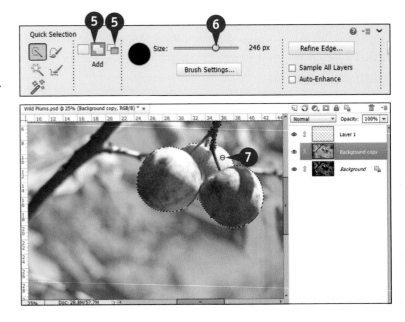

TIP

What do the brush settings do?
To work with the brush settings, click the **Brush Settings** button. Decrease the **Hardness** slider setting to blur the edges of the selection. When you apply an edit to the selection, the effect or filter fades in at the edges of the selection. Increase **Spacing** when selecting an object with jagged edges. Decrease **Roundness** to make the brush more elliptical. You can set the angle by dragging in the **Angle** box. If you have a graphics tablet or a wheel/touch mouse, you can use the **Pen Pressure** menu to set up your device so you can change the size of the brush with stylus pressure or with the mouse wheel.

Select an Area with the Selection Brush

With the Selection Brush, you can select areas by "painting" them with the mouse. This brush is not "smart." It tracks your mouse movements but does not look for edges or colors. Use this brush when you need to select an area that has similar color and contrast to the areas around it.

As with the Quick Selection tool, you can add to or subtract from the selection. You also can set the size and hardness of the brush. Paint with a large brush to sketch out the selection, and then fine-tune it with smaller brushes, adding or subtracting smaller areas.

Select an Area with the Selection Brush

Select with the Selection Brush

1 Click the **Selection Brush** tool ().

Note: If , , , or appears instead, press **A** until the Selection Brush tool appears.

2 If the Tool Options panel is not open, click **Tool Options** on the taskbar to open it.

Note: Use the Zoom tool () to zoom in on the image to help you make a clean selection.

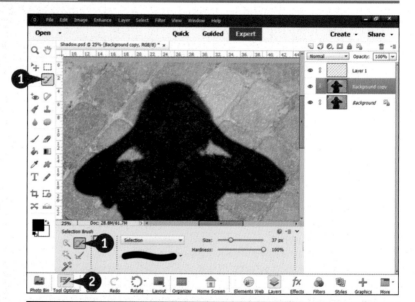

3 Drag the **Size** slider to set the brush size. Start with a size that's smaller than the area to select.

4 Drag the **Hardness** slider to set the hardness. Use 75% to 100% unless you need soft edges.

5 With the desired layer selected in the Layers panel, drag on the area or object to select.

A Photoshop Elements selects the areas you paint.

Note: Here the left arm is being selected; it has no contrast or color difference with the rest of the shadow.

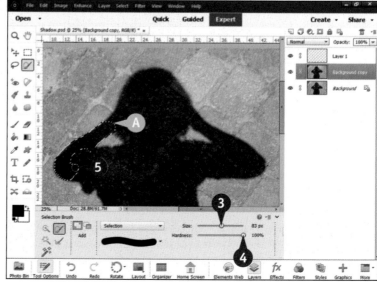

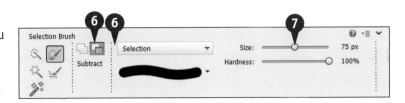

6 After you make an initial selection, you can click the **Add to Selection** button (🔲) or **Subtract from Selection** button (🔳) to fine-tune the selection.

7 Select a smaller brush **Size** for finer control.

8 Click or drag to "sculpt" the selection, adding and removing further areas as needed.

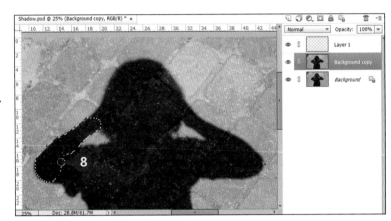

Note: Typically you "outline" the area you want to select by painting around its edges, next select the center, and finish by fixing the edges.

Photoshop Elements modifies the selection.

What does the "wavy line" menu do?
You can use this menu to select various brush presets, with a range of ready-made sizes and hardness values. You also can paint a selection with shaped effects, including butterflies and grainy paint-like lines because this tool uses the standard Photoshop Elements brushes. The textured special effects brushes can be useful in creating photo art. For more about painting and drawing with the standard brushes, see Chapter 9.

Save and Load a Selection

After you make a selection in an image file, you can save the selection to reload it later. When you save the file, Photoshop Elements prompts you to save it as a Photoshop PSD file, the file format that supports saved selections, unless it's already saved as a PSD file. The selection is then available when you reopen the file. See Chapter 2 for more about saving image files.

You can save more than one selection and give each one a different name within each image file. You cannot copy saved selections between images. However, you can reload any saved selection within an image file using the **Load Selection** command on the **Select** menu.

Save and Load a Selection

Save a Selection

1 With the desired layer selected in the Layers panel, make a selection by using one or more of the selection tools.

2 Click **Select**.

3 Click **Save Selection**.

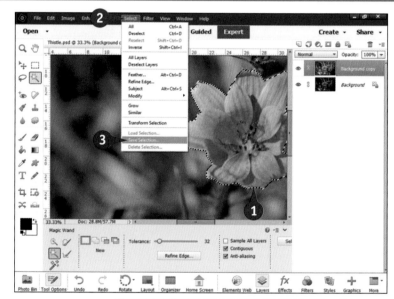

The Save Selection dialog box opens.

4 Make sure **New** appears as the **Selection** drop-down list choice.

5 Type a selection name in the **Name** text box.

Note: You can reuse the selection name in a different image file if desired.

6 Click **OK**.

Photoshop Elements saves the selection.

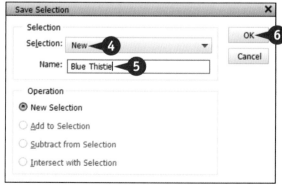

Load a Selection

1️⃣ With the layer on which you want to load the selection selected in the Layers panel, click **Select**.

2️⃣ Click **Load Selection**.

Note: Saved selections are layer independent. You can load a selection saved from one layer on another layer when you need to select the same shape.

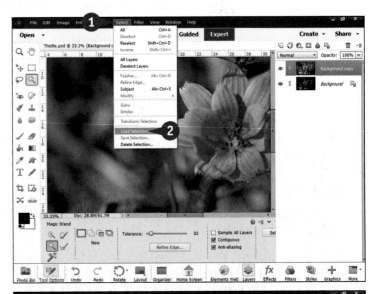

The Load Selection dialog box opens.

3️⃣ Click the **Selection** drop-down list.

4️⃣ Click the saved selection you want to load.

5️⃣ Click **OK**.

🅐 The selection reappears on the selected layer.

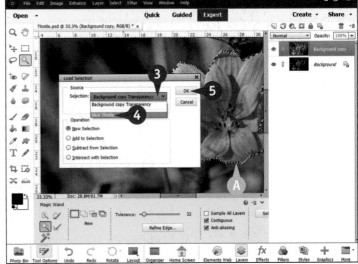

What do the Operation option buttons do?
Instead of reloading a selection, you can use it to modify a selection you have already made in your image. Use the **Add to Selection** option to combine the current and saved selections. Use the **Subtract from Selection** option to remove the saved selection from the current selection. Use **Intersect with Selection** to select only the overlapping areas between the current and saved selection.

Why do I lose all my saved selections when I close the image?
You must save the file as a PSD (Photoshop file) to save and load selections. If you save a file in any other format, Photoshop Elements forgets your selections.

Invert a Selection

You can use the Invert Selection command to select the background around an object instead of the object itself. Inverting a selection deselects the area inside it and selects the area around it — all the way to the edges of the photo. You could then edit or delete the background selectively.

The inverted selection has the same properties as your initial selection, but it's a "negative" of it. For example, if you have *feathered* a selection to soften its edges, the inverted selection also has soft edges. For more information about feathering and modifying selections, see Chapter 6.

Invert a Selection

1 With the desired layer selected in the Layers panel, make a selection using one of the selection tools.

Note: For more on the various selection tools, see the previous sections in this chapter. For more on layers, see Chapter 4.

2 Click **Select**.

3 Click **Inverse**.

Note: You also can press [Shift]+[Ctrl]+[I] ([Shift]+[⌘]+[I] on a Mac) to invert a selection.

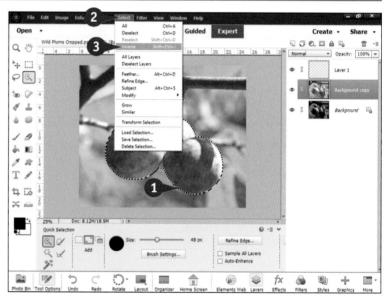

A Photoshop Elements inverts the selection.

Note: If you have an object against a plain background such as the sky, you can use the Magic Wand tool (🪄) to select the background and then invert the selection to select the object.

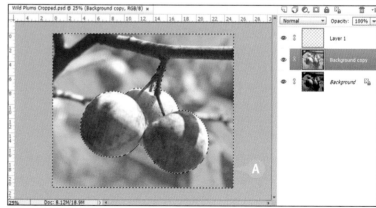

Deselect a Selection

You can deselect a selection when you have finished editing your image or if you decide that a selection is not necessary. When you deselect an image, the "marching ants" marquee outline around the selection disappears. If you make further edits, Photoshop Elements applies them to the entire image or layer.

If you accidentally deselect an area, click **Edit** and then click **Undo** or press `Ctrl`+`Z` (`⌘`+`Z` on a Mac). Photoshop Elements restores the selection.

Deselect a Selection

1 With the desired layer selected in the Layers panel, make a selection using any of the selection tools.

2 Click **Select**.

3 Click **Deselect**.

Note: You also can press `Ctrl`+`D` (`⌘`+`D` on a Mac) to deselect a selection. Or, click outside the selection if a selection tool is active.

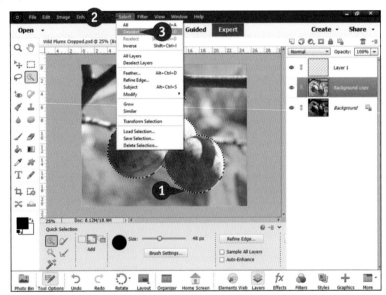

Photoshop Elements deselects the selection.

Note: You then can click **Select** and then click **Reselect** or press `Shift`+`Ctrl`+`D` (`Shift`+`⌘`+`D` on a Mac) to reselect the selection. This must be done immediately after deselecting the selection.

Manipulating Selections

Making a selection in Photoshop Elements isolates a specific area on a specific layer in an image file. This chapter shows you how to move, copy, resize, reshape, delete, and otherwise work with the content within a selection. You can use these selection techniques to rearrange objects in your image, enlarge an element to make it stand out, or delete selected content altogether. Use these techniques on any pixel-based layer, such as the Background layer or a layer added with the Create a New Layer icon in the Layers panel.

You can make a selection bigger or smaller without having to start a new selection from scratch. Adding to a selection expands the selected area. Subtracting from a selection removes some of the area. If you zoom in, use a small selection brush, and take your time adding and subtracting, you can create a very accurate selection area.

The Tool Options panel for most of the Photoshop Elements selection tools has add and subtract settings. You also can create a selection using one tool and then use another tool to add or subtract an area. See Chapter 5 for an introduction to the available selection tools.

Add to or Subtract from a Selection

Add to a Selection

1 In the Editor, click **Expert**.

Note: For more on opening the Editor, see Chapter 1.

2 With the desired layer selected in the Layers panel, make a selection with any selection tool.

A This example shows a selection made with the Magic Wand tool (🪄).

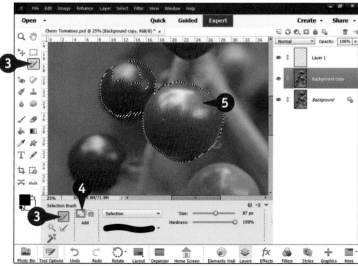

3 Either continue with the same selection tool or click a different tool to select it.

4 Click the **Add to Selection** button (🔲).

5 Select the area to add.

This example shows the Selection Brush tool (🖌️) used to expand the selection area.

Photoshop Elements adds the specified area to the selection.

You can enlarge the selection further by repeating steps **3** to **5**.

You also can add to a selection by pressing Shift while selecting.

Subtract from a Selection

1 With the desired layer selected in the Layers panel, make a selection with a selection tool.

A This example shows a selection made with the Magic Wand tool (◼).

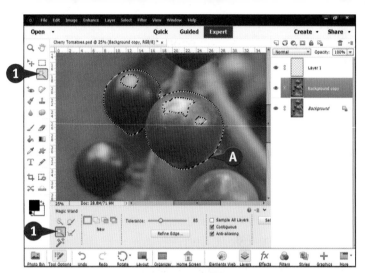

2 Either continue with the same selection tool or click a different tool to select it.

3 Click the **Subtract from Selection** button (◻).

4 Select the area to subtract.

This example shows an area deselected using the Selection Brush (◻).

Photoshop Elements deselects (subtracts) the specified area.

You can subtract other parts of the selection by repeating steps **2** and **3**.

You also can subtract from a selection by pressing **Alt** (**Option** on a Mac) while selecting.

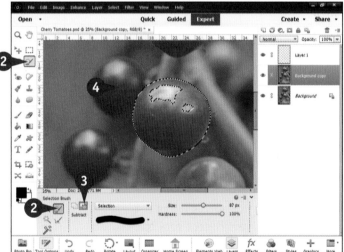

TIPS

What is a selection intersection?
An intersection is the area where two selections overlap, excluding the rest of the original selection areas. For example, two overlapping rectangles form a smaller rectangular intersection area. Click the **Intersect with Selection** button (◻) if available in the Tool Options panel before selecting a new area to select the overlap between the old and new areas and deselect any outside area.

Can I move the selection marquee without moving the item selected?
Yes. Use any of the selection tools to select an area and then press an arrow key — ◻, ◻, ◻, ◻ — to move the selection in 1-pixel increments. Press **Shift** plus an arrow key to move the selection in 10-pixel increments.

Move a Selection

You can move a selection to a different area on the layer using the Move tool. If you select areas carefully, you can rearrange your photo, putting features into different — better — places.

By default, Photoshop Elements keeps pixels in a Background layer — the original photo. If you use the Move tool on the Background layer, Photoshop Elements fills the resulting gap with the background color. If you move a selection on another regular layer, Photoshop Elements fills the gap with transparent pixels. For more about using layers, see Chapter 4.

Move a Selection

1 In the Editor, click **Expert**.

2 With the desired layer selected in the Layers panel, make a selection.

A This example shows a selection made with the Rectangular Marquee tool ([::]).

Note: For more on making selections, see Chapter 5.

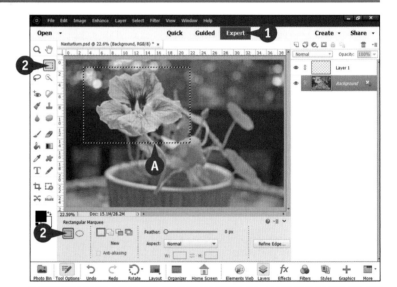

3 Click the **Move** tool ([⊹]).

B Photoshop Elements adds handles to the selection to show you can move or edit the selection.

Note: To move a selection to another layer, cut it from the current layer (Ctrl+X or ⌘+X on a Mac), select the destination layer, and paste (Ctrl+V or ⌘+V on a Mac).

4 Move the mouse pointer inside the selection, and then drag in the desired direction.

C When you release the mouse button, Photoshop Elements moves the selection to its new location.

D The current background color fills the selection's original location.

If you press **Alt** (**Option** on a Mac) while you drag, Photoshop Elements creates a copy of the selection and moves it instead of the original area.

TIPS

How do I move a selection in a straight line?
Press and hold **Shift** while you drag with the Move tool (🖐). This constrains the movement to one dimension. You can move the selection horizontally, vertically, or diagonally, depending on the direction you drag.

Why would I copy a selection to a different layer?
Use layers to keep different elements in an image separate and make them visible/invisible with a single click. You can move content on other layers without changing the Background layer. Layers are ideal for assembling a photo composition out of different elements. Chapter 4 covers layers.

You can use the smart Content-Aware Move tool to move a selection. Instead of leaving a gap or filling the original selection location with a solid color, the Content-Aware Move tool fills the area with surrounding colors and textures.

Although the tool is smart, it is not miraculous. For good results, use it with objects surrounded by simple colors and soft textures.

Apply the Content-Aware Move Tool

1 In the Editor, click **Expert**.

Note: For more on opening the Editor, see Chapter 1.

2 With the desired layer selected in the Layers panel, click the **Content-Aware Move** tool (✖).

Note: Make sure the **Move** option button beside Mode is selected (◉, not ○).

3 Drag an outline around the object you want to move.

Note: The Content-Aware Move tool works like the Lasso tool. See Chapter 5 for details.

Note: You also can select an area with any other selection tool and then click the Content-Aware Move tool to move it.

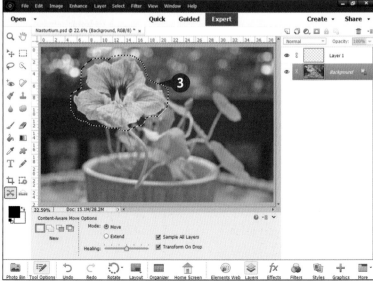

4 Move the mouse pointer inside the selection, and drag to the desired location on the layer.

Photoshop Elements displays the distance moved in the current selected units.

5 After you release the mouse button, click ✔ or press `Enter` (`Return` on a Mac) to apply the move.

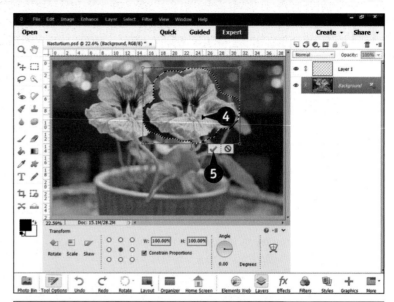

Ⓐ Photoshop Elements moves the object to the new location.

Ⓑ A blend of surrounding content fills the original location.

Note: The object stays selected, so you can move it again, if needed.

TIPS

How can I extend an object in my image?
You can use the Content-Aware Move tool to extend objects such as buildings and fences. With the **Content-Aware Move** tool (✂) selected, click the **Extend** option button. Select an object, drag the selection, and then after you release the mouse button press `Enter` (`Return` on a Mac). Photoshop Elements extends the object. It adjusts colors and textures automatically, based on the content near the selection.

How can I get better results?
For good results, select smaller objects rather than larger ones. Also try to move your object to an area with similar colors and textures. The tool cannot fix large differences.

You can copy and then paste a selection for a few different reasons: to add a duplicate of the object on the current layer, to copy the object to another layer, or to cover flaws and blemishes.

In many cases, using the **Copy** and **Paste** commands creates a new layer to hold the pasted content. If you select a layer holding a copied selection, you can move the object to a different position without changing the content on other layers such as the Background layer. You also can filter, edit, or otherwise change the layer with the copied content without changing the original content or other layers. For more about layers, see Chapter 4.

Copy and Paste a Selection

1 In the Editor, click **Expert**.

2 With the desired layer selected in the Layers panel, make a selection with a selection tool.

Note: For more on opening the Editor, see Chapter 1. For more on using selection tools, see Chapter 5.

3 Click **Edit**.

4 Click **Copy**.

Note: You also can press Ctrl+C (⌘+C on a Mac).

5 Click **Edit**.

6 Click **Paste**.

Note: You also can press Ctrl+V (⌘+V on a Mac).

Ⓐ Photoshop Elements pastes the copied selection onto a new layer.

From there, you can manipulate the copy on the new layer as desired. For example, you could click the **Move** tool (⊹) and then drag the copy to a new location.

Note: You can repeat steps **2** to **6** with another area.

Note: To move a selection to a new layer rather than copying it, click **Edit**, and then click **Cut** (Ctrl+X or ⌘+X on a Mac). Select the destination layer, and then paste the selection.

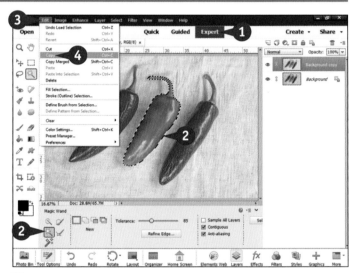

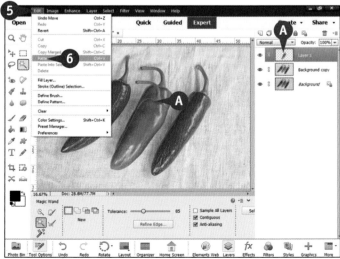

You can delete a selection to remove unwanted features from a layer in an image. By default, when you delete an area from the Background layer, Photoshop Elements fills the deleted area with the current background color. For more about setting the background color, see Chapter 9.

If you delete a selection from any other layer, Photoshop Elements removes the pixels and leaves a transparent hole. Content on layers under the hole show through. This enables you to "sculpt" the layer opening until it is the right size and shape for the composition. For more about working with layers, see Chapter 4.

Delete a Selection

1 In the Editor, click **Expert**.

2 With the desired layer selected in the Layers panel, make a selection with a selection tool.

Note: This example uses the Magic Wand tool (![wand]).

Note: For more on opening the Editor, see Chapter 1. For more on using selection tools, see Chapter 5.

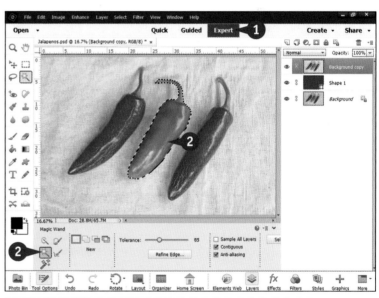

3 Press Delete.

Ⓐ Photoshop Elements deletes the contents of the selection, making the area transparent so the contents of the layer(s) below show through.

Ⓑ In this example, the *Shape 1* layer contents both show in the deleted area and hide the original Background layer content.

If you delete a selection from the Background layer, the location fills with the background color.

Note: Photoshop Elements displays an error message if you try to delete content from a layer that isn't pixel-based.

You can use the **Free Rotate Selection** command to *rotate* — spin — a selection. You can drag a selection handle to rotate it by hand, or you can specify an exact number of degrees. For example, rotating by 180 degrees turns the selection upside down. You can use rotation to make corrections — for example, to fix a horizon — or for creative effects.

When you rotate a selection in the Background layer, Photoshop Elements replaces the exposed areas that the rotation creates with the current background color. If you rotate a selection in another layer, the underlying layer content appears in the exposed areas. See Chapter 4 for more details.

Rotate a Selection

1 In the Editor, click **Expert**.

2 With the desired layer selected in the Layers panel, make a selection with any selection tool.

3 Click **Image**.

4 Click **Rotate**.

5 Click **Free Rotate Selection**.

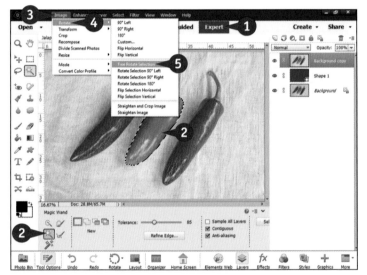

A A selection box with handles on the sides and corners appears.

The mouse pointer changes to a rotation pointer.

6 Drag a selection handle.

B Specify an exact rotation by typing a value into the **Degrees** text box in the Tool Options panel.

C Or drag the **Angle** line.

7 Click ✔ or press Enter (Return on a Mac) to apply the rotation.

D Click 🚫 or press Esc to cancel.

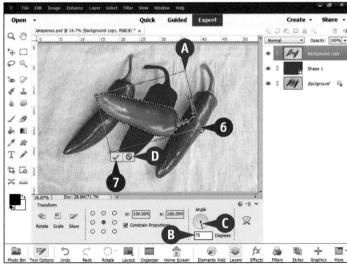

You can *scale* a selection to make it larger or to shrink it. Scaling is useful when you want to change how obvious a feature is or to make it seem it closer to or farther from the viewer. Photoshop Elements fills in blank areas around a downsized selection with the background color (on the Background layer) or a transparent gap (on other layers).

Scaling an image or selection to make it much larger often makes it blurry. You can partially correct this by applying the Sharpen filter. See Chapter 7 for details. But as a guideline, scaling by more than about 200% (2×) usually causes a loss of sharpness.

Scale a Selection

1 In the Editor, click **Expert**.

2 With the desired layer selected in the Layers panel, make a selection with a selection tool.

Note: See Chapter 5 for more on using selection tools. See Chapter 4 for more on layers.

3 Click **Image**.

4 Click **Resize**.

5 Click **Scale**.

Note: You also can press Ctrl+T (⌘+T on a Mac).

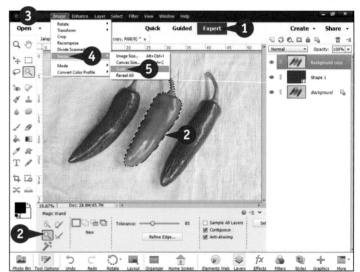

A A selection box with handles on the sides and corners appears.

6 Drag a side handle to change the height or width, or drag a corner handle to change the height and width.

B Specify a precise size by typing percentage values into the **W** and **H** text boxes in the Tool Options panel.

C With **Constrain Proportions** selected, the ratio of height and width is locked.

7 Click ✔ or press Enter (Return on a Mac) to apply the scaling.

D Click ⊘ or press Esc to cancel.

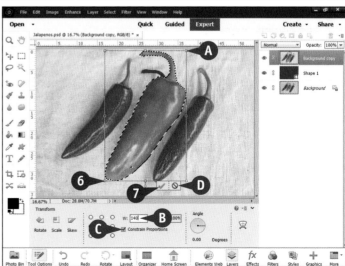

You can *transform* a selection with the **Skew** and **Distort** commands. These commands essentially pin the selection to a piece of virtual rubber. You can pull the corners and sides of the rubber to stretch or shrink the selection by different amounts in different directions. You also can pin the corners or sides to limit the effect and make the process easier.

Use these tools to correct leaning perspective in photos with strong verticals, such as columns. You also can use them for creative experiments. Note that you can distort a selection created by any tool, including the Magic Wand. You do not have to start with a rectangular area.

Skew or Distort a Selection

Skew a Selection

1 In the Editor, click **Expert**.

2 With the desired layer selected in the Layers panel, make a selection with any selection tool.

Note: This example shows a selection made with the Magnetic Lasso tool ().

Note: For more on opening the Editor, see Chapter 1. See Chapter 5 for more on using selection tools.

3 Click **Image**.

4 Click **Transform**.

5 Click **Skew**.

A A selection box with handles on the sides and corners appears.

6 Drag a handle.

B Photoshop Elements skews the selection.

Because the Skew command works along a single axis, you can drag either horizontally or vertically.

7 Click ✔ or press Enter (Return on a Mac) to complete the edit.

C Click ◯ or press Esc to cancel.

Note: In these examples, the Background layer shows the sign's original size and shape.

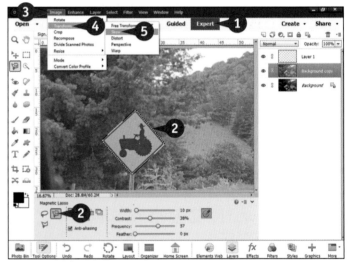

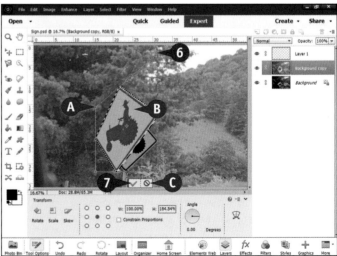

122

Distort a Selection

1 With the desired layer selected in the Layers panel, make a selection with a selection tool.

Note: See Chapter 5 for more on using selection tools.

2 Click **Image**.

3 Click **Transform**.

4 Click **Distort**.

Ⓐ A selection box with handles on the sides and corners appears.

5 Drag a handle.

Ⓑ Photoshop Elements distorts the selection. The Distort command works independently of the selection's axes, so you can drag a handle both vertically and horizontally.

Note: You can repeat step **5** any number of times.

Note: Scale and rotate the selection by typing values into the **W**, **H**, and **Degrees** text boxes.

6 Click ✔ or press Enter (Return on a Mac) to complete the edit.

Ⓒ Click ⊘ or press Esc to cancel.

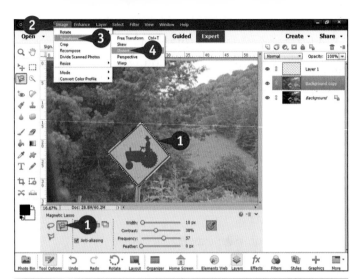

TIPS

What do the Free Transform and Perspective transforms do?

Free Transform forces you to scale the selection when you drag any corner or side, rather than enabling you to move corners independently. **Perspective** applies mirror symmetry when you drag corners. When you move a corner in one direction, the opposite corner moves in the opposite direction.

Is there a shortcut for transforming and working with a selection?

Make a selection, right-click it, and click any of the commands in the shortcut menu that appears. You can click **Free Transform** or **Transform Selection**, for example. Other choices include **Layer Via Copy** or **Layer Via Cut**, which copy and move the selection to a new layer, respectively.

You can use the Refine Edge dialog box to modify a selection by softening it, smoothing sharp edges, and widening it or shrinking it. Use this option to improve and correct edits made with many selection tools. It is a good way to smooth rough selections drawn with a mouse.

You also can use this dialog to *feather* — soften the edges of — a selection. Feathered selections look more natural than the hard edges created by an unfeathered selection. For more on feathering, see the next section, "Feather the Border of a Selection."

Refine the Edge of a Selection

1 In the Editor, click **Expert**.

2 With the desired layer selected in the Layers panel, make a selection with a selection tool.

Note: For more on opening the Editor, see Chapter 1. For more on using selection tools, see Chapter 5.

This example shows a selection made with the Polygonal Lasso tool (⊠) and then inverted to select the background.

A If the Tool Options panel is not open, click here to open it.

3 Click **Refine Edge**, if available.

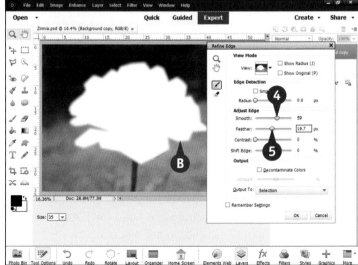

The Refine Edge dialog box opens.

Note: If the dialog box covers your photo, drag it to one side.

4 Drag the **Smooth** slider to determine the smoothness of the edge.

5 Drag the **Feather** slider to determine the softness of the edge.

Note: The **Smooth** slider makes selection edges more curved. The **Feather** slider blurs selection edges.

B Photoshop Elements previews the changes.

6 Drag the **Contrast** slider to sharpen a selection that is now too soft.

7 Drag the **Shift Edge** slider to move the selection edge in or out from the selected object.

Note: Explore these settings until you get as much of the object as you can, with as little of the unwanted area. Be careful around fine edges such as fences and hair.

8 Click **OK**.

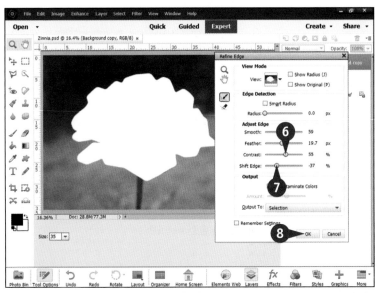

C Photoshop Elements adjusts the selection.

Note: Refine Edge does not change the layer content. It improves the selection so you can make more precise and professional edits.

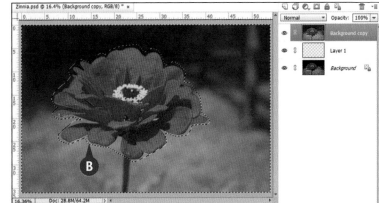

You can feather a selection's border to create soft edges. You can create feathering with the Refine Edge tool introduced in the previous section. You also can apply feathering using the **Feather** command on the **Select** menu. Wide soft edges can create a sentimental or romantic feel. Thinner soft edges create subtle blending and help make edits look more natural.

To create a soft border around an object, select the object, feather the selection border, and then delete the part of the image that surrounds your selection. You could then vary the mood by altering the background.

Use Feathering to Create a Soft Border

Feather a Selection

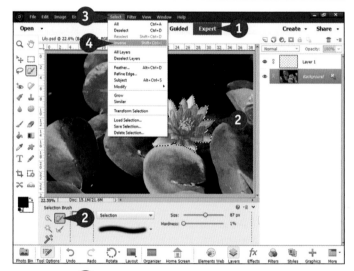

1 In the Editor, click **Expert**.

2 With the desired layer selected in the Layers panel, make a selection with a selection tool.

Note: Smooth selections work better than rough ones. This example shows a selection created with multiple tools, including the Selection Brush tool ().

3 Click **Select**.

4 Click **Inverse**.

Photoshop Elements inverts the selection.

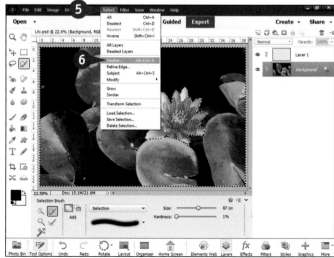

5 Click **Select**.

6 Click **Feather**.

Note: You also can right-click the selection and click **Feather** in the shortcut menu.

The Feather dialog box opens.

7 Type a number into the **Feather Radius** text box.

Note: This sets the width of the feather in absolute pixels. Use larger numbers on larger images.

8 Click **OK**.

Photoshop Elements feathers the edge of the selection. It may not look very different if you specified a low Feather Radius.

9 Press Delete or Ctrl+X (⌘+X on a Mac) and then Ctrl+D (⌘+D on a Mac).

Deleting the selection and then removing the selection outline enables you to see the feathering effect.

A If you selected the Background layer, the current background color fills the deleted area.

Note: On other layers, the deleted area becomes transparent, so content on the layers below shows through.

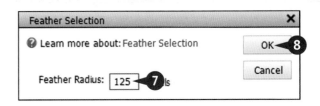

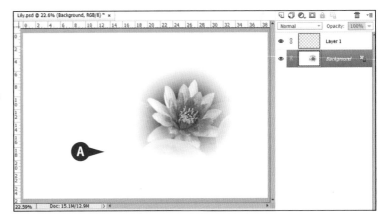

TIPS

How do I feather my selection into a colored background?

You can paste your selection to a new layer and then add a layer below it filled with a different background color. For more about layers, see Chapter 4.

What happens if I feather a selection and then apply an edit command to it?

The strength of the new effect fades out toward the feathered edge of your selection. For example, if you change coloring in a selection with the **Brightness/Contrast** command, the center of the selection remains more intense, but the effect fades toward the edge of the selection. For more on Brightness/Contrast, see Chapter 7.

Enhancing Lighting, Color, and Sharpness

Does your photo suffer from overly dark shadows that are too dark, faded colors, or blurriness? Photoshop Elements has an impressive selection of tools for fixing lighting, color, and sharpness in an image file.

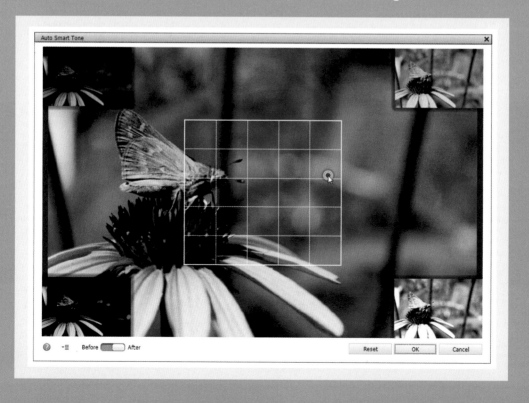

Adjust Levels

You can use the Levels dialog box in Photoshop Elements to fine-tune the balance between shadows, highlights, and the *midtones* in between. The Levels tool can bring detail out of shadows and set the overall brightness and contrast in the image file.

The Levels dialog box displays a *histogram* — a graph that counts the number of pixels at every possible brightness level, with darker pixels to the left and brighter pixels to the right. Adjusting the settings stretches and squeezes the graph to change the lighting in the image.

Adjust Levels

1 In the Editor, click **Expert**.

Note: For more on opening the Editor, see Chapter 1.

2 With the desired layer selected in the Layers panel, click **Enhance**.

3 Click **Adjust Lighting**.

4 Click **Levels**.

Note: Alternatively, you can press Ctrl+L (⌘+L on a Mac).

Note: Working on a copy of the Background layer is a good practice. Or, click **Layer**, click New **Adjustment Layer**, and then click **Levels** to add an *adjustment layer* to hold the tone changes without changing the Background layer.

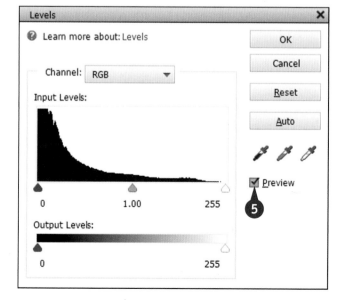

The Levels dialog box opens.

5 Make sure **Preview** is selected (☐ changes to ☑).

When Preview is selected, Photoshop Elements updates the image as you make changes.

6 Drag the black **Input Levels** slider to control the shadows.

7 Drag the gray **Input Levels** slider to control midtones.

8 Drag the white **Input Levels** slider to control highlights and bright areas.

A You also can double-click each slider value and type a new setting in the text box.

Photoshop Elements displays a preview of the adjustments.

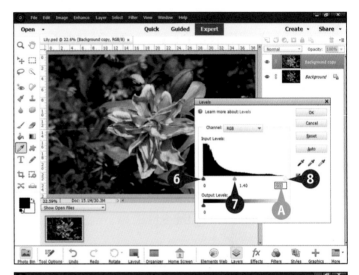

9 Drag the black **Output Levels** slider to the right to lighten the image.

10 Drag the white **Output Levels** slider to the left to darken the image.

Note: Bringing them closer reduces the contrast in the image.

11 Click **OK**.

Photoshop Elements applies the level adjustments.

Note: You can make a selection to change the levels in part of an image. See Chapter 5 for more about selections.

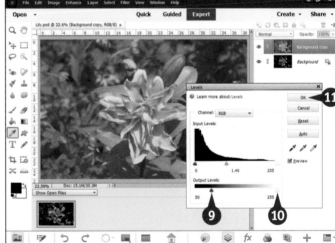

TIPS

How do I adjust levels automatically?
With the desired layer selected in the Layers panel, click **Enhance** and then **Auto Levels**. Photoshop Elements sets the lightest pixels to white and the darkest pixels to black, adjusting other brightness levels between these extremes. Some images with more extreme lighting may need manual adjustment.

Can I set the darkest, mid-gray, and brightest light levels directly from the image?
Yes. The Levels dialog box includes three eyedropper tools, one for the darkest (🖊), midtone (🖊), and lightest tones (🖊). Click a tool, and then click the desired area in the image to set the dark/midtone/bright levels. Note that if you click colored pixels instead of black/gray/white pixels, this changes the color balance in your image. Click **Reset** to restore the original balance and try again.

Adjust Shadows and Highlights

You can use the Shadows/ Highlights feature to make quick adjustments to the dark and light areas of an image file. Shadows/Highlights is less complicated than the Levels tool but also less flexible.

In an image with poor exposure, change the **Lighten Shadows** setting to improve underexposed areas, and use **Darken Highlights** to tone down overexposed areas. Adjust the **Midtone Contrast** setting to show further detail.

Adjust Shadows and Highlights

1 In the Editor, click **Expert**.

Note: For more on opening the Editor, see Chapter 1.

2 With the desired layer selected in the Layers panel, click **Enhance**.

3 Click **Adjust Lighting**.

4 Click **Shadows/Highlights**.

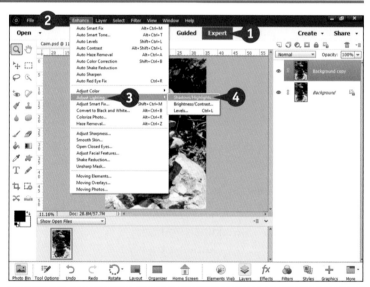

The Shadows/Highlights dialog box opens.

5 Make sure **Preview** is selected (☐ changes to ☑).

When Preview is selected, Photoshop Elements updates the photo as you make changes.

6 Drag the **Lighten Shadows** slider to the right to make dark areas lighter.

7 Drag the **Darken Highlights** slider to the right to make bright areas darker.

Note: This slider does not darken burned-out white areas. It only darkens the areas with a little less brightness.

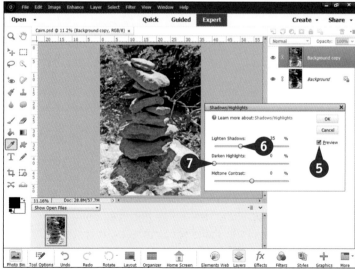

8 Drag the **Midtone Contrast** slider to increase or decrease the midtone contrast.

Note: Decreasing contrast brings detail out of darker areas but also can make the image look washed out.

A You also can double-click any of the slider values and type a new setting in the text box.

9 Click **OK**.

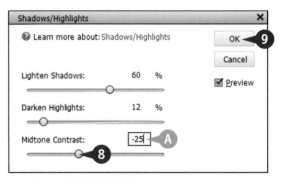

Photoshop Elements applies the changes.

Note: Making lighting and color changes on a copy of the Background layer leaves the original image pixels intact. You can try different changes on additional copies of the layer, while preserving the original image content.

TIPS

Why does the image look noisy after using Shadows/Highlights?
The less light a camera receives (*underexposure*), the noisier the image. Usually, the noise remains dark, so you cannot see it. If you brighten a dark area with the **Lighten Shadows** slider, the noise becomes obvious. You can use other tools to make spot corrections instead. See "Use the Dodge and Burn Tools" later in this chapter.

When I open the Shadows/Highlights dialog box, Photoshop Elements immediately adjusts my image. What is happening?
The Shadows/Highlights tool automatically lightens shadows by 35 percent. If you do not want this adjustment, move the **Lighten Shadows** slider all the way to the left before making other changes.

Change Brightness and Contrast

You can use the Brightness/Contrast dialog box to make simple adjustments to the light/dark balance in your image. **Brightness** makes the image lighter, and **contrast** increases the difference between light and dark areas.

The Brightness/Contrast settings are easy to use but not as powerful as the Levels tool. For good results, use this tool for very quick fixes, but take the time to learn how to use the Levels tool so you can rely on it for more complex changes. See the section "Adjust Levels" for more information.

Change Brightness and Contrast

1 In the Editor, click **Expert**.

Note: For more on opening the Editor, see Chapter 1.

2 With the desired layer selected in the Layers panel, click **Enhance**.

3 Click **Adjust Lighting**.

4 Click **Brightness/Contrast**.

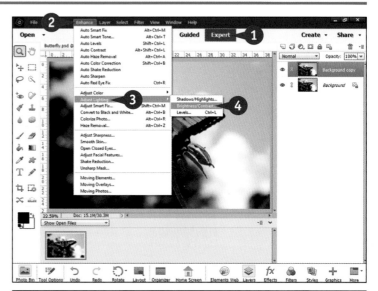

The Brightness/Contrast dialog box opens.

5 Make sure **Preview** is selected (☐ changes to ☑).

6 Drag the **Brightness** slider to adjust brightness.

Drag the slider to the right to lighten the image or to the left to darken the image.

A You also can double-click the slider value and type a number from 1 to 150 to lighten the image or from −1 to −150 to darken the image.

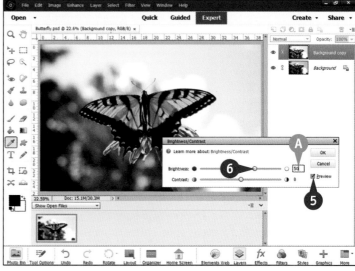

7 Drag the **Contrast** slider to adjust contrast.

Drag the slider to the right to increase the contrast or to the left to decrease the contrast.

B You also can double-click the slider value and type a number from 1 to 100 to increase the contrast or from −1 to −50 to decrease the contrast.

Note: You often need to repeat steps **6** and **7** until you get the overall balance right.

8 Click **OK**.

Photoshop Elements applies the adjustment.

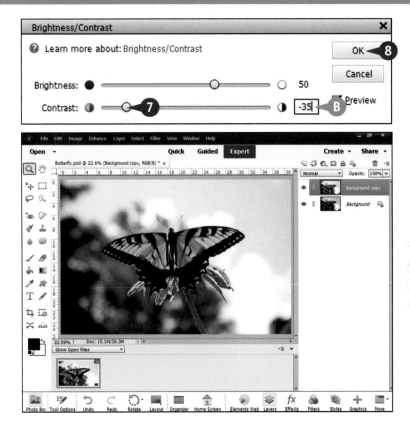

TIPS

How can I automatically adjust the contrast in an image?
With the desired layer selected in the Layers panel, click **Enhance** and then **Auto Contrast**. The Auto Contrast feature converts the very lightest pixels in the image to white and the very darkest pixels to black. You cannot fine-tune its changes.

Is there a tool that makes it easier to check contrast and lighting?
Yes. Click **Window** and then click **Histogram** to open the Histogram panel. The curve graphs dark/bright levels from left to right, showing the number of pixels at each level. Blown-out highlights appear as a spike at the far right. Significant dark areas appear as a spike at the far left. Poor contrast appears as a gap in the curve at the left or right.

Use the Dodge and Burn Tools

You can use the **Dodge** and **Burn** tools to "paint" on an image to lighten or darken specific areas. The Dodge tool lightens, and the Burn tool darkens — which may be the opposite of what you'd expect. These unusual names come from old darkroom processes.

You can change the brush size for these tools and select whether they work on shadows, midtones, or highlights. Use these tools to make corrections or reinterpret an image, adding and removing light from the original scene.

Use the Dodge and Burn Tools

Use the Dodge Tool

1 In the Editor, click **Expert**.

Note: For more on opening the Editor, see Chapter 1.

2 With the desired layer selected in the Layers panel, click the **Sponge** tool ().

Ⓐ If the Tool Options panel is not open, click **Tool Options** on the taskbar to open it.

The Dodge tool appears with the Sponge and Burn tools in the Tool Options panel.

3 Click the **Dodge** tool ().

Note: Pressing toggles between the Sponge, Dodge, and Burn tools.

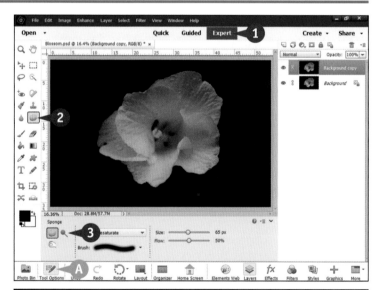

Ⓑ You can click the **Brush** drop-down list and choose a different brush.

Ⓒ You can click the **Range** drop-down list and then click **Shadows**, **Midtones**, or **Highlights**.

Ⓓ You can drag the **Size** slider to change the brush size.

4 Drag over the area to lighten.

This example shows the upper petals being lightened.

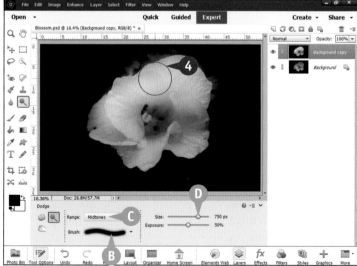

Use the Burn Tool

1. In the Editor, click **Expert**.

2. With the desired layer selected in the Layers panel, click the **Sponge** tool (⬤).

Ⓐ If the Tool Options panel is not open, click **Tool Options** on the taskbar to open it.

The Burn tool appears with the Sponge and Dodge tools in the Tool Options panel.

3. Click the **Burn** tool (⬤).

Note: Pressing Ⓞ toggles between the Sponge, Dodge, and Burn tools.

Ⓑ The Burn tool has the same settings as the Dodge tool.

4. Drag over the area to darken.

This example shows the petal at the left being covered further in shadows.

Is there a way to make small changes?

If you set **Exposure** to a low value, both tools make small changes and give you very fine control. You can paint over an area repeatedly to make more obvious changes.

Why does my image still look wrong?

Dodge and Burn are subtle artistic effects, not extreme corrections. Use them to add and remove light from a scene — for example, to simulate adding a light source or a shade screen. Getting a quality result takes practice and a good eye. The right touch makes a photo look stronger and more dramatic, but also natural and not obviously processed.

Sharpen an Image

You can use the Adjust Sharpness dialog box to sharpen an image. This tool can improve soft images, but it is not a complete cure for focus problems. It cannot transform a badly blurred image into a sharp one.

Sharpening can bring out grain and noise in an image. You often need to adjust the amount of sharpening to get a good balance between noise and sharpness.

Sharpen an Image

1 In the Editor, click **Expert**.

Note: For more on opening the Editor, see Chapter 1.

2 With the desired layer selected in the Layers panel, click **Enhance**.

3 Click **Adjust Sharpness**.

The Adjust Sharpness dialog box opens.

4 Make sure **Preview** is selected (☐ changes to ☑).

Ⓐ You can click plus or minus (⊞ or ⊟) to zoom in and out.

5 Drag the **Amount** slider to control the intensity of the effect.

6 Drag the **Radius** slider to apply the effect to a larger or smaller area.

Note: If you set a large radius and a high intensity, the effect creates halos and blobs of color.

Ⓑ You can click the **Remove** menu and click the type of blur to fix. The **Gaussian Blur** option applies sharpening across the image. **Lens Blur** sharpens details. **Motion Blur** removes blur caused by camera or subject motion and includes a control to set the direction.

⑦ If the settings make the image look unrealistic, click **Shadows/Highlights**.

The dialog box expands and shows further options for **Shadows** and **Highlights**.

⑧ Drag the **Tonal Width** slider under Shadows right to make the effect look more natural around dark areas.

⑨ Drag the **Tonal Width** slider under Highlights right to make the effect look more natural around bright areas and to minimize "salt and pepper" noise.

⑩ Click **OK**.

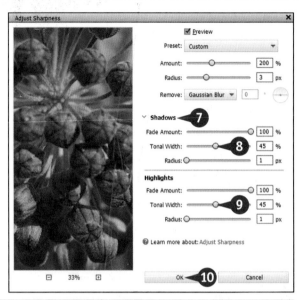

Photoshop Elements applies the sharpening settings.

Note: For good results, avoid adding artifacts and noise.

When should I apply sharpening?
Apply sharpening after you have finished making other changes. You also can sharpen after resizing, which often causes a loss of detail. Sharpening can bring some of the detail back.

How can I sharpen an image in Quick mode?
In Quick mode, click **Adjustments** on the taskbar and then click **Sharpen**. Drag the slider or click a preset thumbnail. The Quick mode Sharpen tool is less sophisticated than the Sharpen dialog box, but offers easy enhancements.

Use the Blur and Sharpen Tools

You can use targeted blurring and sharpening to draw attention to parts of your photo. Blurring a background makes it less eye-catching, while sharpening a subject draws the eye toward it. You also can use blurring to de-emphasize small flaws in the image.

The Blur and Sharpen tools apply very subtle but worthwhile changes that enhance image quality. Later chapters cover less subtle effects that you can apply.

Use the Blur and Sharpen Tools

Use the Blur Tool

1 In the Editor, click **Expert**.

Note: For more on opening the Editor, see Chapter 1.

2 With the desired layer selected in the Layers panel, click the **Blur** tool (⬤).

Note: Pressing ⓡ toggles between the Blur, Sharpen, and Smudge tools.

Ⓐ If the Tool Options panel is not open, click **Tool Options** on the taskbar to open it.

The Blur tool appears in the Tool Options panel with the Sharpen and Smudge tools.

Ⓑ You can click the **Brush** drop-down list and choose a different brush.

Ⓒ You can use these sliders to change the brush **Size** and **Strength**.

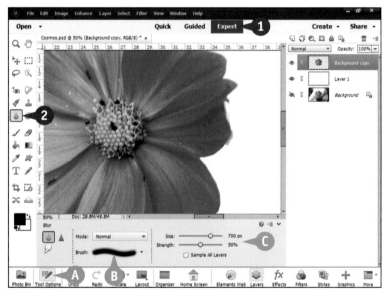

3 Drag the mouse pointer to blur an area of the image.

Photoshop Elements blurs the area.

The blur is very subtle, even at 100 percent strength. Keep dragging the mouse to "scrub in" more blurring.

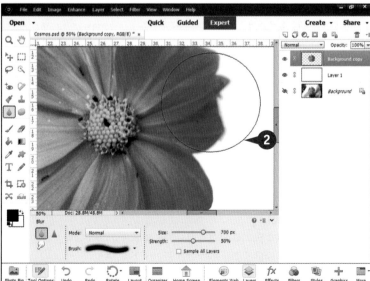

Use the Sharpen Tool

1 In the Editor, click **Expert**.

2 With the desired layer selected in the Layers panel, click the **Blur** tool (⬤).

3 Click the **Sharpen** tool (▲).

Note: Pressing R toggles between the Blur, Sharpen, and Smudge tools.

The Sharpen tool appears in the Tool Options panel with the Blur and Smudge tools.

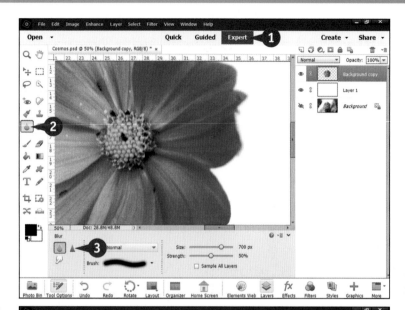

A You can click the **Brush** drop-down list and choose a different brush.

B You can use these sliders to change the brush **Size** and **Strength**.

4 Drag the mouse pointer to sharpen an area of the image.

Photoshop Elements sharpens the area.

The effect is more obvious than the blur, and it is easier to see it working, but it is still a subtle effect.

Note: You also can move the mouse pointer over an area and press and hold the mouse button to apply more sharpening or blurring.

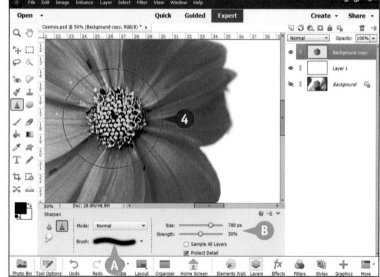

TIPS

What is the Smudge tool?
You can use the Smudge tool (🖐) to create interesting blur effects in your photos. It simulates dragging a finger through wet paint, shifting and smearing colors in the image. The Smudge tool appears in the Tool Options panel with the Blur and Sharpen tools.

What does the Mode menu do?
In Normal mode, the tools change the image texture. In the other modes, they change image texture and also adjust color or contrast. Experiment with various modes to see which applies the desired effect.

Adjust Skin Color

You can improve skin colors that appear tinted or washed out or that were distorted by poor light. The Adjust Color for Skin Tone dialog box includes an eyedropper color sampler. Use it to select an area of skin as a color reference.

The adjustment tool uses the reference to guess a better skin tone and to correct other colors in the image. You often need to fine-tune the effect by adding or removing **Tan** (orange) or **Blush** (pink). You also can shift the color between cool blue and a warmer red/orange.

Adjust Skin Color

1 In the Editor, click **Expert**.

Note: For more on opening the Editor, see Chapter 1.

2 With the desired layers selected in the Layers panel, click **Enhance**.

3 Click **Adjust Color**.

4 Click **Adjust Color for Skin Tone**.

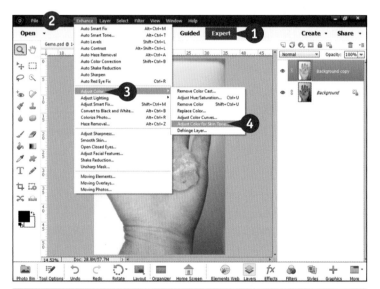

The Adjust Color for Skin Tone dialog box opens.

The mouse pointer changes into an eyedropper when over the image.

5 Click an area of skin to use it as a color reference.

Note: This example shows a close-up of a person holding rough gemstones.

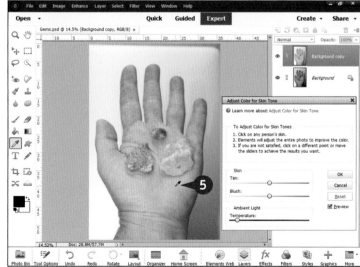

⑥ Drag the **Tan** slider to adjust the level of brown.

⑦ Drag the **Blush** slider to adjust the level of red/pink.

⑧ Drag the **Temperature** slider to adjust the overall coloring of the image.

Dragging to the left creates a cooler, bluish tint; dragging to the right casts a warmer, reddish tint.

⑨ Click **OK**.

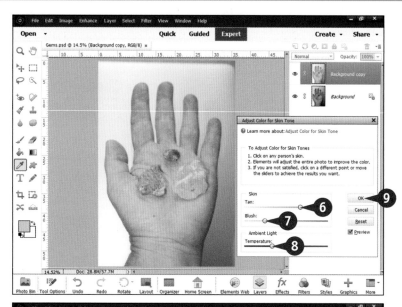

Photoshop Elements adjusts the colors in the image. In this example, the skin's redness has been toned down.

Note: Skin tone varies depending on ethnicity, location, and even whether a subject is feeling too hot or cold. Often, many interpretations are possible. The "right" adjustment is the one that works best for your photo.

TIP

Can Photoshop Elements correct the colors in my image automatically?
Yes. Click **Enhance**, and then click **Auto Color Correction**. Photoshop Elements corrects the colors. The result is often "close enough," but may not be what exactly what you want. For better results, you can adjust the colors manually using other tools — including the **Sponge** tool, described in the next section.

Adjust Color with the Sponge Tool

You can use the Sponge tool to "paint" color adjustments onto a specific area of an image. For example, you can make a person's clothing more colorful, tone down the color in some objects but not others, or even remove the color from most — but not all — of the image.

You can adjust the size and softness of the brush to customize it and apply the brush multiple times to increase the effect.

Adjust Color with the Sponge Tool

Decrease Saturation

1 In the Editor, click **Expert**.

Note: For more on opening the Editor, see Chapter 1.

2 With the desired layer selected in the Layers panel, click the **Sponge** tool (🧽).

Note: Pressing **O** toggles between the Sponge, Dodge, and Burn tools.

Ⓐ If the Tool Options panel is not open, click **Tool Options** on the taskbar to open it.

Ⓑ You can specify a different **Brush**, **Size**, and **Flow**.

3 Click the **Mode** drop-down list.

4 Click **Desaturate**.

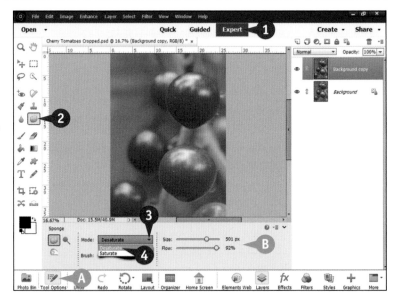

5 Drag the mouse over the desired area to tone down or remove color from the area.

Note: Even with 100% flow, you need to paint over an area a few times before the color disappears.

To confine the effect to a particular area, you can make a selection first. See Chapter 5 for more on making selections.

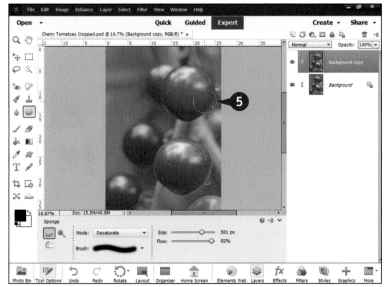

Increase Saturation

1 Perform steps **1** to **3** in the subsection "Decrease Saturation."

2 Click **Saturate**.

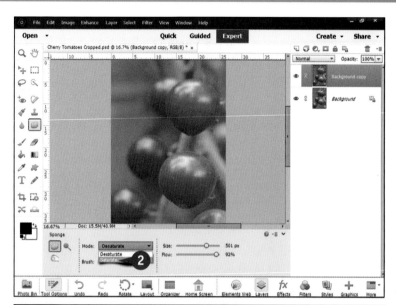

3 Drag the mouse over the desired area to increase the saturation of the area.

Note: You also can click areas instead of painting by dragging over them.

In this example, the upper-right desaturated tomato is darker, while the tomato below it has become more saturated.

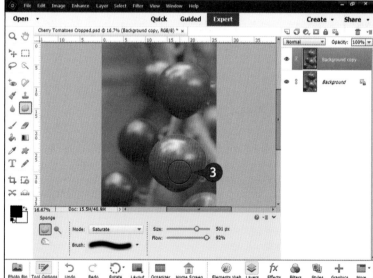

What does the Flow setting do?
The **Flow** slider in the Tool Options panel controls the intensity of the Sponge tool. You can set the **Flow** between 1% and 100%. Because the effect is subtle, you may want to start with 100%.

How do I find the right brush style and size?
The **Brush** menu displays a variety of brush styles with soft, hard, and shaped edges. To blend your sponging effect into the surrounding pixels, select a soft-edged brush style. To make your sponging effect appear more distinct, use a hard-edged brush style. To change your brush size, drag the **Size** slider in the Tool Options panel.

Replace a Color

You can use the **Replace Color** dialog box to alter a color range in your image. After clicking the image to select a color, use the **Fuzziness** slider to include a range of similar colors. You also can use eyedroppers to add or remove colors. Finally, specify the replacement color with **Hue**, **Saturation**, and **Lightness** sliders.

Colored objects often have fringes and shadows, and colors can spill across objects. It can take several attempts to create a natural-looking color replacement.

Replace a Color

1 In the Editor, click **Expert**.

Note: For more on opening the Editor, see Chapter 1.

2 With the desired layer selected in the Layers panel, click **Enhance**.

3 Click **Adjust Color**.

4 Click **Replace Color**.

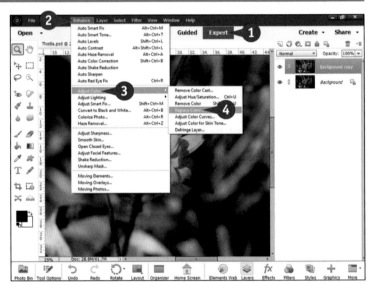

The Replace Color dialog box opens. The mouse pointer changes to an eyedropper when over the image.

5 Click the image to select the color you want to change.

A The preview area shows where that color appears in the image.

6 Drag the **Fuzziness** slider to add or remove similar colors in the selection.

You also can double-click and type a value for **Fuzziness**.

The white areas in the preview expand or shrink to show the selected color range.

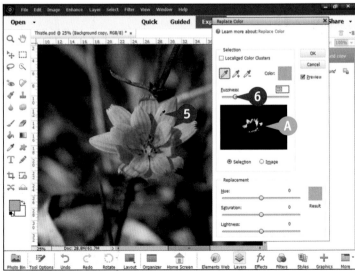

7 Drag the **Hue** slider to change the color.

8 Drag the **Saturation** slider to change the intensity of the color.

Ⓑ You can optionally drag the **Lightness** slider to change the lightness/darkness of the color.

You also can double-click and type values for the **Hue**, **Saturation**, and **Lightness**.

9 Click **OK**.

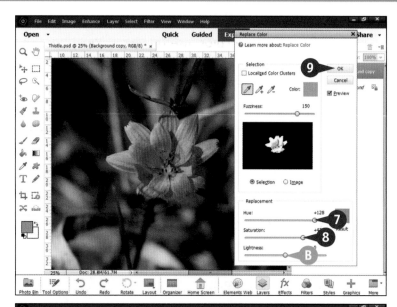

Photoshop Elements replaces the selected color range.

TIPS

How can I replace more than one area of color?
You can press `Shift` and then click the image to add other colors to the selection. The white area inside the preview box expands as you click. To deselect a color, press `Alt` (`Option` on a Mac) and click the color in the image.

How can I avoid color spill?
Colors often spill across objects. Selecting colors in a foreground object sometimes selects the same colors in background areas you do not want to change. To avoid this, paint a selection around your object before using this tool. See Chapter 5 for more about selections.

Convert a Color Photo to Black and White

You can remove the colors from an image to change it to black and white. The **Convert to Black and White** dialog box includes a range of creative styles. You can change the style to add drama or to prepare the photo for a particular use.

It's a good practice to save the original color image and various black and white versions as you work. See Chapter 2 and Chapter 11 for more about saving and viewing versions.

Turn a Color Photo into Black and White

1 In the Editor, click **Expert**.

Note: For more on opening the Editor, see Chapter 1.

2 With the desired layer selected in the Layers panel, click **Enhance**.

3 Click **Convert to Black and White**.

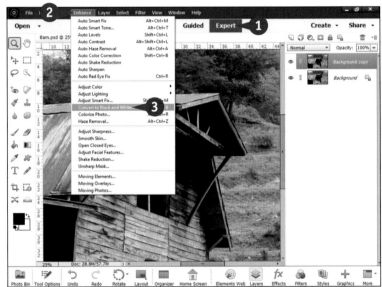

The Convert to Black and White dialog box opens.

4 Click a style in the **Select a Style** list to select it.

A Photoshop Elements displays a preview of the black and white version.

Note: Each style creates a different result by varying the brightness of red, green, and blue separately and setting the overall contrast.

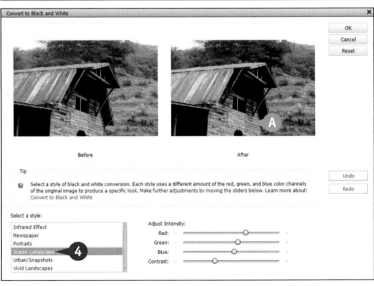

B You can optionally drag the sliders to set the intensity of **Red**, **Green**, and **Blue** manually.

C You can optionally drag the **Contrast** slider to increase or decrease the contrast.

This example shows the **Red** and **Contrast** sliders moved further right.

5 Click **OK**.

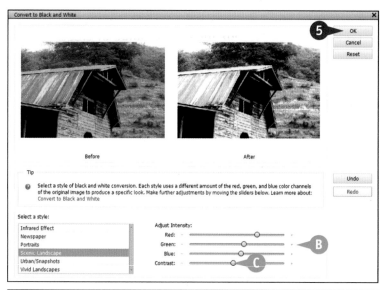

Photoshop Elements converts the image to black and white.

Note: If you're working on a copy of the Background layer, the changes apply only to the layer copy, leaving the colors intact on the Background layer. By hiding and showing the layers, you can control whether the image appears in black and white or color. Or, you can experiment with reducing the **Opacity** setting for the black and white layer to allow some of the color from the Background layer to show through. See Chapter 4 for more on layers.

TIP

How do I know how to set the color sliders?
If you move the **Red** slider to the right, red areas in the photo become brighter. This brightens skin in portraits and is one of the techniques used by professional photographers to improve the look of black and white portraits. You can use the **Blue** slider to control sky brightness and the **Green** slider to control the brightness of grass and foliage. Color balance is a creative choice, so the "right" answer depends on the mood you want to create and the image contents. Simply desaturating an image often creates an uninteresting photo. The Convert to Black and White dialog box gives you more choices.

Add Color to a Black and White Photo

You can enhance a black and white photo by adding color with the painting tools in Photoshop Elements. For example, you can add color to a person's cheeks or to articles of clothing. You also can simulate the hand-tinted color effects used in vintage photos.

Hand-tinting is an artistic process, so you may need to try different colors and brush **Opacity** settings before you create a good result. For many images, an **Opacity** of less than 30 percent can work well. Brighter saturated colors can look garish and unconvincing.

Add Color to a Black and White Photo

1 In the Editor, click **Expert**.

Note: For more on opening the Editor, see Chapter 1.

2 With the desired layer selected in the Layers panel, click the **Brush** tool (✏️).

Note: Pressing B toggles between the Brush, Impressionist Brush, and Color Replacement tools.

Ⓐ You can click the **Brush** drop-down list to select a different brush.

3 Click the foreground color box, and select a color using the Color Picker dialog box that appears.

For more about setting the foreground color, see Chapter 9.

4 Click the **Mode** drop-down list.

5 Click **Color**.

6 Drag the **Size** slider to set the brush size.

Use a large brush to cover a large area with a few strokes and a small brush to fill in details.

7 Drag the **Opacity** slider to reduce the opacity of the color.

8 Drag to paint a color onto the image.

You can repeat steps **2** through **8** to paint additional colors onto the image.

Photoshop Elements creates a tinted image.

Choosing **Color** as the **Mode** means the Brush tool paints color information (hue and saturation) only over the black and white image content.

Can I add color without changing the original image?

Yes. Instead of painting on the original image on the Background layer, you can duplicate the layer and then paint on the copy. As shown in many of the examples in this chapter, this best practice preserves the original image content within the file. You can make lighting, color, and sharpness adjustments on various layer copies and change layer opacity to control the intensity of a change. In this case, you can try different combinations of painted layers until you get an effect you like without changing the original black and white file. For more about layers, see Chapter 4.

Adjust Colors by Using Color Curves

You can make your images look less muddy and punchier by using the **Adjust Color Curves** dialog box. The dialog box graphs the relationship between image shadows, midtones, and highlights. You can change the shape of the graph to improve the image.

The dialog box includes a small selection of style presets. Click a preset to select it. For the best results, use the sliders to adjust the graph manually. Note that you cannot drag points directly on the graph. You must use the sliders to change the curve.

Adjust Colors by Using Color Curves

1 In the Editor, click **Expert**.

Note: For more on opening the Editor, see Chapter 1.

2 With the desired layer selected in the Layers panel, click **Enhance**.

3 Click **Adjust Color**.

4 Click **Adjust Color Curves**.

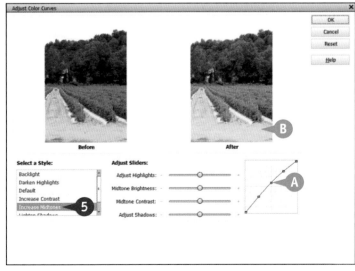

The Adjust Color Curves dialog box opens.

5 Click a preset in the **Select a Style** list.

A The curve changes to match the new setting.

B The **After** area previews the result.

In this example, choosing the **Increase Midtones** style gives the graph a slight curve.

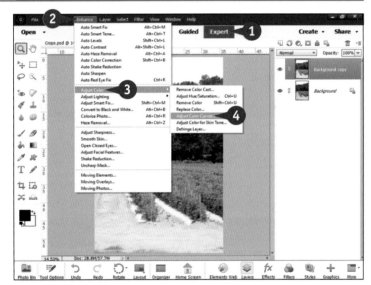

C You can optionally drag the four sliders to fine-tune the result.

6 Click **OK**.

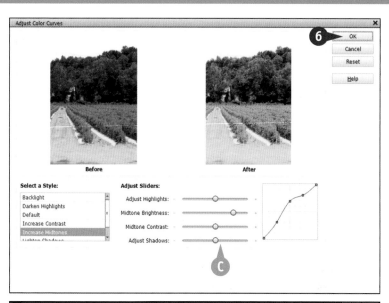

Photoshop Elements applies the adjustment to the image.

TIPS

How do I know how to set the sliders?
The right choices depend on the image. Start by trying the different style presets and seeing which one — if any — improves the image. If you see an obvious improvement, try moving the sliders to make the curve even bigger. Experiment until you get a good result.

Why can I not adjust curves for each color?
This feature is available only in the full version of Adobe Photoshop. The settings in Photoshop Elements offer a simplified version of the adjustment.

Apply the Auto Smart Tone Tool

You can use the **Auto Smart Tone** tool to improve lighting and contrast. Auto Smart Tone combines Levels, Shadows/Highlights, Brightness/Contrast, and Color Curves corrections introduced earlier in this chapter and hides the details behind a simple and intuitive interface.

To use the tool, drag the controller that appears in any direction. Each corner of the window has a preview to show how each direction changes the image. A bigger active preview appears in the window.

Apply the Auto Smart Tone Tool

1 In the Editor, click **Expert**.

Note: For more on opening the Editor, see Chapter 1.

2 With the desired layer selected in the Layers panel, click **Enhance**.

3 Click **Auto Smart Tone**.

The Auto Smart Tone window appears.

A Thumbnails in each corner show how the photo changes as you drag the controller toward them.

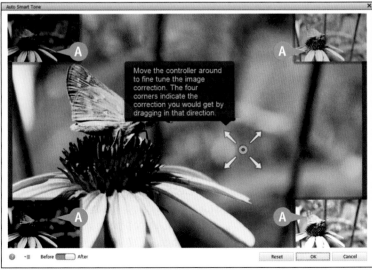

④ Drag the controller, the large onscreen icon.

Ⓑ A grid appears to help you gauge dragging distances.

Dragging from the upper left to the lower right changes the lightness.

Dragging from the upper right to the lower left changes the contrast.

As you drag, the image preview updates.

⑤ Click **OK**.

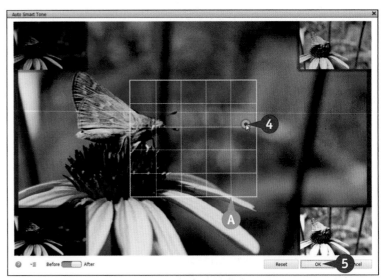

Photoshop Elements corrects the image.

TIPS

What does the menu button in the window do?
You can click the menu (⊞) and select **Learn from this correction** to tell Photoshop Elements to remember your edit. If you open another photo and use the tool again, Photoshop Elements remembers the previous controller position. You also can deselect **Show corner Thumbnails** to hide the thumbnails.

What does the Before/After switch do?
Choose **Before** to see the unedited image. You can use the switch to compare corrected and uncorrected versions of the image to help you find a setting you like.

Applying Quick and Guided Edits

Quick mode in Photoshop Elements offers easy presets for photo fixes, while Guided mode gives you step-by-step instructions for fixes and special effects. You can retouch old photos, apply creative effects, and make other improvements. Guided mode uses tools available in the other modes but presents them in a structured way that helps you create professional results.

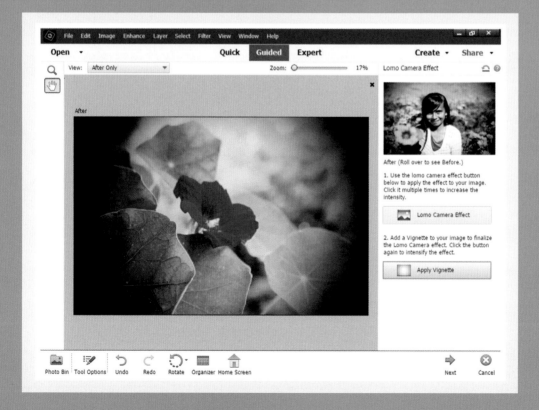

Quickly Fix a Photo

You can use Quick mode in Photoshop Elements to make corrections with a few clicks. Adjust lighting, contrast, color, and more. You also can see a **Before and After** view of your edits.

The Quick mode panel includes a selection of user-friendly tools. The Smart Fix tool automatically corrects lighting, color, and contrast; the Exposure and Levels tools fix lighting problems; the Color and Balance tools fix color problems; and the Sharpen tool sharpens photos.

Quickly Fix a Photo

1 In the Editor, click **Quick**.

Note: For more on opening the Editor, see Chapter 1.

Note: If the image file has multiple layers, select a layer in the Layers panel and hide other layers before changing to Quick mode.

A The Quick mode Adjustments panel shows the six available quick retouching tools.

B You can use the tools in the toolbox to zoom the image and perform basic edits such as cropping.

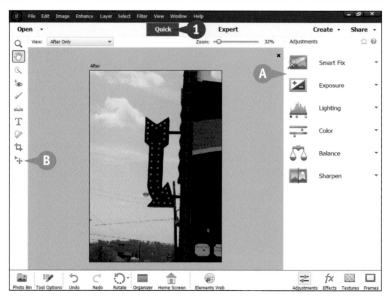

2 Click the **View** drop-down list.

3 Click **Before & After - Horizontal**.

The After Only view shows the image after editing.

The Before Only view shows the image before editing.

The Before and After views show both. Horizontal places the images side by side; Vertical places them above and below.

Note: Click **Adjustments** on the taskbar if you don't see the Adjustments panel.

④ Click **Smart Fix**.

The Smart Fix tool opens.

⑤ Drag the slider to improve the image.

ⓒ You also can click a preset thumbnail.

ⓓ Photoshop Elements makes immediate adjustments to the lighting, contrast, and colors in the image.

ⓔ You can click the reset thumbnail to undo the changes.

ⓕ If you click **Auto**, Photoshop Elements applies a "best guess" setting.

⑥ Click **Color**.

⑦ Click **Vibrance**.

Note: The Vibrance tool boosts colors in a more natural way than the Saturation tool.

ⓖ You can use the thumbnails, slider, and **Auto** button to specify enhancements.

Photoshop Elements enhances the image colors.

You can follow similar steps to use the other Adjustments to improve exposure, lighting, sharpness, and overall balance.

TIPS

Why does Photoshop Elements duplicate the same edit options elsewhere?
Quick mode offers simple tools that apply useful edits, saving you time. The **Enhance** menu and Expert mode include similar editing tools that give you more options and finer control but take more time to use.

How can I improve the look of teeth in Quick mode?
You can use the Whiten Teeth tool (🖊). Drag the tool over a smile; it selects the teeth and whitens them all at once. The result is similar to using the Quick Selection tool (see Chapter 5) to select the teeth and then applying the Dodge tool (see Chapter 7) to lighten them and the Sponge tool (see Chapter 7) to remove any color cast.

Remove Red Eye

Y ou can use the Eye tool (sometimes called the red eye removal tool) to remove *red eye* — a common problem in photos taken with a flash. Light bounces off the blood vessels at the back of the eye, causing the red color. Animal eyes can show a similar effect, usually in yellow, blue, or green.

With the Eye tool, you can fix eye color without changing the shape of the eyes. The tool paints a dark circle over red areas and adds a small highlight. It includes an option for fixing the eyes of pets and other animals.

Remove Red Eye

1 In the Editor, click **Quick**.

Quick mode appears.

Note: For more on opening the Editor, see Chapter 1.

Note: If the image file has multiple layers, select a layer in the Layers panel and hide other layers before changing to Quick mode.

A Make sure that **Before & After - Horizontal** is selected.

2 Click the **Eye** tool ().

Note: Pressing Y selects the Eye tool.

Note: This tool is also available in Expert mode.

B If the Tool Options panel is not open, click **Tool Options** on the taskbar to open it.

3 Drag the **Pupil Radius** slider to set the size of the area you want to fix.

4 Drag the **Darken** slider to adjust how much the tool replaces red/glowing areas with black areas.

Note: You often need to experiment with these values until you get a good result.

5 Click **Pet Eye** (☐ changes to ☑) if you are working on an animal photo.

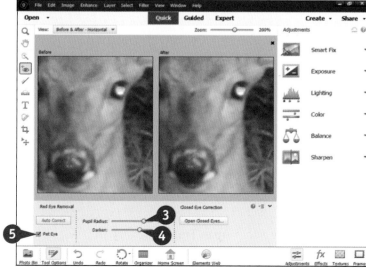

6 Click the pupil of the eye you want to fix.

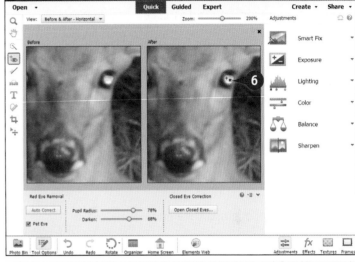

C Photoshop Elements repairs the color.

D If you need to try again with different settings, you can click **Undo** on the taskbar to undo the color change.



TIP

I took a photo and the person's eyes are shut. How do I fix this?

The Eye tool includes a feature for correcting closed eyes. (It works in human faces only.) After clicking the **Eye** tool, click the **Open Closed Eyes** button in the Tool Options panel under Closed Eye Correction. You also can click **Enhance** and then **Open Closed Eyes** in either Quick or Expert mode. The Open Closed Eyes dialog box opens. Click a thumbnail under **Try Sample Eyes**. Or, select another eye source to apply by clicking a choice under **Open From**, opening an image of a face with open eyes, and then clicking the image under **Click to Apply**. Click **OK** to finish.



Remove a Color Cast

You can use the Balance tool to fix a *color cast* — an unwanted tint in a photo. A color cast can happen due to the wrong camera settings — for example, when the camera is set to take photos in daylight but you are shooting indoors. A color reflection from a nearby object or fluorescent lighting or overcast outdoor conditions also can cause a color cast.

The Balance tool applies two color shifts — blue to red (**Temperature**) and green to pink (**Tint**). For example, use a red-to-blue shift to correct for indoor/outdoor colors and the green-to-pink shift to fix skin tones.

Remove a Color Cast

1 In the Editor, click **Quick**.

Note: For more on opening the Editor, see Chapter 1.

Note: If the image file has multiple layers, select a layer in the Layers panel and hide other layers before changing to Quick mode.

The Adjustments panel opens.

A Make sure that **Before & After - Horizontal** is selected.

2 Click **Balance**.

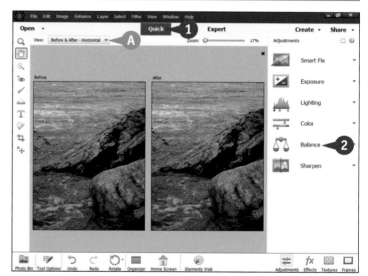

The Balance tool opens.

3 Click **Temperature**.

4 Drag the slider to correct the blue/red balance.

Note: This example looks blue, so it needs more red.

Note: If skin tones look pale after this step, you can correct them in the next step.

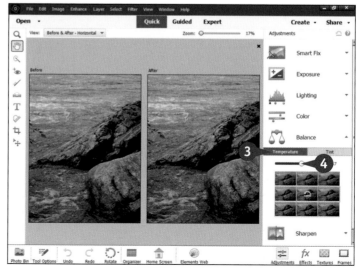

5 Click **Tint**.

6 Use the slider to correct the green/pink balance.

Note: Shifting toward green in this example brought out more of the tones and detail.

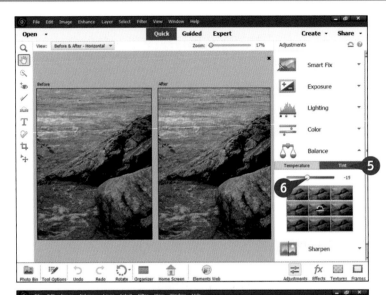

Photoshop Elements applies the correction.

B As you can tell by the preset thumbnails, the **Temperature** and **Tint** settings can make extreme changes. Using the sliders to make small changes first can help you achieve a more natural result.

Note: Guided mode also has a **Remove a Color Cast** tool in the **Color** category, although it makes only subtle changes.

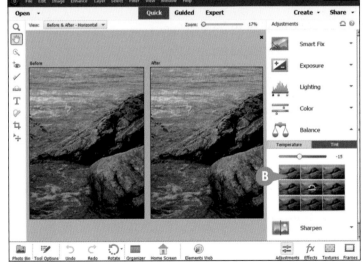

TIPS

Why do the colors still look wrong after using this tool?

Because of the colors it adjusts, the Balance tool has limits. Color balance choice depends on the look you want to achieve. The original lighting also might limit the tool's effectiveness, making the correction look wrong.

Can I use this tool creatively?

Yes. You can often improve a portrait by applying a slightly warm red cast and perhaps adding a further hint of pink. Skies often look cooler with extra blue. You also can use this tool to create strikingly unnatural but atmospheric color distortions.

Restore an Old Photo

You can use the Restore Old Photo steps in Guided mode to fix common problems in scans of old photos — creases, tears, fading, dust specks, smears, and color shifts.

This touchup includes a selection of tools that can help you fix these problems. Note that you do not always have to use all the tools or apply guided edits in order. For example, you may want to use the Dust Remover before Spot Healing, because it gets rid of many small flaws automatically.

Restore an Old Photo

1 In the Editor, click **Guided**.

Note: For more on opening the Editor, see Chapter 1.

Note: If the image file has multiple layers, select a layer in the Layers panel and hide other layers before changing to Guided mode.

Guided mode opens.

2 Click **Special Edits**.

3 Scroll down, and click **Restore Old Photo**.

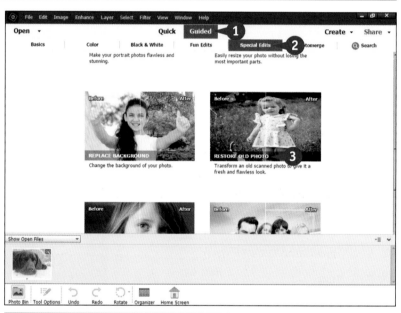

A The Restore Old Photo panel appears.

4 Scroll down, and click **Dust Remover**.

B The Dust & Scratches dialog box opens.

5 Drag the **Radius** slider right until you remove dust without losing detail.

Note: On smaller scans, the correct setting is 1 or 2 pixels.

6 Click **OK**.

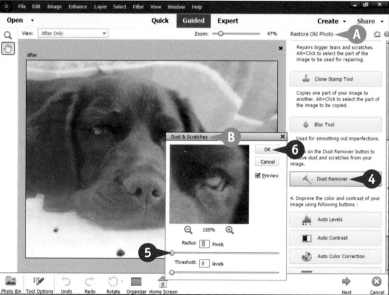

7 Scroll up, and select the **Spot Healing Tool**.

8 Drag or click the image to remove small blemishes and discolorations.

Note: You also can use the **Healing Brush Tool** and the **Clone Stamp Tool** to repair larger tears.

Note: Be careful not to make the photo too perfect. It may lose its character.

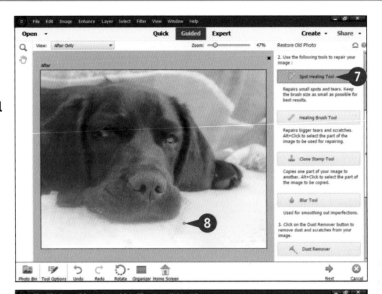

9 Scroll down, and click one or more color correction buttons under step 4.

The choices include **Auto Levels**, **Auto Contrast**, **Auto Color Correction**, and **Convert to B&W**. Use only the buttons needed for the current photo.

10 Scroll down, and click **Sharpen**.

11 Click **Next**.

12 Click **Done** and then switch to Expert mode.

Photoshop Elements creates a retouched old photo, storing the changes on a new layer in the image file.

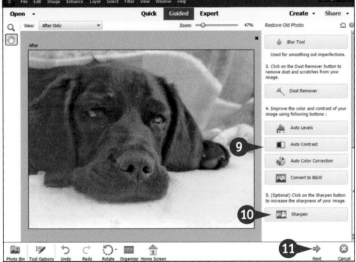

TIPS

How can I fix a color photo?

Click the **Auto Color Correction** button. It guesses the best color balance. Old photos often lose blue and then green, and if the photo is very yellow, Auto Color may not work. If all else fails, click **Convert to B&W** to remove all color.

When should I crop?

You can crop an image before you start a guided edit. However, you may get better results if you crop during the guided edit steps (if available) before you click **Done**. Other steps may reveal details and features you want to keep.

Improve a Portrait

You can use the Perfect Portrait panel to improve portraits of all kinds: head-and-shoulders shots, face-only views, and full-body shots. The panel includes tools for smoothing the skin, reducing blemishes, enhancing facial features, and making a subject look slightly slimmer.

Professional digital artists use similar techniques to create the flawless portraits seen on magazine covers. You can use them to enhance your photos of friends and family.

Improve a Portrait

1 In the Editor, click **Guided**.

Note: For more on opening the Editor, see Chapter 1.

Note: If the image file has multiple layers, select a layer in the Layers panel and hide other layers before changing to Guided mode.

 Guided mode opens.

2 Click **Special Edits**.

3 Scroll down, and click **Perfect Portrait**.

A The Perfect Portrait panel opens and identifies the subject.

B You can use the Zoom tool (🔍) to magnify areas as you work.

4 Click **Smooth Skin**.

Note: It takes a few seconds to apply the correction.

5 Click **Increase Contrast**.

Note: You can click **Increase Contrast** multiple times if desired.

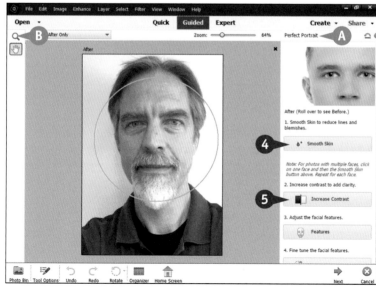

Photoshop Elements increases contrast in the entire photo.

6 Scroll down, and click **Remove Blemishes**.

7 Click or drag on the areas you want to fix.

Note: If you see blue lines in the image after using **Smooth Skin**, drag over them to touch up those areas.

Use a similar process to apply the **Whiten Teeth**, **Brighten Eyes**, and **Darken Eyebrows** facial changes.

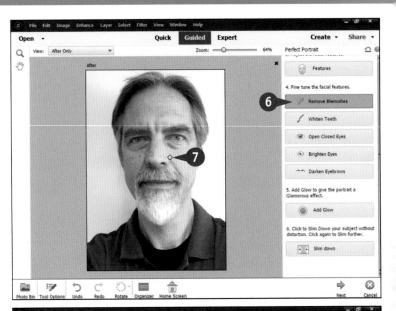

C You can click the **Add Glow** button to open a dialog box that enables you to choose a glow type and glow settings. Click **OK** to apply the glow.

8 Click **Slim Down**.

Note: You can click **Slim Down** multiple times if desired.

Photoshop Elements slims the subject.

D You can click **Undo** to undo the changes one by one.

9 Click **Next**.

10 Click Done and then switch to Expert mode.

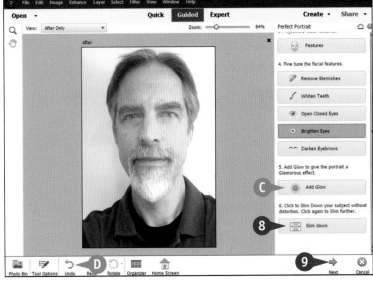

TIP

Where are the changes for a guided edit stored?
In most cases, a guided edit tool will add one or more new layers into the image, preserving the original content of the Background layer and/or the layer copy to which you applied the guided edits. You need to save the image in a format that supports layers to keep the guided edits.

Apply a Lomo Camera Effect

You can make your image look as if it was shot with a Lomo film camera. Lomo cameras are famous for creating warm, vivid images. You can learn more at www.lomography.com.

This guided edit's steps shift the color balance, increase saturation, and add the characteristic vignette (dark corners) to the image.

Apply a Lomo Camera Effect

1 In the Editor, click **Guided**.

Note: For more on opening the Editor, see Chapter 1.

Note: If the image file has multiple layers, select a layer in the Layers panel and hide other layers before changing to Guided mode.

Guided mode opens.

2 Click **Color**.

3 Click **Lomo Camera Effect**.

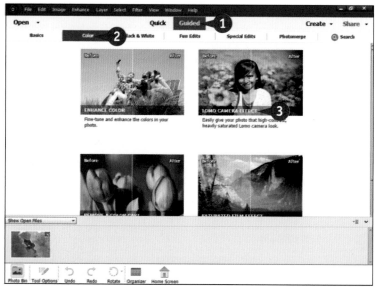

The Lomo Camera Effect panel opens.

4 Click **Lomo Camera Effect**.

Photoshop Elements makes the colors more intense and increases the contrast.

You can click the button multiple times to increase the effect.

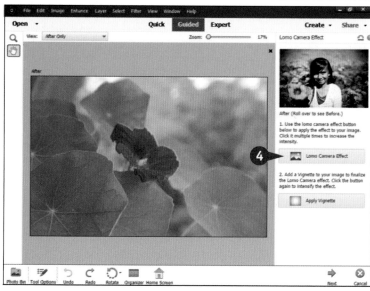

5 Click **Apply Vignette**.

You can click the button multiple times to increase the effect.

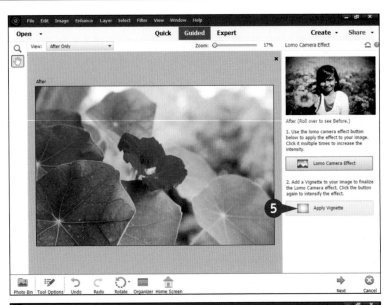

A Photoshop Elements darkens the corners of the image.

B You can click **Undo** to undo the changes.

6 Click **Next**.

7 Click **Done** and then switch to Expert mode.

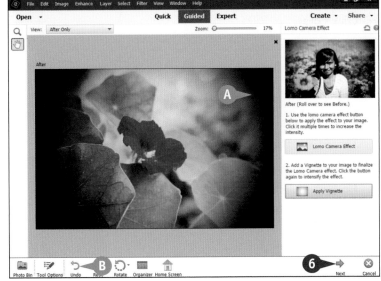

TIPS

What other color effect can I apply?
The **Saturated Film Effect** choice in Guided mode's **Color category** punches up image colors, making them look more like traditional film. You can click the button more than once to increase the intensity.

How do I just add a vignette to an image?
The **Vignette Effect** in Guided mode's **Basics** category enables you to add shadowing to the periphery of your image. You control the color (black or white), intensity, and shape of the vignette.

Add Motion with Zoom Burst

Y ou can use Zoom Burst to simulate motion, add drama, and make a photo look more dynamic. The effect re-creates the look you can produce by zooming in and leaving the shutter open on a professional camera. For good results, crop the image to put the main subject in the center.

After you add the zoom effect, you can add a focus area to remove unwanted blurring. You also can add a vignette (corner and edge shadows) to pull attention toward the subject.

Add Motion with Zoom Burst Effect

1 In the Editor, click **Guided**.

Note: For more on opening the Editor, see Chapter 1.

Note: If the image file has multiple layers, select a layer in the Layers panel and hide other layers before changing to Guided mode.

Guided mode opens.

2 Click **Fun Edits**.

3 Scroll down, and click **Zoom Burst Effect**.

The Zoom Burst Effect panel opens.

A Optionally, you can use the **Crop** tool to remove the edges of the image and place the subject in the center.

4 Click **Add Zoom Burst**.

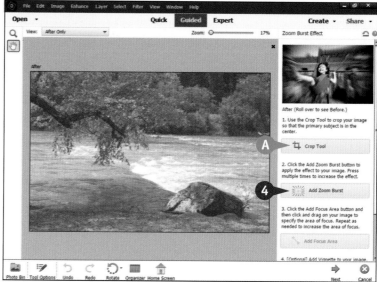

Photoshop Elements adds radial blur to the image. You can click the button multiple times to intensify the effect.

5 Scroll down, and click **Add Focus Area**.

6 Drag a line on the image to remove some of the blur. You can repeat this step to bring the main subject back into focus.

Photoshop Elements removes the blur from the area you specify.

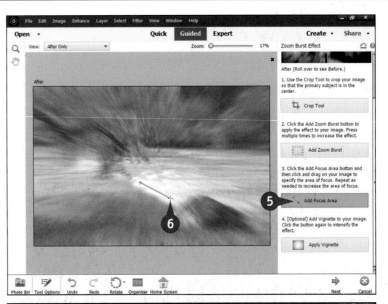

B Optionally, you can scroll down and click **Apply Vignette** to add shadowing to the edges of the image.

You can click the button multiple times to darken the shadowing.

Note: This strong effect may make a photo look dark, so use it sparingly.

Photoshop Elements applies the vignette.

7 Click **Next**.

8 Click **Done** and then switch to Expert mode.

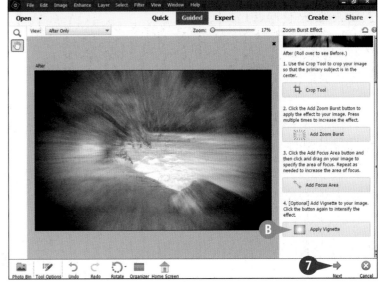

TIP

How else can I add the appearance of motion to my image?
Different blur filters are available that make objects in your image look like they are moving. Click **Expert** to switch to Expert mode. Click **Filter** and then **Blur** to display the Blur submenu. Click **Radial Blur** to apply the effects seen in the Zoom Burst feature, or click **Motion Blur** to add blurring along a straight line.

Create a Perfect Pet Pic

Pet lovers often take numerous photos of their companions, but sometimes less-than-ideal conditions take away some of the adorableness. You can use the Perfect Pet panel in Guided mode to bring your pet's best paw forward.

Perfect Pet offers some expected corrections, such as cropping and removing spots, but it also enables you to select and draw attention to the photo subject and even change the background to black and white.

Edit a Pet Picture

1 In the Editor, click **Guided**.

Note: For more on opening the Editor, see Chapter 1.

Note: If the image file has multiple layers, select a layer in the Layers panel and hide other layers before changing to Guided mode.

Guided mode opens.

2 Click **Special Edits**.

3 Scroll down, and click **Perfect Pet**.

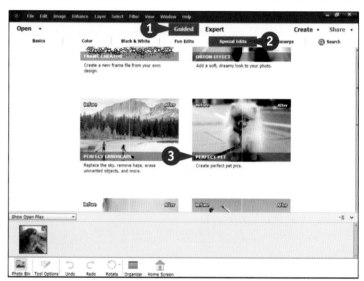

The Perfect Pet panel opens.

A Optionally, you can use the **Crop** tool to remove the edges of the image and the **Straighten** tool to level the image.

4 Click **Remove Dirt and Spots**.

Note: You can change the brush size if needed by pressing [and].

5 Drag on the image to remove blemishes.

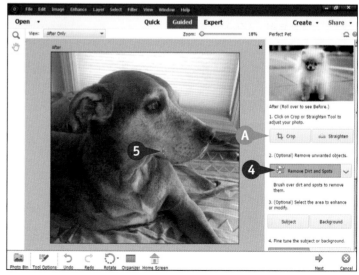

6 Scroll down, and click **Subject**.

B Photoshop Elements selects the image subject.

7 Drag the sliders under **Lighting** to make adjustments.

Photoshop Elements adjusts the **Shadow**, **Highlight**, and **Midtone** lighting as specified.

8 Click **Background**.

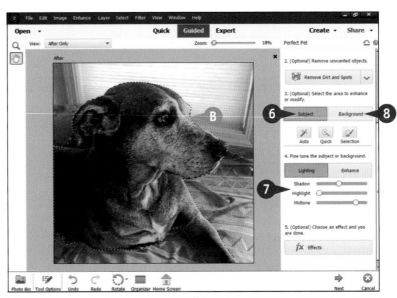

Photoshop Elements selects the image background.

9 Scroll down, and click **Effects**.

10 Click an effect thumbnail.

Photoshop Elements applies the effect to the selected background area.

11 Click **Next**.

12 Click **Done** and then switch to Expert mode.

Note: If the selection still appears in Expert mode, press Ctrl + D (⌘ + D on a Mac) to deselect it.

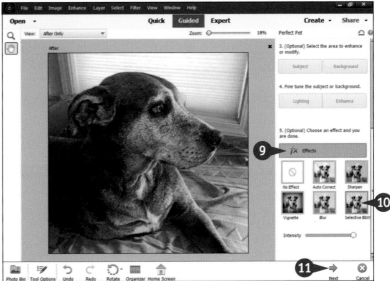

TIP

How can I remove the collar and leash or fix pet red eye (or green-eye)?
While the Perfect Pet panel is open, click the drop-down list arrow beside the **Remove Dirt and Spots** button. You can then click **Remove Collar & Leash** or **Fix Pet Eye** and follow the instructions that appear to apply the change.

Create Soft Focus with the Orton Effect

You can use the Orton Effect panel to add a misty soft focus look to an image. The effect works well on portraits and nature scenes.

To create the effect manually, you make a copy of your image, blur it, and make it partially transparent so sharp details from the original image show through. This Guided mode edit in Photoshop Elements creates the effect with a single click. From there, you can customize the amount of blur, add noise to simulate film grain, and adjust the brightness.

Create Soft Focus with the Orton Effect

1 In the Editor, click **Guided**.

Note: For more on opening the Editor, see Chapter 1.

Note: If the image file has multiple layers, select a layer in the Layers panel and hide other layers before changing to Guided mode.

Guided mode opens.

2 Click **Special Edits**.

3 Scroll down, and click **Orton Effect**.

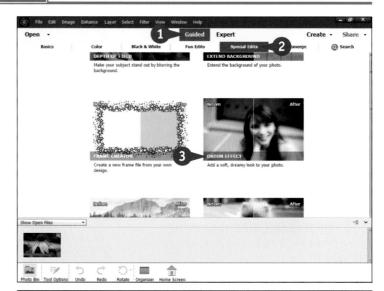

The Create Orton Effect panel opens.

4 Click **Add Orton Effect**.

Photoshop Elements blurs the image but lets some of the original sharpness show through.

Note: This one-click version of the effect often produces good results.

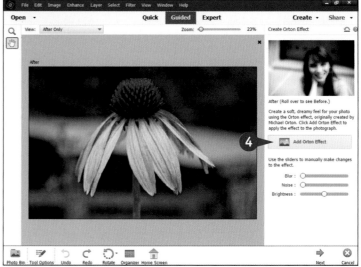

5 Drag the **Blur** slider to modify the blur radius.

Note: The extreme positions of the slider create two very different looks. Both can be equally successful.

Photoshop Elements modifies the blur.

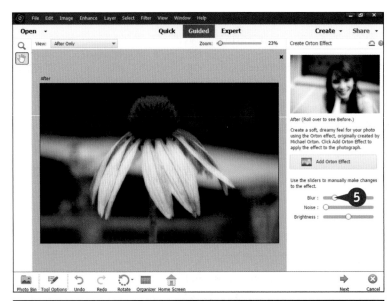

6 Drag the Brightness slider to make the blurred layer brighter.

A You can add grainy noise with the **Noise** slider. Use noise as an occasional refinement, not as an essential part of the effect.

7 Click **Next**.

8 Click **Done** and then switch to Expert mode.

Photoshop creates a bright soft focus look using multiple layers added to the image.

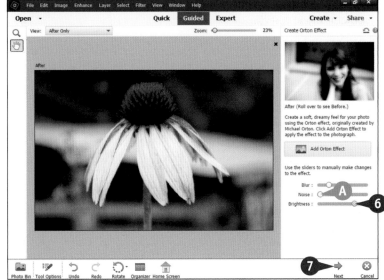

TIP

Why is this guided edit called the Orton Effect?
The effect was originally created by photographer Michael Orton in the 1980s. His version combined two shots of the same scene — one shot normally or a bit overexposed, one deliberately overexposed and blurred. He then combined the two shots optically to create a dreamy "painted" look. You can find out more at www.michaelortonphotography.com.

Apply a Reflection

In Guided mode, you can complete steps to create a realistic reflection of the content in an image. The result makes it appear that the content looms over water or a shiny surface.

To produce the effect, Photoshop Elements duplicates the content, rotates it, and places it below the original image. Then you add color fill, blur, and a gradient to make the reflection more convincing.

Apply a Reflection

1 In the Editor, click **Guided**.

Note: For more on opening the Editor, see Chapter 1.

Note: If the image file has multiple layers, select a layer in the Layers panel and hide other layers before changing to Guided mode.

Guided mode opens.

2 Click **Fun Edits**.

3 Scroll down, and click **Reflection**.

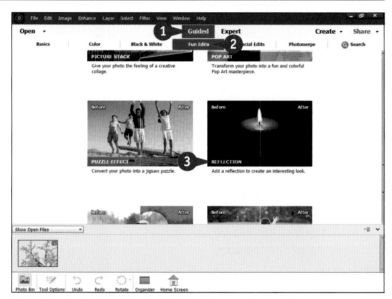

The Create Reflections panel opens.

4 Click **Add Reflection**.

A Photoshop Elements copies and flips the photo to create a reflection effect.

5 Click the **Eyedropper tool**.

6 Click the image to select a background color. A neutral or light gray is often a good choice.

7 Click **Fill Background** to fill the reflection with the selected color.

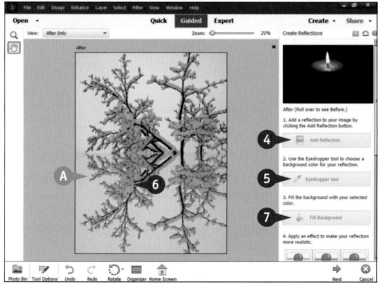

8 Optionally scroll down, and click an effect button.

The **Floor** button adds blur, the **Glass** button distorts the image, and the Water button adds ripples and blur.

9 In the dialog box that appears, change effect settings and click **OK**.

Repeat step **9** if a second dialog box appears.

Note: This example shows the Water effect with a large **Amount** setting for ripple.

B You can use the **Intensity** slider to adjust the effect.

C You can click **Add Distortion** to simulate perspective by vertically shrinking the reflection.

D If you add distortion, you can use the **Crop** tool to remove the colored background that appears.

10 Click **Gradient Tool**.

11 Drag from the bottom of the reflection up to fade the reflection.

12 Click **Next**.

13 Click **Done** and then switch to Expert mode.

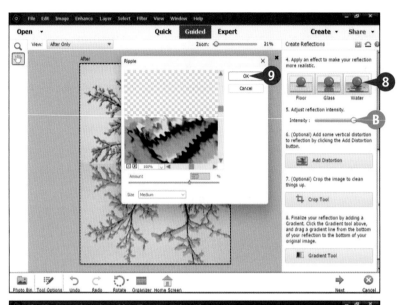

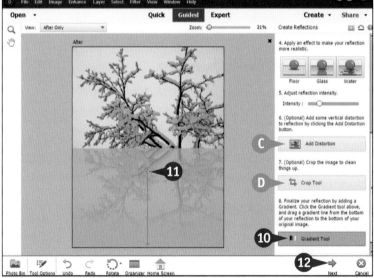

TIP

How else can I create a ripple effect?
Create a plain mirror reflection using the Create Reflections panel. (Click **Add Reflection**, then **Next**, then **Done**.) Switch to Expert mode. Use the Rectangular Marquee tool (🔲) to select the reflected area. Click **Filter** and then **Distort**. Use the submenu choices to experiment with various other effects. **Ocean Ripple**, **Wave**, **Glass**, and **ZigZag** can all add more intensity.

Make a Meme

If you've spent time on social media, chances are you've seen a *meme*. Memes often consist of a photo or collage with text that makes a humorous point.

The Meme Maker guided edit enables you to turn one of your own digital photos into a meme. Apply a simple meme template and then fill in your own text. From there, you can adjust the photo, change the border, or apply an effect.

Create a Fun Meme Image

1 In the Editor, click **Guided**.

Note: For more on opening the Editor, see Chapter 1.

Note: If the image file has multiple layers, select a layer in the Layers panel and hide other layers before changing to Guided mode.

Guided mode opens.

2 Click **Fun Edits**.

3 Scroll down, and click **Meme Maker**.

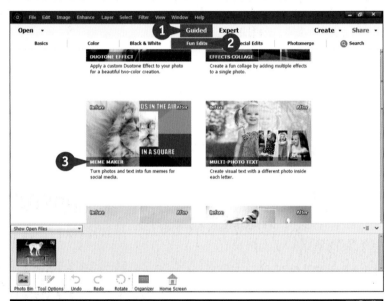

The Meme Maker panel opens.

4 Click **Create Meme Template**.

A Photoshop Elements adds the template with two text placeholders.

5 Double-click the top placeholder.

6 Type text, and then click the ✔ button.

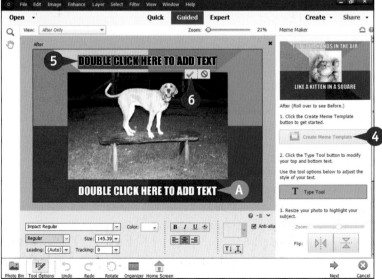

Photoshop Elements selects the bottom placeholder.

⑦ Type text, and then click the ✔ button.

Ⓑ You can use the **Zoom Slider** or **Flip** choices to resize the image.

⑧ Click the left border thumbnail.

⑨ Click a border.

⑩ Click **OK**.

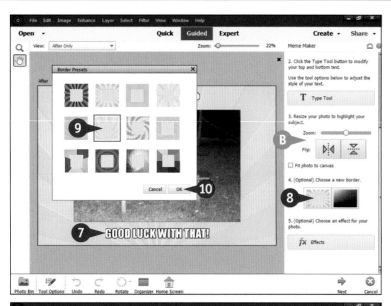

Photoshop Elements applies the new border.

Note: Clicking the right border thumbnail opens the Color Picker dialog box (see Chapter 9) for creating a solid color border.

⑪ Scroll down, and click **Effects**.

⑫ Click an effect thumbnail.

Photoshop Elements applies the effect to the image.

⑬ Click **Next**.

⑭ Click **Done** and then switch to Expert mode.

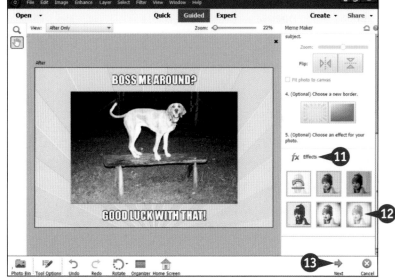

Any other tips for creating a meme?
The Meme Maker guided edit provides the option of changing text settings in the Tool Options panel when you are adding text to a placeholder; be sure to use large, readable text. Most memes use text in all capital letters, as well. And sometimes photos with awkward moments make the best memes because the image itself is humorous — but get permission to share the meme from your subject so you don't cause embarrassment or hurt feelings.

Create a Vintage Look

You can use the new Old Fashioned Photo guided edit to give a photo a vintage look. The edit converts the photo to black and white, changes the brightness and contrast, and applies an overall tint. You also can add some subtle noise to bring out textures.

The edit does not fade the photo or add tears, spots, stains, and other blemishes. You can add these effects by hand later in Expert mode. However, it does create a "good enough" vintage look for casual applications.

Create a Vintage Look

1 In the Editor, click **Guided**.

Note: For more on opening the Editor, see Chapter 1.

Note: If the image file has multiple layers, select a layer in the Layers panel and hide other layers before changing to Guided mode.

Guided mode opens.

2 Click **Fun Edits**.

3 Scroll down, and click **Old Fashioned Photo**.

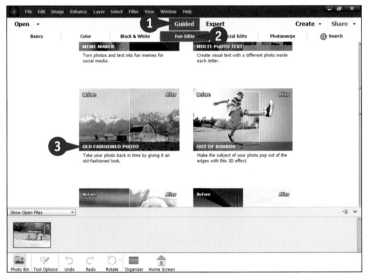

The Old Fashioned Photo panel opens.

4 Click one of the three Black and White presets to remove all color.

A You can click **Undo** on the taskbar after each preset to try a different one.

Photoshop Elements converts the image.

5 Click **Adjust Tone**.

Photoshop Elements makes a small change to the contrast, brightness, and lighting balance.

6 Click **Add Texture**.

Photoshop Elements adds a hint of noise to bring out image textures.

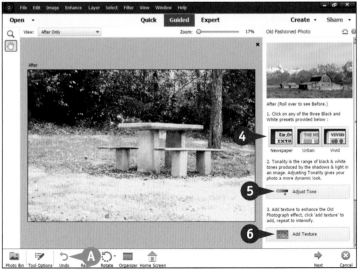

7 Scroll down, and click **Add Hue/Saturation**.

8 Drag the **Hue** slider to change the color.

Note: The default sepia color looks good on many images.

9 Drag the **Saturation** slider to change the color intensity.

Note: A subtle tint often looks more convincingly vintage than a more intense color.

B You can drag the **Lightness** slider to change the brightness of the image, but you do not usually need to.

10 Click **OK**.

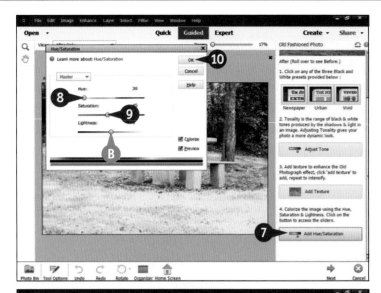

11 Click **Next**.

12 Click **Done**.

Photoshop Elements applies the effect.

B You can click **Undo** to undo all the changes and start again.

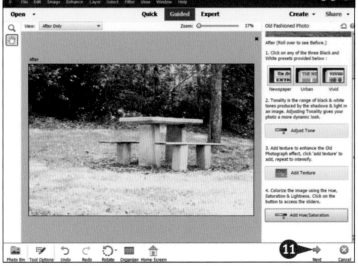

TIP

Why would I use a different color for a vintage photo?
The sepia effect, created with light orange and low saturation, is the definitive vintage look. But you can use other colors. Deep blue creates a colder and starker effect. Light blue creates a cooler, more abstract look. You can use any tint creatively. The effect often works best with just a hint of color. Professional photographers tint black and white images so subtly that you often cannot see any obvious color at all — but the tint still creates a mood.

Painting and Drawing on Photos

Photoshop Elements offers a comprehensive set of tools for painting and drawing on an image, adding shapes and text, and using single colors or gradients.

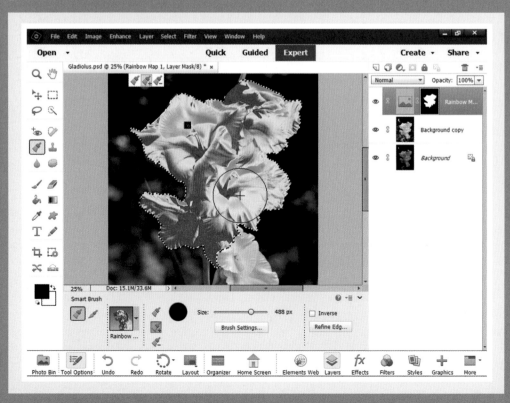

Retouch with the Clone Stamp Tool

You can clean up flaws or erase elements in your image with the Clone Stamp tool. The tool copies — *clones* — part of an image. You can then paste — *stamp* — the detail to a different area. Clone an area near the area to stamp over for the best result.

You can adjust the opacity of the tool to let some of the original detail show through. Cloning from multiple areas in an image works well when removing an unwanted object. Also try to clone areas with matching textures, and avoid breaking or distorting lines and edges.

Retouch with the Clone Stamp Tool

1 In the Editor, click **Expert**.

Note: For more on opening the Editor, see Chapter 1.

2 With the desired layer selected in the Layers panel, click the **Clone Stamp** tool (![clone stamp icon]).

Note: Pressing **S** toggles between the Clone Stamp and Pattern Stamp tools.

Note: If the Tool Options panel doesn't appear, click **Tool Options** on the taskbar.

A You can click the **Brush** drop-down list to choose a brush preset.

B You also can drag the **Size** slider to change the brush size.

You can change the brush size by pressing **[** or **]**.

C You can drag the **Opacity** slider to set the opacity (transparency) of the stamped copy.

A 100% opacity setting is opaque and completely covers the original content.

Note: Change brush settings as needed while you work.

3 Press and hold **Alt** (**Option** on a Mac), and then click the location to clone on the image.

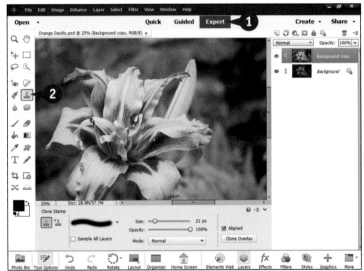

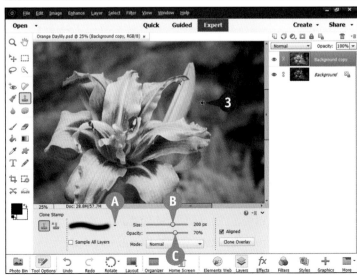

This example uses the Clone Stamp tool to remove the unopened lily blossom by cloning the background around it.

4 Click or drag the area that you want to correct or stamp over.

Photoshop Elements pastes the cloned area over the content where you click or drag and blends the content.

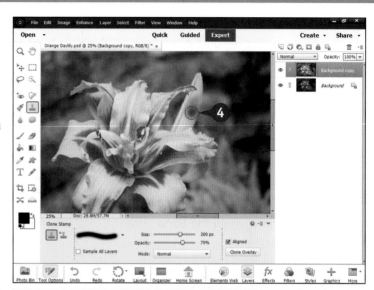

5 Continue changing brush settings as needed and **Alt**-clicking (**Option**-clicking on a Mac) new areas to clone, and then clicking or dragging as needed to achieve the desired effect.

Photoshop Elements replaces old content with cloned content.

Note: Long strokes can copy content from unwanted areas. Short strokes can create repeating textures. Try to avoid these obvious artifacts.

D You can click **Undo** on the taskbar to undo the tool's changes as needed.

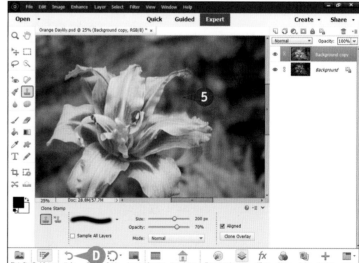

TIPS

How can I make the Clone Stamp tool's effects look seamless?
To erase elements from your image with the Clone Stamp tool without leaving a trace, try to:

• Clone areas of similar color and texture.

• Lower the brush **Opacity** for more subtlety.

• Use a soft-edged brush shape.

What can I do with the Pattern Stamp?
You can use the Pattern Stamp tool (▨), which appears in the Tool Options panel with the Clone Stamp tool (▨), to paint repeating patterns on your images. You can select a **Pattern**, **Brush**, and brush **Size** and then stamp the pattern on the image by clicking or dragging.

Remove a Spot

You can use the Spot Healing Brush tool to quickly repair flaws or remove small objects in a photo. The tool works well on small spots or blemishes on both solid and textured backgrounds. For good results, increase the brush size to cover the feature you want to remove.

The tool's **Proximity Match** choice analyzes pixels surrounding the selected area and replaces the area with a patch of similar pixels. The **Create Texture** setting replaces the area with a blend of surrounding pixels. The **Content Aware** setting, which is often the most useful, is similar to Proximity Match but recognizes and keeps patterns found in the surrounding pixels.

Remove a Spot

1 In the Editor, click **Expert**.

Note: For more on opening the Editor, see Chapter 1.

2 With the desired layer selected in the Layers panel, click the **Spot Healing Brush** tool ().

Note: Pressing J toggles between the Spot Healing Brush and Healing Brush tools.

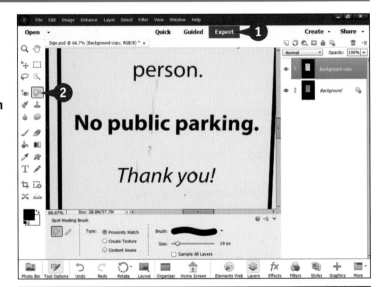

A You can click the **Brush** drop-down list to choose a brush preset.

B You can drag the **Size** slider to change the brush size.

Or change the brush size by pressing [or].

C You can click an option button to select the healing effect **Type**.

The **Content Aware** option often works well.

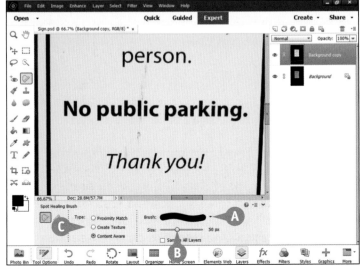

3 Begin dragging over the spot you want to correct.

The mouse pointer and "painted" area temporarily turn black when you drag.

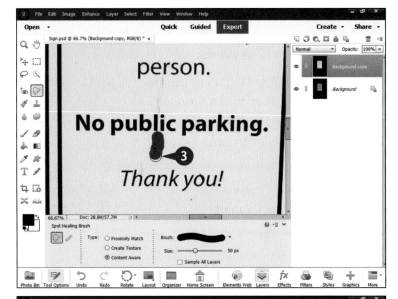

4 Release the mouse button.

D Photoshop Elements duplicates nearby pixels and replaces the area you painted on.

E You can click **Undo** on the taskbar to undo the change.

Note: Repeat the process to remove other spots in the image as needed.

TIP

What is the difference between the Spot Healing Brush and the Healing Brush?
The **Spot Healing Brush** tool (⬭) works on small areas. The **Healing Brush** tool (⬭) works like a version of the **Clone Stamp** tool (⬭). It works best when you sample content first. To use the Healing Brush tool, press and hold **Alt** (**Option** on a Mac) and click the area you want to use as a source or sample. Then drag over the problem area to blend the cloned pixels into the new area.

Set the Foreground and Background Colors

The painting and drawing tools in Photoshop Elements work with foreground and background colors. The Brush, Pencil, and Text tools apply the foreground color. The Eraser tool applies the background color in certain cases.

You can set the colors by using the color selection boxes at the bottom of the toolbox. You also can swap the colors, reset to black and white (the default), and access a selection of popular and/or useful colors called *swatches*.

Set the Foreground and Background Colors

1 In the Editor, click **Expert**.

Note: For more on opening the Editor, see Chapter 1.

2 Click the foreground color box.

The Color Picker dialog box opens.

3 Drag the slider to select a hue.

4 Click in the box to set the saturation and lightness for the hue.

Note: You can sample a color from the open image by clicking on the image in the active image area outside the dialog box.

5 Click **OK**.

A The color appears in the foreground color box.

You can now paint and draw with this color. Repeat steps **2** to **5** to select a different color.

6 Click the background color box.

7 Repeat steps **3** to **5** to set the color.

B The color appears in the background color box.

C You can reset the colors by clicking the default icon (⬛) or pressing D.

D You can swap the foreground and background colors by clicking the switch icon (↔) or pressing X.

TIPS

What do the numbers in the dialog box mean?
Colors are defined as a mix of red, green, and blue (RGB) values, or as hue, saturation, and brightness (HSB) values. RGB values are between 0 and 255. The numbers after the hash (#) are the RGB values in hexadecimal (base 16), as used by web designers. Hue is a value between 0 and 360 degrees that specifies the base color. Saturation defines the color intensity between 0% (no color) and 100%. Brightness sets the light/dark balance between 0% and 100%.

Where can I find preset colors?
Click **Window** and then click **Color Swatches**. To set the foreground color, click one of the swatches. To set the background color, Ctrl+click (⌘+click on a Mac).

Add Color with the Brush Tool

You can use the Photoshop Elements Brush tool to paint color onto an image. By default, the color has no texture, so it looks solid and flat. But you can change the size and softness of the brush or select **Airbrush Mode** to create more subtle changes.

To paint color onto the shading and texture in a photo, select the **Hue** or **Color** option in the **Mode** drop-down list in the Tool Options panel. These modes keep the light and dark detail in the image but paint new colors over it. Use the **Opacity** slider to set the color intensity.

Add Color with the Brush Tool

1 In the Editor, click **Expert**.

Note: For more on opening the Editor, see Chapter 1.

2 Click the foreground color box and set the foreground color.

Note: See the previous section for details.

3 With the desired layer selected in the Layers panel, click the **Brush** tool (🖌).

Note: Pressing **B** toggles between the Brush, Impressionist Brush, and Color Replacement tools.

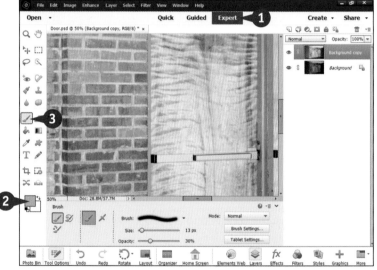

A You can click the **Brush** drop-down list to choose a brush preset.

B You can drag the **Size** slider to change the brush size.

Or change the brush size by pressing **[** or **]**.

C You can drag the **Opacity** slider to set the color intensity.

Note: The lower you set the opacity, the more transparent and less intense the color.

4 Drag on the image to paint the desired areas.

D Clicking this **Airbrush Mode** button changes to a spray effect.

E The mouse paints solid color onto the photo. Even with lowered opacity, the effect may not look realistic.

5 Click the **Mode** drop-down list.

6 Click **Color**.

7 Drag on the image to paint the desired areas.

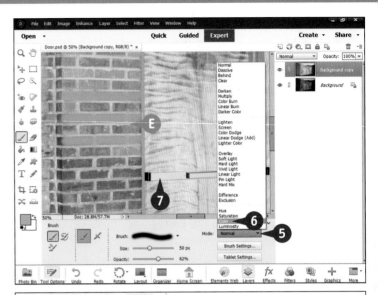

F In this mode, the black-and-white detail blends with the color.

Note: The color in this example is exaggerated for effect.

Note: You can select **Hue** from the **Mode** drop-down list and/or drag the opacity slider to the left to paint with more subtle color.

TIPS

How do I paint hard-edged lines?
Use the Pencil tool (). It works like the Brush tool (🖌) and applies the foreground color but paints lines with hard edges.

What can I do with the Impressionist Brush tool?
The Impressionist Brush (🖌) blends colors from the image to create thicker impressionistic stroke effects. It does not use the foreground or background colors. You can select the tool in the Tool Options panel after clicking the Brush tool (🖌). Click the **Advanced** button to display more options. You can create different effects by changing the **Mode**, too.

Change Brush Styles

You can make more interesting edits by selecting any of the numerous preset brush styles in Photoshop Elements. Choices include plain brushes with varying sizes and hard or soft edges, textured brushes, and special effect brushes that paint familiar shapes and objects.

You can customize any brush to set the spacing of each "stroke," the fade, the amount of color variation, the hardness, and the roundness.

Change Brush Styles

Select from a Predefined Set

1 In the Editor, click **Expert**.

Note: For more on opening the Editor, see Chapter 1.

2 Click the foreground color box, and set the foreground color.

3 With the desired layer selected in the Layers panel, click the **Brush** tool (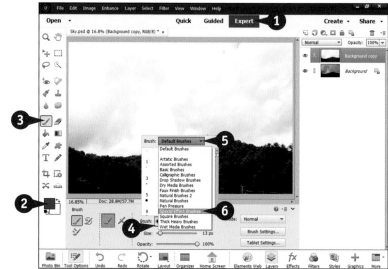).

Note: Pressing **B** toggles between the Brush, Impressionist Brush, and Color Replacement tools.

4 Click the **Brush** drop-down list in the Tool Options panel.

5 Click the **Brush** drop-down list within the main list.

6 Click a set of brushes.

Ⓐ The set's brushes appear.

7 Click a brush to select it.

The mouse pointer changes to the new brush shape.

Ⓑ You can drag the **Size** slider to adjust the brush size.

8 Click or drag the brush on the photo.

Photoshop Elements paints the area. The color tone applied may vary depending on the selected brush.

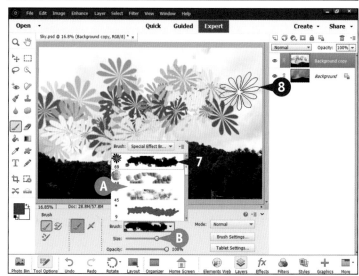

Customize a Brush

1 Click **Brush Settings** in the Tool Options panel.

The Brush Settings dialog box opens.

Ⓐ You can limit the length of your brushstrokes with the **Fade** slider.

Ⓑ You can randomize the painted color with the **Hue Jitter** slider.

Ⓒ You can change the shape of the brush tip by dragging controls here.

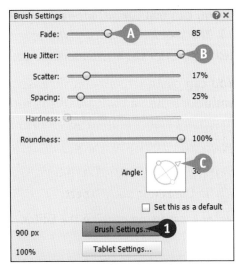

2 Click or drag the brush on the image.

Photoshop Elements paints the area with the customized brush.

Note: For more on applying the brush, see the previous section, "Add Color with the Brush Tool."

Note: You also can add a blank, transparent layer and paint on it with the Brush tool, to avoid changing another layer's content. See Chapter 4 for more about layers.

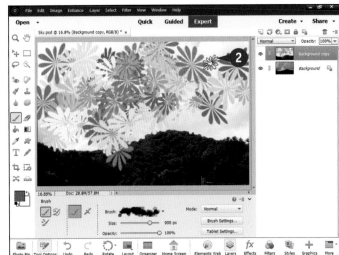

TIP

How can I make a brush apply dots instead of a continuous line?

In the Tool Options panel, click **Brush Settings** to open the Brush Settings dialog box. Drag the **Spacing** slider to increase the value to greater than 100%. When you then drag the brush shape, you get dots (**Ⓐ**), patches, or individual shapes instead of a line or curve.

Use a Brush to Replace a Color

You can use the Color Replacement tool to paint the foreground color over an existing color. The tool keeps black-and-white detail but replaces colors. You can use this to replace one color with another. If you are skillful, you can repeat the process to repaint an area with a selection of different colors.

Unlike the Brush tool, the Color Replacement tool includes a **Tolerance** setting, which paints matching colors around your brush strokes. Set a low tolerance to match colors precisely, and set a high tolerance to select a wider area. You also can change the brush size.

Using a Brush to Replace a Color

1 In the Editor, click **Expert**.

Note: For more on opening the Editor, see Chapter 1.

2 With the desired layer selected in the Layers panel, click the **Brush** tool ().

Note: The selected layer must hold the content to replace. This process does not work on a blank, transparent layer.

3 In the Tool Options panel, click the **Color Replacement** tool ().

Note: Pressing **B** toggles between the Brush, Impressionist Brush, and Color Replacement tools.

4 Click the foreground color box, and select the replacement color to use.

5 Drag the **Size** slider to adjust the brush size.

Note: Feel free to select a large brush to save yourself some work.

6 Drag the **Tolerance** slider to a setting from 1% to 100%.

Note: Experiment with the tolerance. Specify a low value that modifies the color to change but does not spill into surrounding colors.

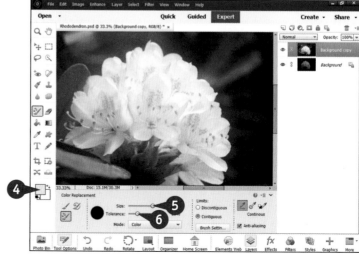

7 Click or drag in the image.

Note: Move the plus sign at the center of the mouse pointer over the exact color to replace before clicking or while dragging.

Photoshop Elements replaces the color.

A If you have set the tolerance correctly, the color does not spill into surrounding areas even if you paint over it.

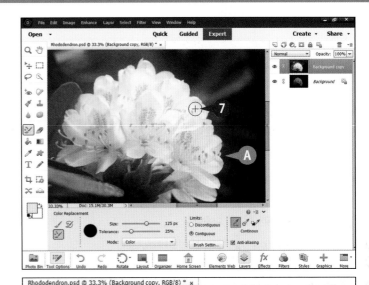

8 Continue painting to replace the color in all the needed areas or objects.

Photoshop Elements replaces more color.

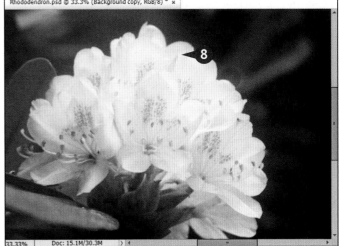

TIP

How do I fill a selection with a color?
Make a selection with a selection tool, and then click **Edit** and **Fill Selection**. In the Fill Layer dialog box that appears, click the **Use** drop-down list, and then click **Foreground Color** (Ⓐ). Double-click the **Opacity** text box and type a new value (Ⓑ). You can optionally change the **Mode** as well. Click **OK** to fill the selection. This technique does not create a new fill layer as the dialog box name implies. Instead, it recolors the pixels within the selection on the active layer. To avoid that, create a new layer first and make sure it's selected in the Layers panel. Then follow the previous process to fill the pixels on the new layer. See Chapter 4 for more about layers.

Adjust Colors with the Smart Brush

You can paint color adjustments onto areas with a similar color and texture using the Smart Brush tool in Photoshop Elements. You can employ this versatile tool to increase, decrease, remove, or transform color in a selected area. You also can darken overexposed areas, brighten areas that are in shadow, or apply patterns and effects.

The tool includes presets grouped into categories. For example, use the effects in the **Portrait** category to change skin tone, whiten teeth, or change lip color. Options in the **Special Effects** category create striking colorized effects.

Adjust Colors with the Smart Brush

1 In the Editor, click **Expert**.

Note: For more on opening the Editor, see Chapter 1.

2 With the desired layer selected in the Layers panel, click the **Smart Brush** tool (🖌️).

Note: Pressing F toggles between the Smart Brush and Detail Smart Brush tools.

3 Click the current effect.

4 Click the **Presets** drop-down list.

5 Click a category.

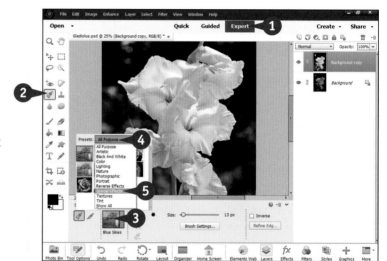

A Thumbnails for the effects in the selected category (Special Effects in this case) appear.

6 Double-click an effect thumbnail.

Note: This example applies rainbow map colors.

Note: You can click anywhere outside the list to close it or simply continue to step **7**.

7 Drag the **Size** slider to adjust the brush size.

Note: Make the brush small enough to paint within the area to edit.

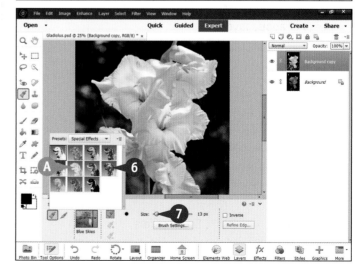

8 Click or drag on objects and areas in the image.

Photoshop Elements selects the area or object and applies the painting effect.

Ⓑ You can click **Inverse** (☐ changes to ☑) to invert the selection and apply the effect to the other pixels in the layer.

Ⓒ Click the **Detail Smart Brush** tool (🖌) in the Tool Options panel or press F and specify a smaller brush size when you need to paint the effect on a specific area.

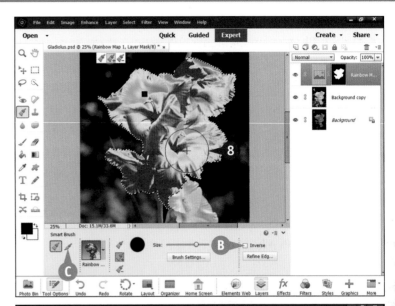

9 Repeat step **8** as needed.

Ⓓ You can click the **Subtract from Selection** button (🖌) as needed to remove areas from the selection.

Ⓔ You can click the **Add to selection** button (🖌) as needed to resume adding areas to the selection.

Ⓕ A new adjustment layer stores the Smart Brush effects. See Chapter 4 for details about layers.

10 Click another tool or layer to deselect the selection and finish using the Smart Brush tool.

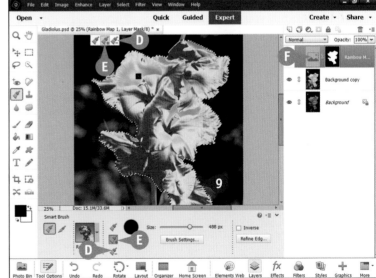

TIP

How can I apply different effects to the same image layer?
After you apply a Smart Brush effect, press Ctrl+D (⌘+D on a Mac) or click **Select** and then **Deselect**. Photoshop Elements deselects the current selection. You can then reselect the Smart Brush tool (🖌) in the Tool Options panel if needed, choose a different effect, and paint a new selection.

Draw a Simple Shape

You can use the various shape tools to draw shapes on your image. The tool includes rectangles, rounded rectangles, ellipses, polygons, stars, straight lines, and custom shapes.

You can fill a shape with a solid color. You also can apply styles — preset graphic effects that apply colors and textures to the shape. Photoshop Elements creates each shape as a vector object on a new layer, so you can easily resize it or try out different fill colors and styles.

Draw a Simple Shape

1 In the Editor, click **Expert**.

Note: For more on opening the Editor, see Chapter 1.

2 With the desired layer selected in the Layers panel, click the **Custom Shape** tool (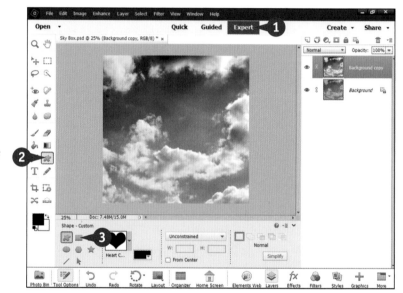).

Note: The tool often defaults to the Rectangle tool. But you can select one of seven tools — Custom Shape, Rectangle, Rounded Rectangle, Ellipse, Polygon, Star, and Line.

3 Click the **Rectangle** tool (▦). **Note:** Pressing Ⓤ toggles between the various shape tools.

4 Click this drop-down list, and then click an aspect ratio.

Note: Click **Square** to force the tool to draw a square instead of a rectangle.

Note: The options vary depending on the selected shape.

5 Drag to draw the shape.

Photoshop Elements adds the shape to the image.

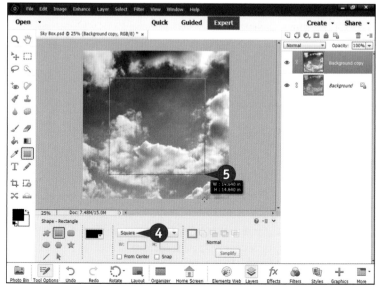

Ⓐ The shape appears on its own layer, so you can edit it and delete it without changing the content on other layers. See Chapter 4 for more about layers.

Ⓑ You can click the **Color** menu to display the available Color Swatches.

Ⓒ You can double-click one of the colors to apply it to the shape.

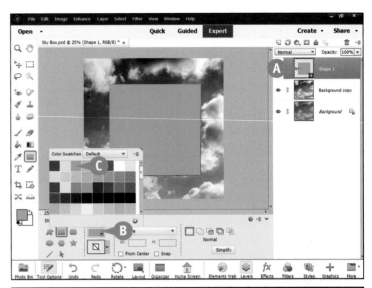

Ⓓ You can click the style box to view a collection of style presets.

Ⓔ You can click the **Styles** drop-down list and then click a different style category.

Ⓕ You can double-click one of the styles to apply it to the shape.

Photoshop Elements applies the style to the shape.

Note: Most styles override the fill color.

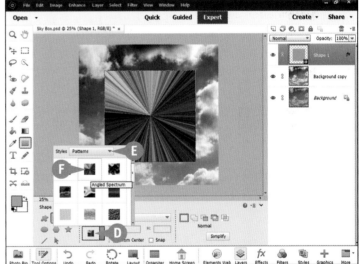



TIPS

How do I apply a simple stroke to the shape?
You can apply plain black strokes to the current shape layer by clicking **Styles** near the right end of the taskbar, clicking the drop-down list at the top of the panel, and then clicking **Strokes**. Click a preset stroke to apply it to the current shape layer. To customize the stroke settings, click 🔲 and click the right triangle next to **Stroke** to see the available settings.

What options do other shapes have?
Both stars and polygons have a setting for the number of **Sides**. Your entry in that text box specifies the number of sides for a Polygon but the number of points for a star. Stars also have an Indent setting, which sets how "pointy" the star is. For a custom shape, you can choose a Shapes category and then the specific shape to draw.



Add an Arrow

You can use the Custom Shape tool in Photoshop Elements to draw complex shapes, including arrows and other graphics. The Custom Shape tool includes a large selection of ready-made shapes you can draw on an image.

This example explains how to draw an arrow. You can find various arrow shapes under the **Arrows** submenu.

Add an Arrow

Draw the Arrow

1 In the Editor, click **Expert**.

Note: For more on opening the Editor, see Chapter 1.

2 With the desired layer selected in the Layers panel, click the current Shape tool.

Any of the shape tools may be visible.

3 Click the **Custom Shape** tool (⬚).

Note: Pressing U toggles between the various shape tools.

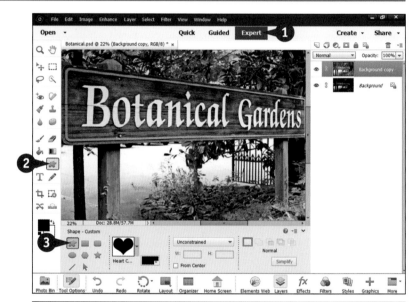

4 Click the current shape.

5 Double-click an arrow shape to select it.

A For a wider selection of arrows, first click the **Shapes** drop-down list and click **Arrows**.

B You can use the **Color** menu to select an eye-catching color.

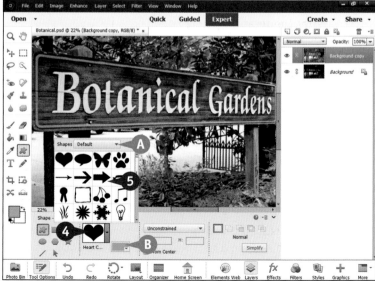

6 Drag diagonally to draw the arrow.

The arrow is horizontal. Dragging diagonally specifies its width (length) and height (thickness).

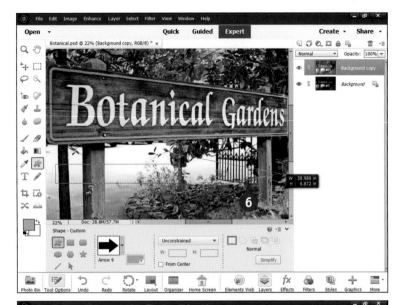

Rotate or Move the Arrow

1 With the arrow layer selected in the Layers panel, click the Move tool ().

A You can move the mouse pointer inside the selection box and then drag to move the arrow.

B You can move the mouse pointer close to a corner handle and then drag after the rotation pointer appears to rotate the arrow.

2 Click ✓ to confirm the edit.

Photoshop Elements moves and/or rotates the arrow.

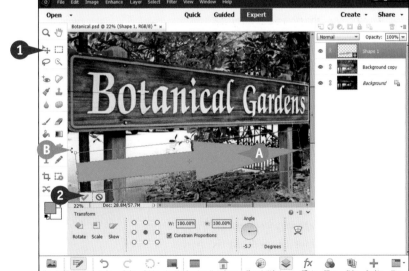

TIP

Can I draw arrows with the line tool?

Yes. The line tool includes a smaller selection of arrow shapes than the custom shape menu, but you can use the tool to draw an arrow diagonally without having to rotate it. Click the currently selected shape tool, and then click the **Line** tool in the Tool Options panel. Click the **Arrow Head** drop-down list, and click **No Arrow Head**, **At the Start**, **At the End**, or **At Both Ends**. Drag to draw the line. Photoshop Elements applies fill colors and styles in the usual way.

Apply the Eraser

You can use the Eraser tool to remove unwanted objects and areas. The regular Eraser tool paints with the background color when erasing on the Background layer. On other layers, it erases pixels and makes the erased area on the layer transparent. You can select from three modes: **Pencil** for a hard edge, **Brush** for a softer effect, or **Block** for jaggedness.

The Background Eraser makes erased pixels transparent on any layer. The Magic Eraser deletes pixels of similar color around the spot you click.

Apply the Eraser

Use the Eraser

1 In the Editor, click **Expert**.

Note: For more on opening the Editor, see Chapter 1.

2 With the desired layer selected in the Layers panel, click the **Eraser** tool (![eraser icon]).

Note: Pressing **E** toggles between the Eraser, Background Eraser, and Magic Eraser tools.

Ⓐ If the standard Eraser is not selected, you can click its icon in the Tool Options panel.

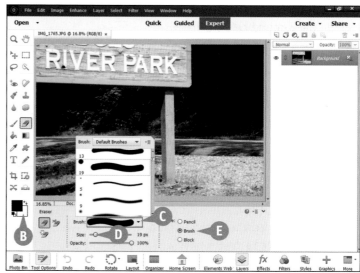

Ⓑ You can click the background color box to select the color for the Eraser to use on the Background layer.

Note: For more, see the section "Set the Foreground and Background Colors."

Ⓒ You can click the **Brush** drop-down list to select an eraser preset.

Ⓓ You also can drag the **Size** slider to set an eraser size.

Or change the eraser size by pressing **[** or **]**.

Ⓔ You can click one of the **Type** options to refine the brush shape and hardness.

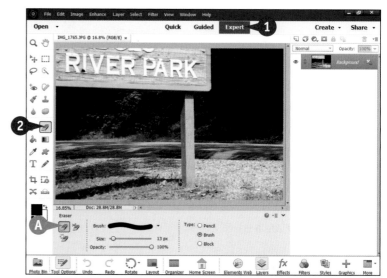

③ Drag on the image with the mouse.

Photoshop Elements replaces areas of the Background layer with the background color. On other layers, the Eraser makes the pixels transparent, letting the content of one or more layers below show through.

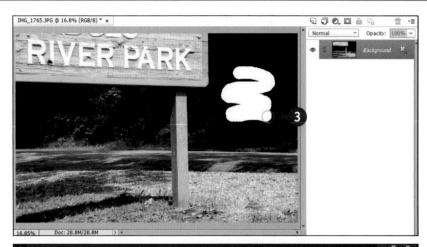

Use the Magic Eraser and Background Eraser

① With the desired layer selected in the Layers panel, click the Magic Eraser (🧽).

② Drag the **Tolerance** slider to set how aggressively the Magic Eraser erases areas of similar color.

③ Click or drag the area to erase.

On any layer with locked transparency, Photoshop Elements replaces the specified area with the background color. Otherwise, it makes the pixels transparent.

Ⓐ You also can click the Background Eraser (🧽) to make areas on the Background layer transparent.

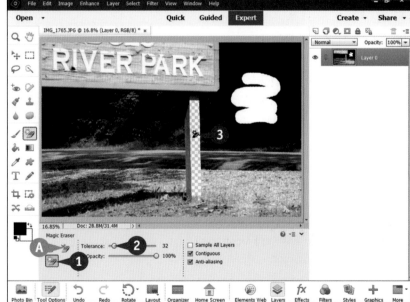

TIP

Why does the standard Eraser sometimes make pixels transparent?
The Eraser tool paints the background color when used on the Background layer. But images can include other independent layers. Using the Eraser on a regular layer makes pixels transparent. When used on the Background layer, the Background and Magic Eraser tools convert the background into a regular layer (*Layer 0*) and then delete pixels. If you use the standard Eraser on Layer 0 after using these tools, it makes pixels transparent, too. For more about layers, see Chapter 4.

Apply a Gradient

You can apply a gradient, which is a smooth blend of colors, to a selected portion of an image or the entire image. The Gradient tool offers predefined color combinations, or you can create your own blends.

You also can set the shape of the gradient to control the shape of its color bands. For example, a linear gradient has parallel color bands. A radial gradient has circular bands.

Apply a Gradient

1 In the Editor, click **Expert**.

2 With the desired layer selected in the Layers panel, make a selection.

Note: For more on opening the Editor, see Chapter 1. See Chapter 5 for more on making selections.

　　If you do not make a selection, the gradient fills the whole layer.

3 Click the **Gradient** tool (▣).

Note: Pressing G also selects the Gradient tool.

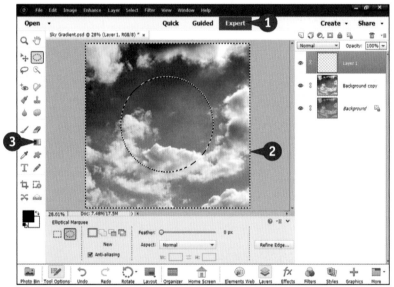

Ⓐ You can select the gradient shape by clicking one of these buttons.

4 Click the gradient drop-down arrow.

Ⓑ You can click the **Gradient** drop-down list to select another gradient category.

5 Double-click a gradient preset to select it.

6 Click **Edit** to customize the gradient.

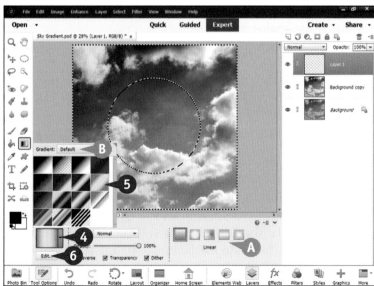

The gradient is defined by arrows called *stops*.

C To change the color of a stop, double-click its color box to open the standard Color Picker.

D To change the banding, drag stops left or right.

E To add a stop, click a **Color Midpoint** diamond.

Note: The diamonds appear on the last stop you clicked.

F To remove a stop, click it and click the Trash icon (🗑).

7 Click **OK** to apply the changes.

8 Drag inside the selection with the mouse.

The angle and distance you drag define the angle and width of the gradient.

Photoshop Elements paints a gradient inside the selection.

Note: You also can set a gradient's **Opacity** before adding it. If you apply the gradient to a new layer, you also can add a layer mask (see "Add a Layer Mask") to vary the opacity of the layer.

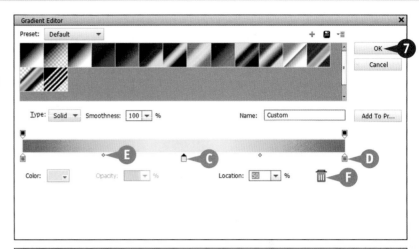

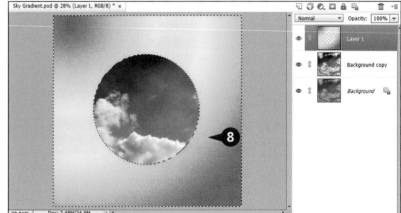

TIP

What do the different gradient shapes do?
The default gradient is **Linear** and paints parallel bands of color. The **Radial** gradient paints concentric circles of color. You can use it to create halo effects. The **Angle** gradient sweeps colors out from a single point, like a radar scan. It creates a 3D effect. The **Reflected** gradient creates a mirrored version of the Linear gradient. To create a good mirror effect, drag the mouse across half the target width or height. The **Diamond** gradient creates concentric squares.

Add Content from the Graphics Panel

You can use the Graphics panel to add backgrounds, frames, graphics, and other content to an image. You can move, resize, and transform the content and add more than one element.

The panel includes hundreds of clip art items grouped into categories. Many of the items need to be downloaded the first time you use them, so your computer must be connected to the Internet before you can add them.

Add Content from the Graphics Panel

Add a Transparent Frame

1 In the Editor, click **Expert**.

Note: For more on opening the Editor, see Chapter 1.

2 With the desired layer selected in the Layers panel, click **Graphics**.

Ⓐ The Graphics panel opens.

3 Click the drop-down list, and then click **By Type** if it is not already selected.

4 Click the drop-down list, and then click **Graphics**.

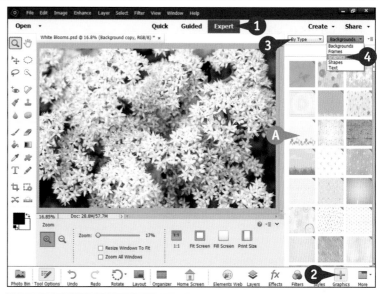

Photoshop Elements displays a selection of clip art.

5 Scroll down to the find the **Golden Overlay** item.

6 Drag it onto the active image area.

7 Drag any corner.

B The **Transform** tool options appear.

Note: You can access the Transform tool options only by dragging an object onto the image and resizing it. The Transform tool does not appear in the toolbox.

8 Click the **Constrain Proportions** box to uncheck it (☑ changes to ☐).

9 Drag corners of the frame object as needed until the frame covers the edges of the photo.

10 Click ✔.

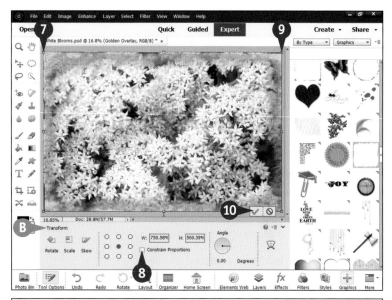

C You can add further graphics to the image by repeating steps **5** to **8**.

You can move a graphic object you are adding by moving the mouse pointer within its selection box and then dragging.

You can use the Move tool (⊹) to move a graphic you've added on its layer.

Photoshop Elements combines the graphics with your original photo.

TIP

How can I place a photo over a background?
When you add a background or other graphic from the Graphics panel, Photoshop Elements places it onto a separate layer. To make your photo float over the background, you need to duplicate the Background layer, move it above the graphic background layer in the Layers panel, and then make it a bit smaller so the background shows. See the "Reorder Layers" section in Chapter 4 for more about changing the layer order.

Add Text

You can add text to label an image, add a caption, or use letters and words in more creative ways. To add text, use the Type tool. You can add horizontal or vertical text or make the text follow a selection.

You can edit text to move it or resize without losing sharpness. Text appears in its own layer, so you can add an adjustment layer or change the layer opacity or blending. For more about layers, see Chapter 4.

Add Text

1 In the Editor, click **Expert**.

Note: For more on opening the Editor, see Chapter 1.

2 With the desired layer selected in the Layers panel, click the **Horizontal Type** tool ().

Note: Pressing toggles between the various type tools.

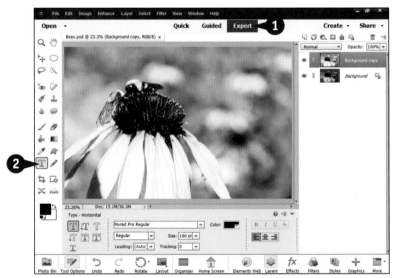

3 Click the font drop-down list arrow.

4 Click a font to select it.

You can see a preview of each font next to the font name.

5 Double-click the **Size** text box, type a value, and press Enter (Return on a Mac).

Large sizes create a readable caption on larger images.

A You can click the Color box and then click a swatch to specify the font color.

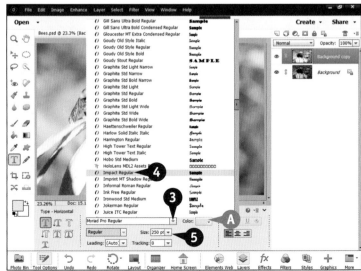

6 Click the image to position the text.

Photoshop Elements displays a text insertion point to show the position and size of the text.

You also can drag diagonally to define a bounding box to contain the text.

7 Type the desired text.

To create a new line, press Enter.

8 When you finish typing your text, click ✔ or press Ctrl + Enter (⌘ + Return on a Mac).

You can click ⊘ or press Esc to cancel.

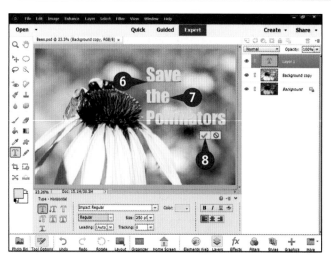

Photoshop Elements adds text to the image on a new layer.

The text appears inside a selection box. To dismiss the selection box, click any tool except the Move tool (🔧).

Can text have special styles?
With the text layer selected, click **Styles** on the taskbar. Choose a category from the drop-down list at the top of the Styles panel, and then click a style. You can apply some filters to a text layer; click **OK** when prompted to simplify the layer.

Where can I get other fonts?
Try a web search for "free fonts" to find thousands, or even tens of thousands, of free fonts. Professional designers use expensive, high-quality commercial fonts from sources such as Adobe (fonts.adobe.com). Fonts are distributed as downloadable files. To install them in Windows 10 or 11, open the Settings app, click **Personalization**, and then scroll down and click **Fonts** or copy them to \Windows\Fonts. On a Mac, use the Font Book app or copy them to ~System/Library/Fonts. Not all fonts are compatible. After you install fonts, you must restart Photoshop Elements before you can use them.

Modify Text

You can change the font, style, size, and other characteristics of text on a text layer, as long as it hasn't been simplified (rasterized). This can help emphasize or de-emphasize your text.

Photoshop Elements has access to all the fonts installed in your computer's operating system. Installing Photoshop Elements adds fonts, too. Available styles for some fonts include italic, bold, and more. The default size measurement is the point (pt), which is 1/72 of an inch. You can enter other units of measurement in the size field in the Tool Options panel, such as 5 cm, and Photoshop Elements converts the value to points.

Modify Text

Move and Rotate Text

1 In the Editor, click **Expert**.

2 With the text layer selected in the Layers panel, click the **Move** tool (⊹).

Note: Pressing **V** selects the Move tool.

Note: If the text layer isn't selected in the Layers panel, you can try to click the text you want to move, but that may not always work.

Ⓐ A selection box appears around the text.

3 Move the mouse pointer inside the selection box, and then drag to move the text.

4 Move the mouse pointer just outside a corner, and then when the two-headed pointer appears, drag to rotate the text.

Note: You can use the side, top, and bottom selection handles to change the selection box width and/or height. This also resizes the text.

5 Click ✔ to confirm the edit.

You also can click ⊘ to cancel the edit.

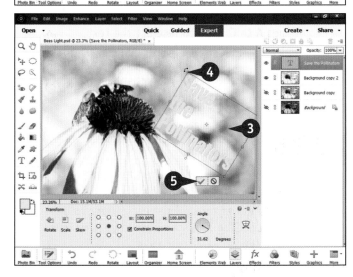

Change the Text

1 With the text layer selected in the Layers panel, click the **Horizontal Type** tool (\boxed{T}).

Note: Pressing \boxed{T} toggles between the various type tools.

2 Drag over the text to change.

Note: You can select some or all of the text.

Photoshop Elements selects (highlights) the text.

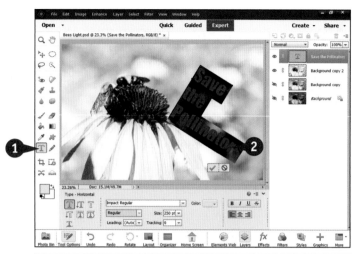

A You can click the font drop-down list to select another font.

Note: Fonts have different letter widths, so if you select another font, the text may no longer fit into the selection box.

B You can click the **Color** box and click another color for the font.

C You can double-click the **Size** text box and type a new font size.

D You can type new text to replace the old text.

Note: Retyping text removes the highlighting. To apply changes A to C, drag to reselect the text.

E Click ✔ to confirm the edit or ⊘ to cancel the edit.

Photoshop Elements applies the changes to the text.

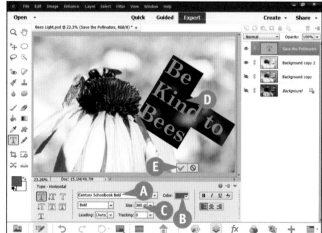

TIPS

What are leading and tracking?
Leading is the spacing between lines of text. *Tracking* is the horizontal space between letters on a line of text. The Horizontal Type tool's options includes the **Leading** and **Tracking** drop-down lists for changing these in selected text.

Can I use variations such as bold and italic?
Photoshop Elements supports bold, italic, underline, and strikethrough text. You also can set left-aligned, center-aligned, and right-aligned text. You can find the standard buttons for these, as used in most word processing apps, at the right side of the Horizontal Type tool's options.

Create Warped Text

You can easily bend and distort text on a layer with the Warp Text feature in Photoshop Elements. This tool helps stylize text to match the theme of the image. For example, text in a sky can be distorted to appear windblown.

Warp **Style** options include **Arc** and **Arch**, which curve text in one direction across the image, and **Flag** and **Wave**, which create rippling text. You can warp the text horizontally or vertically to create different effects.

Create Warped Text

1 In the Editor, click **Expert**.

Note: For more on opening the Editor, see Chapter 1.

2 With the text layer selected in the Layers panel, click the **Horizontal Type** tool (T).

Note: Pressing T toggles between the various type tools.

Note: You do not need to drag over the text if you select the text layer.

3 Click **Layers** on the taskbar if you need to hide the Layers panel.

Note: The Layers panel may hide some settings, depending on screen resolution.

4 Click the **Warp Text** button (T).

Note: If you do not see the Warp Text button, try changing to Quick mode, closing the Adjustments panel, and clicking the Horizontal Type tool.

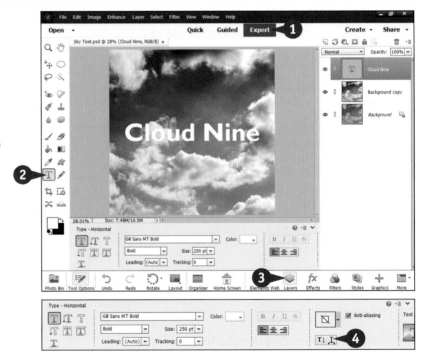

The Warp Text dialog box opens.

5 Click the **Style** drop-down list.

6 Click a style to select it.

Note: The drop-down list preview icons show each of the 15 styles.

Photoshop Elements applies the warp style to the text.

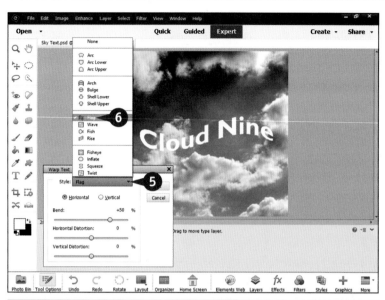

A You can click an option button to select **Horizontal** or **Vertical** warping.

B You can drag the **Bend** slider to adjust the warp amount.

C You can add further warping with the **Horizontal Distortion** and **Vertical Distortion** sliders.

D Photoshop Elements previews the warp effect.

7 Click **OK**.

Photoshop Elements warps the text.

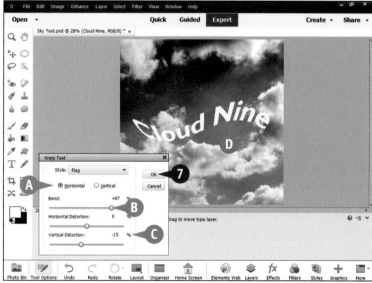

TIPS

How do I unwarp text?
In the Warp Text dialog box, click the **Style** menu and click **None**.

When would I use warped text?
You can use this artistic effect to emphasize the meaning of the text within an image. For example, you could use the vertical arc effect to show words coming out of a bull horn. For more ideas, experiment with the presets, explore the settings, and imagine possible applications for each effect.

Draw Text Around a Shape

Instead of drawing text on a straight line, you can draw it around any of the standard shapes included in Photoshop Elements, including rectangles, rounded rectangles, ellipses, polygons, and more.

The simplest shapes work best. Text on a circle usually looks good. Text around a custom shape can be hard to read, although you can sometimes create a good result with text in a small font size.

Draw Text Around a Shape

1 In the Editor, click **Expert**.

Note: For more on opening the Editor, see Chapter 1.

2 With the desired layer selected in the Layers panel, click the **Horizontal Type** tool (T).

Note: Avoid selecting another shape layer.

3 Click the **Text on Shape Tool** (T).

Note: Pressing T toggles between the various type tools.

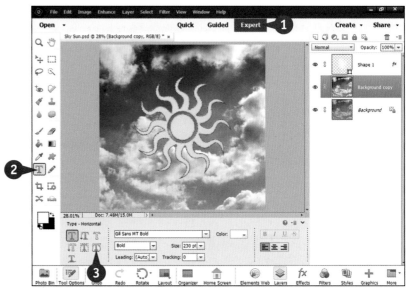

4 Click a shape to select it.

5 Drag on the photo to draw the shape.

For details, see the "Draw a Simple Shape" section in this chapter.

This example shows a circle.

Note: You cannot move or resize the shape after drawing it. You can only Ctrl + Z (⌘ + Z on a Mac), reselect the correct layer, and start again.

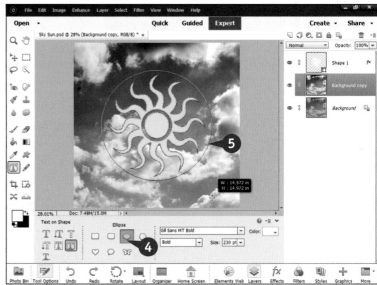

Ⓐ You can set the font, size, color, and style of the text using these options.

6 Click the shape outline.

The I-beam insertion point appears on the shape.

7 Type the text.

Photoshop Elements bends the text around the shape.

8 Click ✔ when you are finished.

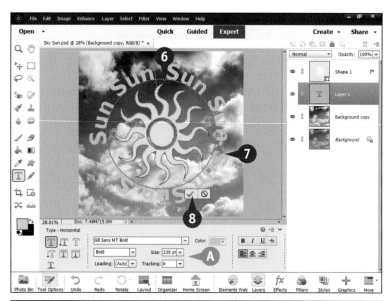

Photoshop Elements first selects the Move tool (✥).

Ⓑ You can drag the selection box to move the text.

Ⓒ You can hover the mouse pointer near a corner of the selection, and when the two-headed mouse pointer appears, drag to rotate the text. The Transform choices appear.

9 Click ✔ to apply the changes.

Photoshop Elements adds the text to the image.

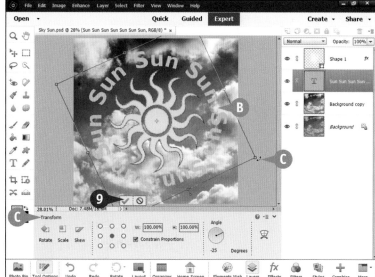

TIP

Are there other ways to wrap text around a shape?
You can use the Text on Custom Path tool (🖫) to draw a freehand line on an image and run text along it. The line — known as a *path* — can be any shape. You can even loop the path over itself. Although this tool is flexible, it can be hard to use, because it is not easy to draw a clean line with the mouse. Simple paths, including simple shapes, often create a more successful result.

Add a Layer Mask

When you change a layer's opacity setting, it affects the entire layer. You can use a *layer mask* to vary opacity across the layer. White areas in the mask have 100 percent opacity. Black areas have 0 percent opacity. Gray areas have in-between values controlled by the darkness/lightness of the gray.

You can use a layer mask to isolate an object on a layer, letting content from layers below show around the object. You can edit a layer mask as needed, so you can keep fine-tuning the mask until you get the object's edges just right. You also can use masks to create adjustments that vary over the image.

Add a Layer Mask

1 In the Editor, click **Expert**.

2 Click **Layers** on the taskbar to open the Layers panel if it is not already open.

Note: For details about opening the Editor or panels, see Chapter 1.

3 Click the layer to mask in the Layers panel.

4 Click the **Add Layer Mask** icon (■).

Note: Alternatively, you can click **Layer**, click **Layer Mask**, and then click either **Reveal All** or **Hide All**. This creates an all-white or all-black layer mask, respectively.

A Photoshop Elements adds a layer mask thumbnail to the layer.

The new mask is white, so the entire layer remains visible.

Note: If you add a mask to the Background layer, it is converted to a regular layer named *Layer 0* and is no longer locked.

Note: The mask is selected automatically.

You can now use any of the selection, drawing, painting, fill, and text tools to change the mask.

This example uses the Magic Wand tool to mask out the green foliage.

5 Press **A** as needed to toggle to the **Magic Wand** tool (◣).

Note: In this example, the **Contiguous** check box is turned off to make selecting easier.

6 Click the areas to select as needed.

See the "Select an Area with the Magic Wand" section in Chapter 5 for details.

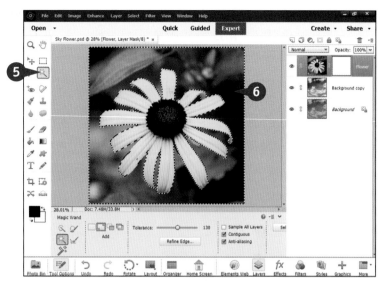

7 Set the foreground color to black if needed.

See the earlier section "Set the Foreground and Background Colors."

8 Click the **Paint Bucket** tool (◣).

9 Click the area you selected in step **6**.

Ⓑ Photoshop Elements fills the selected area in the mask with black.

Ⓒ The masked area disappears, allowing content from a lower layer to show.

Note: You can delete the mask to redisplay all of the layer, or you can edit the mask to control how much of the layer appears.

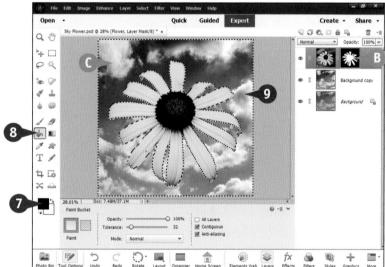

TIPS

How do I edit a masked layer?
Click the layer thumbnail to the left of the mask in the Layers list. You can then edit the layer in the usual way. To go back to editing the mask, click the mask thumbnail.

Can I apply a mask as a permanent edit?
Yes. Right-click (Control + click on a Mac) the layer mask icon in the Layers panel, and select Apply Layer Mask from the menu that appears. Photoshop Elements "bakes" the mask opacity into the layer and deletes the mask.

Edit a Layer Mask

After creating a layer mask, you can edit it. You can invert the mask to swap the visible and hidden areas, blur it to soften the mask edges, or paint on it in either black or white to hide or reveal more of the original content.

For more advanced effects, you can apply gradient fills to create a smooth fade over the mask, add type to create text cut out effects, or use the mask to vary the intensity of an effect over the image.

Edit a Layer Mask

Invert the Mask

1 In the Editor, click **Expert**.

2 Add a layer mask to a layer in the image.

Note: See the previous section, "Add a Layer Mask," for details.

3 Click the layer mask thumbnail for the mask you want to edit.

4 Click **Select**.

5 Click **All** to make sure the entire mask is selected.

Note: You also can press Ctrl + A (⌘ + A on a Mac).

6 Click **Filter**.

7 Click **Adjustments**.

8 Click **Invert**.

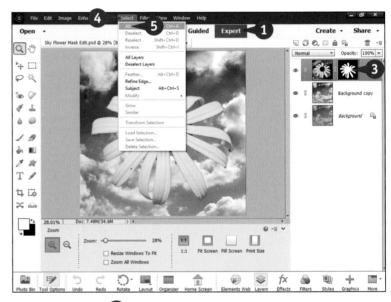

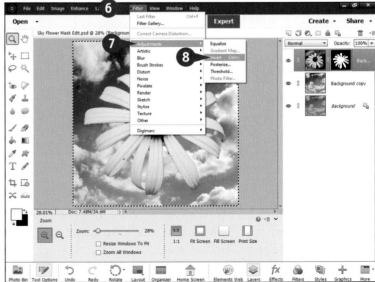

Ⓐ Photoshop Elements inverts the mask, swapping white and black areas.

Ⓑ In this example, inverting the mask hides the object and reveals the layer below.

Paint on the Mask

1 With the layer mask thumbnail selected in the Layers panel, click the **Brush Tool** ().

2 Change the foreground color to white if needed. (It should change to white automatically any time you click a layer mask thumbnail.) "White to reveal, black to conceal."

See the earlier section "Set the Foreground and Background Colors."

3 Paint with the brush to show more of the layer.

Note: You can use a variety of tools to edit the mask.

Note: This is an exaggerated example. In a typical project, you would use a small brush to hide or reveal detail around the edges of an object.

TIP

What happens if I create a selection on a mask?
Often, you click **Select** and then **All** to select the entire canvas when editing a mask. But if you select an area on the mask, any changes you make stay within the selection. You can use this option to create precise rectangular or elliptical areas or to limit mask edits using any of the brushes or selection tools. If you edit the mask and nothing happens, you probably forgot to click **Select** and then **All**.

Applying Filters and Styles

You can use the filters and styles in Photoshop Elements to quickly and easily apply enhancements to an image, including artistic effects, texture effects, and distortions. Filters can help you correct defects in an image or even turn a photograph into something resembling an impressionist painting. This chapter highlights a few of the dozens of filters available in Photoshop Elements and previews styles.

Equalize an Image

You can use the Equalize filter to attempt a quick fix of exposure and lighting. The Equalize filter finds the brightest and darkest pixels in an image. Then it makes bright areas as light as possible and makes dark areas as dark as possible. This often improves photos with poor exposure or contrast.

The Equalize filter has no settings. The results depend on the quality and composition of the original image. Like all filters, you can apply it to an entire layer or to a selected area. For more about layers, see Chapter 4, and for more about selections, see Chapter 5.

Equalize an Image

1 In the Editor, click **Expert**.

Note: For more on opening the Editor, see Chapter 1.

2 With the desired layer selected in the Layers panel, click **Filter**.

3 Click **Adjustments**.

4 Click **Equalize**.

Photoshop Elements equalizes the selected layer or area.

Note: For a similar effect you can control, use the Levels tool. See Chapter 7 for details.

Note: You cannot apply an adjustment filter to a text layer unless you first click **Layer** and then click **Simplify Layer**. Doing so means you can no longer edit the text, however.

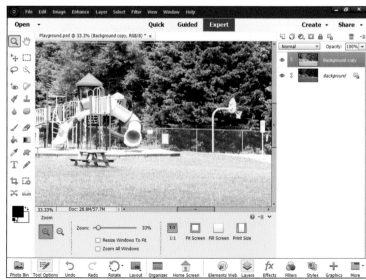

Create a Negative

You can use the Invert filter to create a negative image. Use this filter to convert scanned film negatives into recognizable photos or as a creative effect. Negative images often look spooky or otherworldly, so you might want to use this effect to help you make Halloween posters.

The Invert filter has no settings. When you select this filter, it converts dark areas into light areas. It also inverts the colors so blues become orange, for example. Like all filters, you can apply it to an entire layer or to a selected area. For more about layers, see Chapter 4, and for more about selections, see Chapter 5.

Create a Negative

1 In the Editor, click **Expert**.

Note: For more on opening the Editor, see Chapter 1.

2 With the desired layer selected in the Layers panel, click **Filter**.

3 Click **Adjustments**.

4 Click **Invert**.

Note: You can also press Ctrl+I (⌘+I on a Mac).

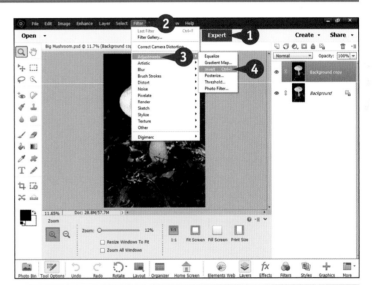

Photoshop Elements converts the layer or selected area into a negative.

Note: You cannot apply an adjustment filter to a text layer unless you first click **Layer** and then click **Simplify Layer**. Doing so means you can no longer edit the text, however.

Blur an Image

You can use the Blur filters to apply a variety of blurring effects to your photos. For example, you can use the Gaussian Blur filter to obscure background objects while keeping foreground objects in focus. The Motion Blur filter can create a blur in a single direction.

To blur a background, select the foreground object using one or more selection tools, invert the selection, and apply the filter. This leaves the object sharp but blurs the surrounding area. For more details about using selections creatively, see Chapters 5 and 6.

Blur an Image

1 In the Editor, click **Expert**.

Note: For more on opening the Editor, see Chapter 1.

2 With the desired layer selected in the Layers panel, optionally select an area to blur. In this example, an elliptical marquee () has been drawn around the bloom.

Note: For a smoother effect, drag the **Feather** slider to soften the selection. For more about feathering, see Chapter 6.

3 To blur the background instead of the selected object, click **Select**.

4 Click **Inverse**.

5 Click **Filter**.

6 Click **Blur**.

7 Click **Gaussian Blur**.

Note: If you try to apply most filters or styles to a text layer, you will be prompted to either rasterize or simplify the layer. Click **Rasterize** or **OK** when prompted.

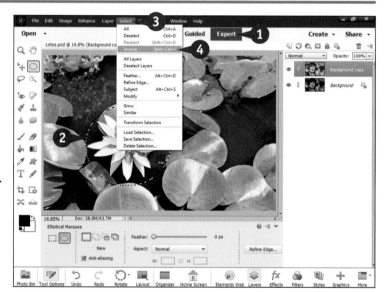

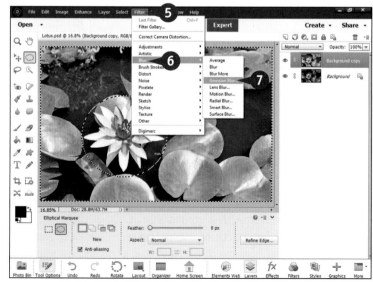

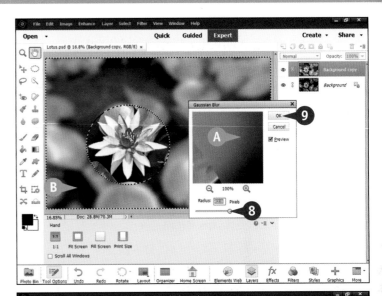

A The Gaussian Blur dialog box opens, displaying a preview of the filter's effect.

Note: Drag the box to one side if it covers the active image area.

Note: You can click the zoom out button (🔍) or zoom in button (🔍) to zoom the dialog box preview. You need to do this only if you cannot see the preview in the active image area.

8 Drag the **Radius** slider to adjust the blur.

B You can preview the blur in the active image area.

Note: The best blur effects keep some detail in the blurred area. If you set the **Radius** value too high, the blurred area turns into nondescript fog.

9 Click **OK**.

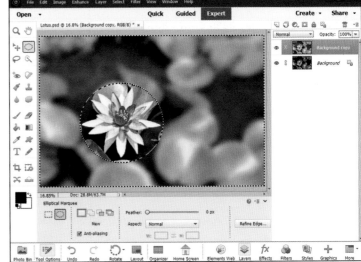

Photoshop Elements applies the blur filter.

Note: Click **Select** and then **Deselect** to deselect the blurred area if needed.

How do I simulate a shallow depth of field in an image?
Shallow depth of field is a photographic effect where one object is focused and the rest of the scene is blurred. You can achieve this with a guided edit. Click **Guided** at the top of the Photoshop Elements workspace. Click **Special Edits**, click **Depth of Field**, and then click **Custom**. Follow the steps to define an area of focus and to blur the rest of the image. Click **Next** and then **Done** to apply the effect.

Distort an Image

You can use any of the Distort filters to stretch and squeeze your image, creating the appearance of waves, glass, swirls, and more. For example, the Twirl filter twists the image, and the Ripple filter adds wavelike effects. Glass and Ocean Ripple simulate glass distortions. The Shear filter lets you tilt your image at an angle.

You can experiment with the filter settings to control the strength of the effect. Small settings apply subtle textures. Stronger settings can make an image unrecognizable.

Distort an Image

1 In the Editor, click **Expert**.

Note: For more on opening the Editor, see Chapter 1.

2 With the desired layer selected in the Layers panel, click **Filter**.

3 Click **Distort**.

4 Click **Twirl**.

Note: If you try to apply most filters or styles to a text layer, you will be prompted to either rasterize or simplify the layer. Click **Rasterize** or **OK** when prompted.

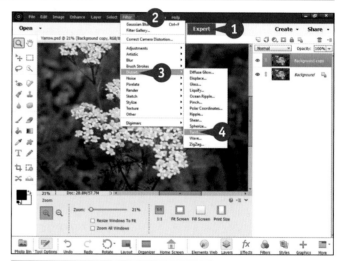

The filter's dialog box opens.

5 Change filter settings as desired. Each filter has different settings.

A Some filters include a preview in the dialog box.

Note: The Distort filters do not display a preview in the active image area.

Note: You can click ⊞ or ⊟ to zoom the preview.

6 Click **OK** to apply the filter, or click **Cancel** if you change your mind.

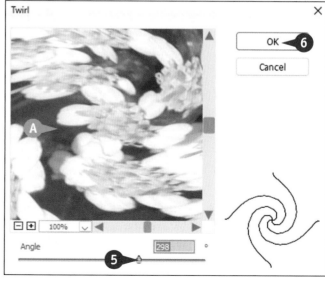

Photoshop Elements applies the filter.

This example shows the Twirl filter applied.

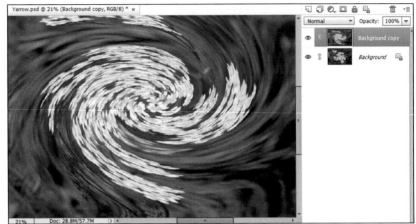

This example shows the Wave filter applied. Click **Filter**, click **Distort**, and then click **Wave** to use this filter.

Note: Some filters require you to do some manual work to apply the effect. For example, if you choose the Liquify filter, you have to drag on the image as if painting with a "wet pixels" brush.

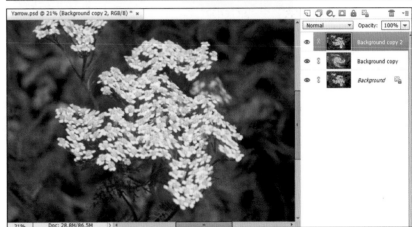

Does the effect depend on the image or selection size?
Unfortunately, most Photoshop filters do not. This means small, medium, and large images can display very different results. For example, on small images ripples look like ripples. On large images they look like fine spray. To compensate for this, experiment with the settings or resize the image before filtering.

What is the Filter Gallery?
The Filter Gallery lists some filters by category. Click a category to see thumbnails of the specific filters; click a thumbnail to see filter settings. Some filters use the Filter Gallery dialog box, or you can open it by clicking **Filter** and then **Filter Gallery**.

227

Turn an Image into Art

The Artistic filters in Photoshop Elements enable you to make your image look as if you created it with a paintbrush or other art media. The Watercolor filter, for example, applies a painted effect by converting similarly colored areas in your image to solid colors. The Palette Knife creates a similar but softer effect. The Colored Pencil filter converts strong image lines to pencil strokes with some crosshatching.

To apply a filter to just part of an image layer, select that portion by using one or more selection tools. For more on selection tools, see Chapter 5.

Turn an Image into Art

1 In the Editor, click **Expert**.

Note: For more on opening the Editor, see Chapter 1.

2 With the desired layer selected in the Layers panel, click **Filter**.

3 Click **Artistic**.

4 Click **Cutout**.

Note: Artistic filters have little impact on text, unless the text has been simplified/rasterized and flattened onto another layer.

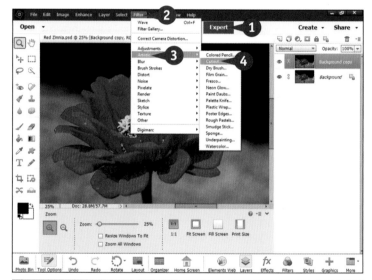

The Filter Gallery dialog box opens and lists filter categories with thumbnail previews of filters in the selected category. (You can click another category and filter thumbnail if desired.)

A The dialog box previews the filter.

Note: You can click ⊞ or ⊟ to zoom the preview.

5 Adjust filter settings as desired.

6 Click **OK**.

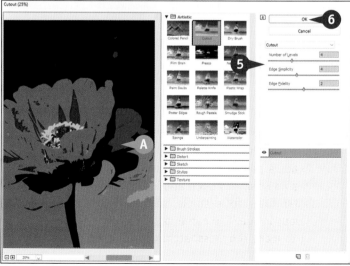

Photoshop Elements applies the filter. This example shows the Cutout filter, which simulates a torn paper effect.

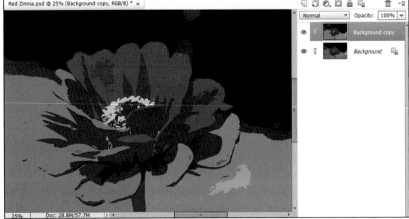

This example shows the Colored Pencil filter applied. Click **Filter**, click **Artistic**, and then click **Colored Pencil** to use this filter.

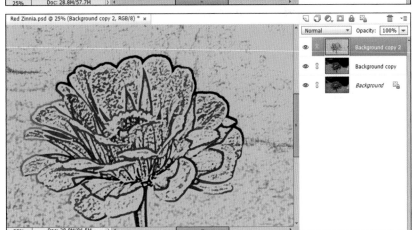

What are the Brush Strokes filters?
The filters on the **Brush Strokes** submenu also can give your image a painterly feel. These filters make an image look like its color has been applied with brushes. The Crosshatch filter, for example, adds diagonal stroking across your image. You can boost the filter's **Strength** setting to make the crosshatching more pronounced.

How can I make these filters more convincing?
Some may feel that the Artistic filters do not create an accurate simulation of genuine artistic effects. You can experiment with changing the Hue/Saturation tool or apply distortions before you work with Artistic filters. Truly artistic results combine many different filters and effects.

Turn an Image into a Sketch

You can use the Sketch filters to make a photo look like a hand-drawn sketch. Most of the Sketch filters "draw" with the foreground color on the background color. Check and set the foreground and background colors before working with these filters. The colors you choose make a big difference. The one exception is the Water Paper filter, which keeps original image colors.

Although you can make a selection and apply the filters to part of an image, the results are rarely successful. It's more usual to apply these filters to a complete image.

Turn an Image into a Sketch

1 In the Editor, click **Expert**.

Note: For more on opening the Editor, see Chapter 1.

2 Check the foreground and background colors, and change them if desired.

Note: For more about setting the foreground and background colors, see Chapter 9.

3 With the desired layer selected in the Layers panel, click **Filter**.

4 Click **Sketch**.

5 Click **Stamp**.

Note: Sketch filters have little impact on text, unless the text has been simplified/rasterized and flattened onto another layer.

The Filter Gallery dialog box opens and lists filter categories with thumbnail previews of filters in the selected category. (You can click another category and filter thumbnail if desired.)

A The dialog box previews the filter.

Note: You can click ⊞ or ⊟ to zoom the preview.

6 Adjust filter settings as desired.

7 Click **OK**.

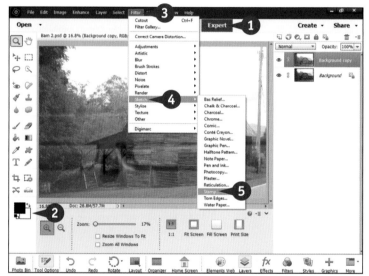

Photoshop Elements applies the filter. This example shows the Stamp filter, which simulates a rubber or wooden stamp appearance.

This example shows the Charcoal filter, with a red foreground color set before applying the filter. Click **Filter**, click **Sketch**, and then click **Charcoal** to use this filter.

How do I know which settings look good?
Mostly, you don't. As you experiment, you can begin to get an intuitive feel for the settings for each filter. The results depend on the photo and the settings, so you must explore each filter and its settings to find good results.

Can I choose any foreground/background colors?
Yes. For example, you can reverse black and white to create negative sketches. But Photoshop Elements allows you to "sketch" with any pair of colors, including lurid and unusual combinations such as hot pink and lime green. The results will not be to everyone's taste, but some artistic styles rely on bright color combinations.

Create a Print Halftone

You can use the Halftone Pattern filter to create an artistic print look. The filter splits an image into four grids of colored dots. When the dots are small, the image looks unchanged. As you make the dots bigger, the image becomes more abstract, creating a popular look found in certain kinds of art and graphic design.

For example, you can use the Halftone effect to create an image that looks like a field of dots when viewed close up, but becomes a recognizable object or person when viewed from a distance. Type values to set the dot size and the grid rotation for each color when applying this filter.

Create a Print Halftone

1 In the Editor, click **Expert**.

Note: For more on opening the Editor, see Chapter 1.

2 With the desired layer selected in the Layers panel, click **Filter**.

3 Click **Pixelate**.

4 Click **Color Halftone**.

Note: If you selected a text layer, this filter prompts you to simplify it. Click **OK** to do so.

The Color Halftone dialog box appears.

5 Type a number in the **Max. Radius** text box to set the dot size.

Note: You can also experiment with changing the **Screen Angles** values, but you do not usually need to do this. Channels 1 through 4 are for Cyan, Magenta, Yellow, and Black in color images, so you can adjust any of them as desired. Grayscale images only use Channel 1.

6 Click **OK**.

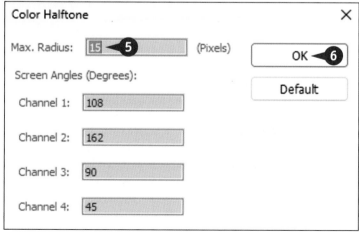

Photoshop Elements applies the Color Halftone filter.

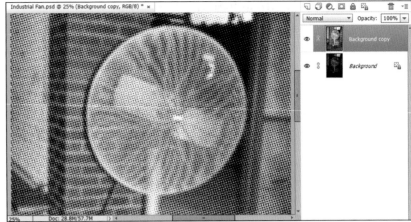

A larger **Max. Radius** value makes the image more abstract, while a smaller value makes it more recognizable. This example shows the previous image with double the **Max. Radius** value.

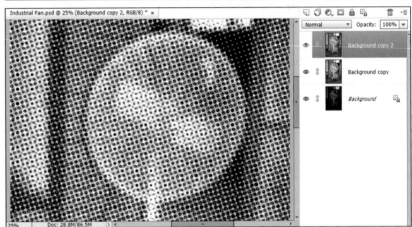

TIPS

What does the Sketch Halftone Pattern filter do?
The **Halftone Pattern** filter in the **Sketch** submenu is a simpler version of the halftone effect. You can create a single grid of dots in a single color to simulate a newsprint image. You can also apply a line effect to simulate TV lines or a more abstract concentric circle effect. This effect ignores the colors in an image.

What is halftone printing?
The halftone effect was originally invented to print color images in newspapers and magazines. Printing presses could not print shaded color directly: The halftone process makes it possible to print images that appear to have smooth, shaded color tones.

Add a Drop Shadow to a Layer

Y ou can add a *drop shadow* to a layer to create a 3D effect. Photoshop Elements creates a drop shadow by copying the shape of an area, offsetting it slightly, softening it, and placing the shadow under the area. Drop shadows are usually black, but you can use other colors for special effects. They are often used for text but can also be used with images.

Photoshop Elements includes a selection of predefined drop shadow styles, with varying sizes, opacities, and offsets. You can double-click one of these preset styles to apply it. You can also use a dialog box to create a drop shadow with your own customized settings.

Add a Drop Shadow to a Layer

Apply a Drop Shadow Preset

1 In the Editor, click **Expert**.

Note: For more on opening the Editor, see Chapter 1.

2 Create a text layer or copy a selection to a layer.

Note: For more about creating layers from selections, see Chapter 4.

Note: This example shows a text layer above a white Background layer.

3 Click the new layer in the Layers panel.

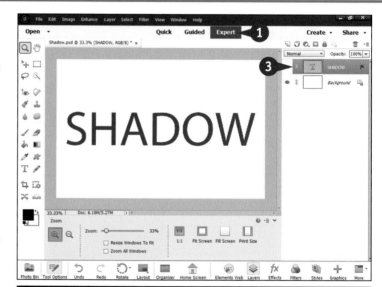

4 Click **Styles** on the taskbar.

5 Click the type drop-down list.

6 Click **Drop Shadows**.

The Drop Shadow presets appear in the Styles panel.

7 Click a preset.

A Photoshop Elements applies the drop shadow to the layer.

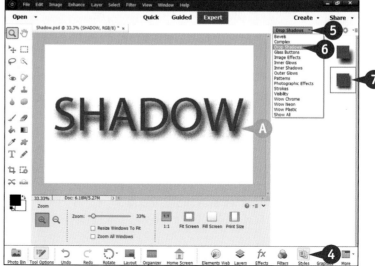

Customize the Drop Shadow

8 Click the settings icon ().

The Style Settings dialog box opens.

9 Click the Drop Shadow check box if it is not already selected (☐ becomes ☑).

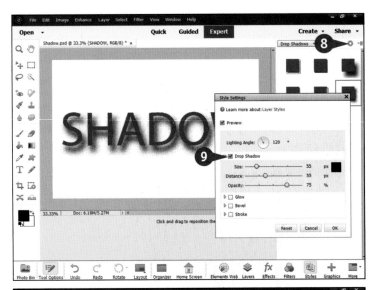

10 Drag the **Lighting Angle** dial to specify the shadow direction.

11 Drag the **Size** slider to set the size of the shadow.

12 Drag the **Distance** slider to set the shadow offset.

13 Drag the **Opacity** slider to control the density of the shadow.

14 Click **OK**.

Photoshop Elements applies the style settings.

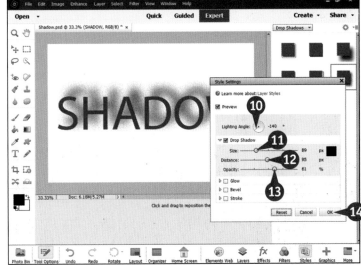

TIP

How can I select a different color?
In the Style Settings dialog box, click the color box to the right of the sliders (B). Use the standard Photoshop color picker to change the shadow color.

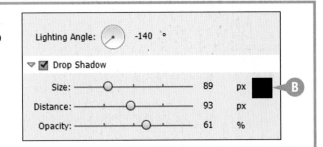

Apply Other Styles

In addition to its selection of Drop Shadows presets, the Styles panel offers numerous other categories of preset styles you can apply to a layer. Some, like Inner Glows and Inner Shadows, apply inside the outline of the layer content. Others, like Outer Glows, apply outside the outline of the layer content. And others, like Wow Neon, apply to the outline of the layer content.

You can use most styles on either text or pixel content layers. You can even apply multiple styles in some cases to create more dramatic changes.

Apply a Style

1 In the Editor, click **Expert**.

Note: For more on opening the Editor, see Chapter 1.

2 With the desired layer selected in the Layers panel, click **Styles** on the taskbar.

3 Click the type drop-down list.

4 Click the desired style type.

Photoshop Elements displays the category presets in the Styles pane.

5 Click the desired style preset.

Ⓐ Photoshop Elements applies the style to the layer content.

Enhance with an Effect

In Photoshop Elements Expert mode, you can do even more with an image layer after applying a style. You can use the Effects or Filters panels to apply numerous other choices to enhance a layer's content.

Be playful with the combinations you try. For more about layers, see Chapter 4, and for more about selections, see Chapter 5.

Add on an Effect

1 In the Editor, click **Expert**.

Note: For more on opening the Editor, see Chapter 1.

2 With the desired layer selected in the Layers panel, click **Effects** on the taskbar.

3 Click a tab at the top of the Effects panel.

4 Click the desired preset.

Ⓐ Photoshop Elements applies the effect to the layer.

Note: A filter can be applied within a selection on a layer, leaving the rest of the layer unchanged. To apply a filter preset quickly in Expert mode, make the selection on the layer, click **Filters** on the taskbar, select a type from the drop-down list, and then click the thumbnail for the filter to apply.

CHAPTER 11

Organizing Your Photos

Organizing your digital photos can make your work in Photoshop Elements more efficient. You can catalog, view, and sort photo files by using the Organizer. You also can use it to search your photo library and to find people, places, and events. This chapter shows you how to take advantage of the many photo-management features in the Organizer.

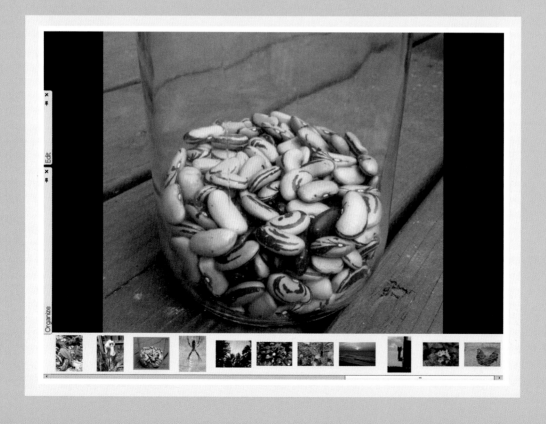

Introducing the Organizer

You can use the Photoshop Elements Organizer to manage your collection of digital images. When you import a photo or save an edited photo, Photoshop Elements adds it to the Organizer. To help you manage and search your photos, you can associate them with people, places, or events or group photos into albums and tag them with descriptive keywords.

If you want to edit one or more photos, you can click the **Editor** button on the taskbar to launch the Photoshop Elements Editor. You can make the changes you want to the photo and then switch back to the Organizer when you are finished. The Editor disappears, and you can continue browsing and organizing your photos.

Image Viewer

The Organizer acts as an image viewer, showing you *thumbnails*, or smaller versions, of your pictures and other images. This enables you to preview many photos in a single window. The thumbnails you see in the Organizer link to the original files. You can delete images from the Organizer without deleting them from your computer's hard disk.

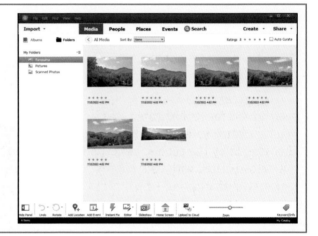

Catalog

When the Organizer adds images or you add them yourself, they become part of a *catalog* of images. Images are listed by date. You can keep all your photos in one catalog, or you can create separate catalogs. If you want to group your photos further, you can collect them into albums. See the sections "Create a Catalog" and "Work with Albums" for details.

Keyword Tags

You can use keyword *tags* — words or short descriptions — to help you sort and track your photos. You can assign more than one tag to each photo. You can then search for photos that match certain tags or sort your photos in tag order. The Organizer includes a few ready-made tags to help you group photos and also automatically adds Smart Tags to some images, such as flower or sky photos, when you import them. You also can assign custom tags of your own. For more on image tags, see "Perform Other Organization Tasks" at the end of the chapter.

People, Places, and Events

We often group photos by the people in them, the places they were taken, and the events at which they were taken. Photoshop Elements has special features to help you group your photos in these ways. If your camera includes a GPS feature, you can find where your photos were taken on a map. You also can add an event name to photos from a particular time and date.

2/10/2000
Rooster Arrives

Find Photos

The Organizer also includes full-featured search tools for sophisticated searches. You can search your catalog by date, by filename, or by the people, places, and events associated with your photos. You can apply ratings using a five-star system and then view photos that meet a certain rating criteria. See "Perform Other Organization Tasks" later in the chapter for more information.

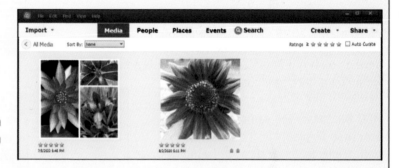

Create and Share

After grouping and organizing your photos, you can use the Organizer to share them. For example, you can select one or more photos to share on social networks such as Facebook or Twitter, on the Flickr photo sharing site, and more. See "Perform Other Organization Tasks" later in the chapter to get started.

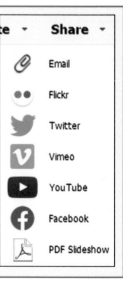

Open the Organizer

You can organize and manage your digital photos in the Organizer in Photoshop Elements. The Organizer works alongside the Editor to help you keep track of your digital photos and other media. You can open the Organizer from the Home Screen that appears when you start Photoshop Elements. Or, you can switch to the Organizer from the Editor.

The main feature of the Organizer is Media view, which displays thumbnails of your photos in a grid arrangement. You can select a thumbnail and make basic changes to a photo directly in the Organizer or open the image in the Editor to make more complex changes.

Open the Organizer

1 Double-click the **Adobe Photoshop Elements 2023** shortcut icon on the desktop to start Photoshop Elements.

Note: See Chapter 1 for more on starting Photoshop Elements.

Note: On a Mac, you can search for Adobe Photoshop Elements in the Finder in the Applications folder or through Launchpad.

The Home Screen appears.

2 Click **Organizer** to open the Organizer.

Note: To start Organizer from the Editor, click **Organizer** on the taskbar.

The Organizer opens.

To import photos into the Organizer workspace, see Chapter 2.

To change the view in Organizer, see "Change the View," next.

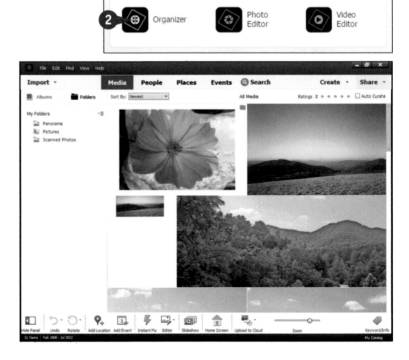

Change the View

B y default, the Organizer shows its Media view, with the Albums and Folders panel at the left where you can select folders or albums and larger thumbnails of the images in the catalog. It also includes the People, Places, and Events views.

You can use the Albums and Folders panel to navigate between albums and folders, and you can display a Keyword Tags or Information panel at the right to view file details. Click a taskbar button to hide and display each of these panels. You also can display limited file details under each image thumbnail.

Change the View

1 Click a tab at the top to change views.

A You can click a choice to display **Albums** or **Folders**.

B You can click a listed album or folder to display only its images in the current view.

2 Click **Hide Panel** on the taskbar.

The Albums and Folders panel closes.

Note: The button changes to **Show Panel**. Click it later to redisplay the Albums and Folders panel.

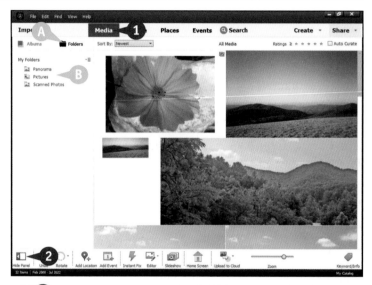

3 Click **Keyword/Info** on the taskbar.

The Keyword Tags or Information panel opens.

Note: Click the **Keyword/Info** button again to close the panel.

C You can click a choice to display keywords (**Tags**) or file info (**Information**) for the selected image.

4 Click **View**.

5 Click **Details**.

Note: Or press Ctrl + D (⌘ + D on a Mac).

Photoshop Elements displays the rating and creation date/time below each image.

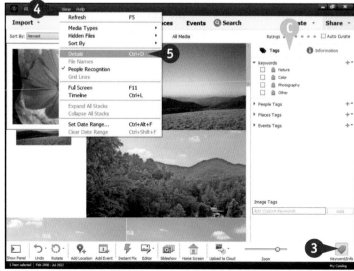

243

Create a Catalog

The Organizer stores images in catalogs. You can keep your photos in one large catalog or create separate smaller catalogs. When you launch the Organizer for the first time, Photoshop Elements creates a default catalog called My Catalog.

You can further divide the photos in a catalog into smaller groups called *albums*. See the section "Work with Albums" for more. You also can combine similar photos into stacks to save space.

Create a Catalog

1 In the Organizer, click **File**.

2 Click **Manage Catalogs**.

Note: Or press Ctrl + Shift + C (⌘ + Shift + C on a Mac).

Ⓐ You can restore a catalog you have previously backed up by clicking **Restore Catalog** on the **File** menu.

The Catalog Manager dialog box opens.

Photoshop Elements lists the available catalogs.

3 Click **New**.

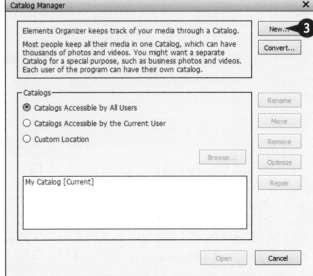

4 Type a name for the new catalog.

B You can click this check box (☐ changes to ☑) to import free music included with Photoshop Elements for use in slideshows.

5 Click **OK**.

Note: If a screen prompting you to import media appears, click **Skip**.

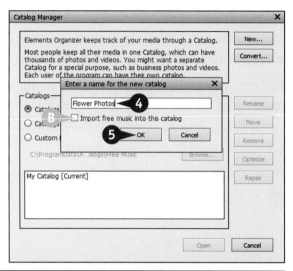

Photoshop Elements creates the new catalog and opens it.

You can now import images into it. See Chapter 2 for more about importing photos.

C Photoshop Elements displays the name of the current catalog.

D The number of files in the catalog appears here.

How do I switch to a different catalog in the Organizer?

Click **File** and then **Manage Catalogs** to open the Catalog Manager. (You also can click the catalog name in the lower-right corner of the Organizer window.) Click the catalog to open in the catalog list, and click **Open**. You can open one catalog at a time.

How can I keep others from viewing the photos in a catalog?

Change the catalog security settings so that only the user currently signed into your computer can access it. Click **File** and then **Manage Catalogs** to open the Catalog Manager. Click the catalog to protect in the list in the Catalog Manager dialog box, and then click **Move**. Click the **Catalogs Accessible by the Current User** option, and then click **OK**.

View Photos in Media View

The Organizer's default Media view displays image thumbnails. When details are displayed (see "Change the View" earlier in the chapter), information appears below each thumbnail, including a star rating, an optional caption, and the date and time the image was created.

You can change the size of the thumbnails. Make thumbnails smaller to see more at once. To see more detail in each photo, make the thumbnails bigger. You also can filter and sort your photos in various ways to find specific photos in your collection.

View Photos in Media View

1 In the Organizer, click the **Media** tab.

Media view displays the photos in the current catalog and the current folder or album if one is selected.

Media view sorts images by creation date from newest to oldest by default.

2 Drag the Zoom slider.

Dragging right increases the thumbnail size. Dragging left decreases the thumbnail size.

A You can use the scroll bar to move up and down through the thumbnails.

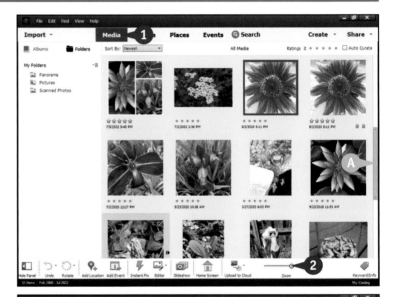

3 Click the **Sort By** drop-down list.

4 Click **Oldest**.

Note: You can optionally display a timeline panel above the images. It has a thumb you can drag to display images from a particular year and month. Click **View** and then **Timeline** or press Ctrl+L (⌘+L on a Mac) to toggle the pane on and off.

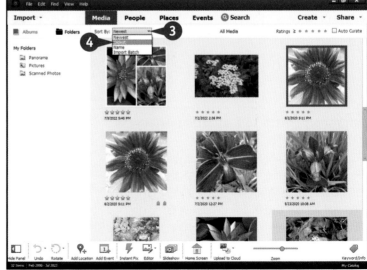

The oldest photos now appear first.

5 Click the **Sort By** drop-down list.

6 Click **Import Batch**.

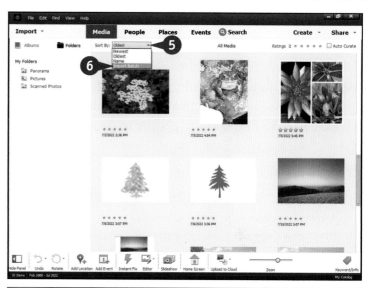

B Photoshop Elements groups the photos into batches imported at the same time from the same source.

How can I hide certain file types in Media view?
Media view can display photos (including PSD files), videos, audio and music files, and Adobe project files. Click **View**, click **Media Types**, and then click a media type in the submenu to control which file types appear (checked) or are hidden (unchecked).

Why does the list of thumbnails not scroll when I click Newest or Oldest?
For convenience, Media view typically does not change the currently displayed photos when you change the sort order. If it does and you need to redisplay the thumbnails you were viewing, you can use the scroll bar.

View Photos in Full Screen

You can use Full Screen view in the Organizer to get a clearer view of a selected image. Photoshop Elements zooms the photo to fill the workspace and displays special controls for applying commands.

Full Screen view is useful when you want to perform basic edits on a large version of your photo without switching to the Editor. You can display a Film Strip of thumbnails of the images in the current catalog. Use the Film Strip to display another image.

View Photos in Full Screen

1 In the Organizer, click the photo to view.

A check appears in the thumbnail's lower-right corner.

2 Click **View**.

3 Click **Full Screen**.

Note: Or press F11.

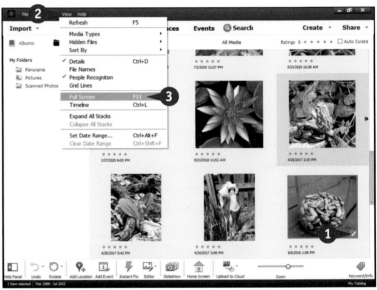

Photoshop Elements opens the photo in Full Screen view.

Ⓐ You can use this Edit panel to perform quick edits.

Ⓑ You can use this Organize panel to add images to albums and to manage keyword tags.

Ⓒ The panels automatically hide if not used. You can click the pin icon (📌) to turn this hiding on and off.

Ⓓ Controls for viewing different photos and managing panels appear here.

Ⓔ You can click the **Next** (▶️) and **Previous** (◀️) buttons to view other photos.

Note: You also can press → and ←.

4 Click **Film Strip**.

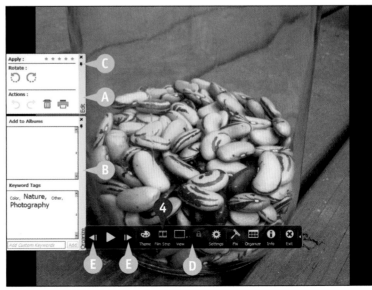

Ⓕ The Film Strip opens, displaying thumbnail versions of your images.

Ⓖ Use the scroll bar at the bottom to scroll through the thumbnails.

5 Click a thumbnail.

Photoshop Elements displays the selected photo.

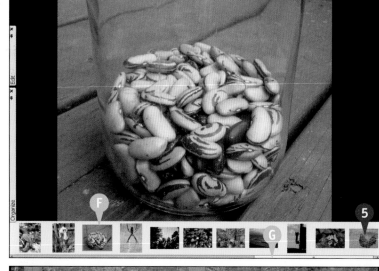

6 Click **Exit** or press the `Esc` key to exit Full Screen view.

Note: The controls for Full Screen view auto-hide. Wiggle the mouse to redisplay them.

TIP

How do I zoom and pan the photo in Full Screen mode?
Click the image to change between 100% zoom and a fit-to-screen zoom percentage calculated by Photoshop Elements. Or roll the wheel on a scroll wheel mouse to zoom in or out by the desired percentage. To pan the image, zoom in to a percentage that causes the image to be larger than the screen, and then drag it with the mouse.

View File Information

You can use the Information panel to view general information about an image or other media file, including the filename, file size, image dimensions, and location. You can edit add a **Caption**, **Notes**, or **Image Tags** in the panel.

You also can view tags, creation date, import date and source, and *metadata* — detailed information about a digital photo. Metadata includes the camera and settings used to take a photo, so you can check the exposure time, flash settings, and f-stop/aperture.

View File Information

1 In the Organizer, click an image to select it.

A check mark appears on the thumbnail.

2 Click **Keyword/Info** on the taskbar.

3 Click **Information** at the top of the panel, if needed.

Note: You also can right-click (Control + click on a Mac) an image and then click **Show File Info**.

The Information panel opens.

A The General properties appear by default.

B You can add or edit a **Caption** for the file here.

C The Ratings, Size, creation Date, and other information for the photo appear in this area.

If you have assigned keyword tags to the photo, they also appear at the bottom of the panel.

4 Click **Metadata**.

The Metadata properties appear. This includes the camera make and model and other settings if the image came from a digital camera or smartphone.

Ⓓ You can click ≣≣ to display complete file information.

❺ Click **History**.

The History properties appear.

Ⓔ Photoshop Elements displays information about the file, including when the file was last modified and when it was imported.

Note: The History information does not include a detailed history of all the edits you make.

❻ Click **Keyword/Info** on the taskbar.

The Information panel closes.

TIP

Can I change the date and time the Organizer uses to sort files?
Yes. Right-click (Control+click on a Mac) the file, and then click **Adjust Date and Time**. The Adjust Date and Time dialog box appears. Leave **Change to a Specified Date and Time** selected, and then click **OK**. Make changes to the **Year**, **Month**, **Day**, and **Known Time** as needed, and click **OK**. Use this option if you want to fix sorting errors — for example, if you copied an image from an old collection, which changed its date and time.

Work with Albums

You can use albums to group images, for example photos that feature specific people or were taken on certain dates. For example, you could create an album for photos taken during a memorable vacation or other special event.

You can create as many albums as you want. The same photo can appear in many albums. Albums are also a convenient way to group photos before making a slideshow or photo book using the **Create** button near the upper-right corner of the Organizer.

Work with Albums

Create a New Album

1 In the Organizer, open the desired catalog.

Note: For more on catalogs, see the section "Create a Catalog."

2 Click **Show Panel** on the taskbar if needed.

The button changes to **Hide Panel**.

The Albums and Folders panel appears.

3 Click **Albums** at the top of the panel if needed.

4 Click the plus sign icon ().

Ⓐ The New Album panel appears.

5 Type a name for the album.

Ⓑ If you have created at least one album category, you can click the **Category** drop-down list to assign the album to it. See the Tip for details.

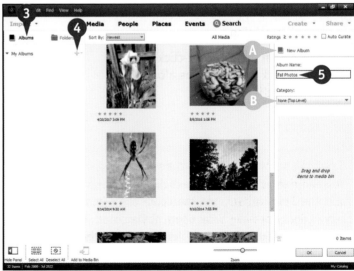

6 Click a thumbnail to select it.

7 Drag the thumbnail to the media bin in the panel.

The Organizer adds the photo to the album.

8 Repeat steps **5** and **6** for all the photos you want to add to the album.

You can Ctrl+click (⌘+click on a Mac) to select multiple photos and then drag them all to the album.

9 Click **OK** to save the album.

View an Album

1 Click **My Albums** to display the list of albums if needed.

2 Click the album to display.

Ⓐ The Organizer displays the files in the album.

Ⓑ An album icon (■) identifies photos that are in an album.

Note: If you cannot see the icons, click **View** and then click **Details**.

Ⓒ You can click **All Media** to return to the entire catalog.

Ⓓ To delete an album, right-click (Ctrl + click on a Mac) the album name and click **Delete**.

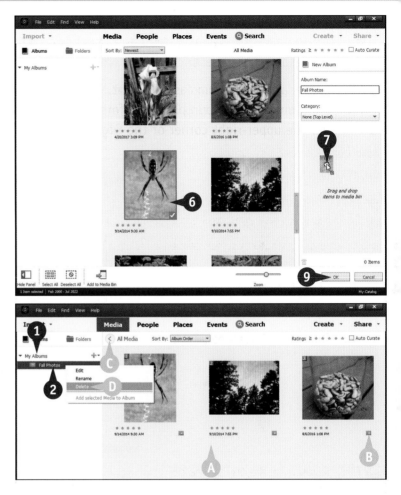

TIPS

How do I remove a file from an album?

You can right-click (Control+click on a Mac) any file, click **Remove From Album**, and then click the album name. The album does not have to be open. You also can right-click an album, click **Edit**, click a file in the Edit Album panel media bin, click the trash icon (🗑), and then click **OK**.

What are album categories?

Album categories are like folders for albums. You can use them to group related albums. Click ▼ next to ➕, and click **New Album Category**. Type a name, and click **OK**. You can drag one or more albums into the new category.

Find Photos

The Organizer includes powerful search capabilities. You can look for images by date, by filename, by location, or by tags. As you add more images to the catalog, these search methods can help you display the images you want without scrolling.

These examples find photos in a date range, and by searching all the text associated with a photo, including captions, keyword tags, and album names.

Find Photos

Find Photos by Date

1 In the Organizer, click **View**.

2 Click **Set Date Range**.

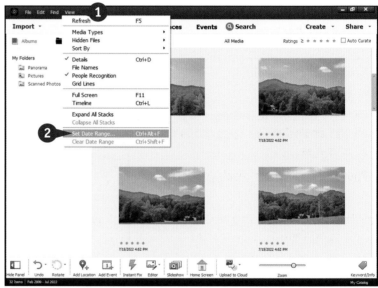

The Set Date Range dialog box opens.

3 Specify the **Start Date** for the search.

4 Specify the **End Date** for the search.

5 Click **OK**.

The Organizer displays files created between the specified dates.

Note: If displayed, the timeline shows the start date.

Note: You can reset the date search by clicking **View** and then **Clear Date Range**.

Find Photos with a Text Search

1 Click **Search** near the top of the screen.

A larger Search text box appears across the top of the screen.

2 Type a tag or keywords in the **Search** box.

3 Click the matching term in the list that appears as you type.

4 Repeat steps **2** and **3** to add other search terms as needed.

Photoshop Elements searches the file names, captions, keyword tags, album names, and other text associated with your images.

Ⓐ Photoshop Elements displays files that match the search terms.

Ⓑ Move the mouse pointer over a button here to perform a quick search.

5 Click **Clear Search**.

6 Click **Grid**.

Photoshop Elements cancels the search.

TIP

What other search options can I use?

You can search the Organizer using the following **Find** menu commands.

Search Option	Searches for Files by Matching:
By Caption or Note	Text in the notes and captions
By Filename	A particular filename
By History	The import, email, print, export, share, and project dates
By Media Type	The photo, video, audio, projects, or audio captions as specified

View Versions of a File

After you make edits to an image file in Photoshop Elements, the Organizer can keep different versions grouped together. The group is called a *version set* and has a special icon. You can use version sets to keep an original unedited photo and compare it with one or more edited versions and to try different interpretations of a photo to see which works best.

To save an edited image file in a version set, click **Save in Version Set with Original** when saving. See Chapter 2 for more about saving photos.

View Versions of a Photo

1 In the Editor, save a file in a version set. See Chapter 2 for details.

A A version set icon (📷) appears in the upper-right corner of a thumbnail for a version set.

2 Click ▶ to expand the set.

B Photoshop Elements displays the photos in the version set with a darker background.

C You can click ◀ to collapse the version set.

By default, the most recent version appears on top of the collapsed set.

To display a different version on top, you can right-click a version, click **Version Set** in the shortcut menu, and then click **Set as Top Item**.

Remove a Photo from the Organizer

You can remove a photo from the Organizer. The photo disappears from the current catalog. Use this feature to eliminate unsuccessful photos, get rid of old photos you no longer want, and make a catalog less cluttered.

By default, removing a photo leaves the original file on your computer's disk drive. You can delete the file permanently by checking a box in the confirmation dialog box, but you should usually leave the file on disk in case you change your mind.

Remove a Photo from the Organizer

1 Right-click (Control +click on a Mac) a file.

2 Click **Delete from Catalog.**

Note: You can Ctrl +click (⌘ +click on a Mac) to select multiple images. Then press Del or click **Edit**, and then click **Delete Selected Items from Catalog.**

The Confirm Deletion from Catalog dialog box appears.

Ⓐ You can click this check box (☐ changes to ☑) to delete the photo from your system's disk drive.

3 Click **OK.**

Photoshop Elements removes the photo from the Organizer catalog.

Ⓑ You can click **Undo** on the taskbar to return the photo to the catalog.

Apply an Instant Fix

You can optimize color, lighting, and make other basic edits in the Organizer using the Instant Fix tools. You can make simple improvements without opening the Editor.

Most of the fixes are one-click improvements with no settings. They work on many photos but may not give good results on photos with unusual lighting. After you apply a fix, the Organizer saves the photo with the original in a version set.

Apply an Instant Fix

1 In the Organizer, click the image you want to fix.

2 Click **Instant Fix** on the taskbar.

The Instant Fix tools appear.

3 Click an instant fix, such as **Crop**.

4 Click a preset.

5 Drag the edges and corners of the crop tool to adjust the area of the image to keep.

6 Click ✔ to apply the crop.

Ⓐ You can click ⊘ to cancel the crop.

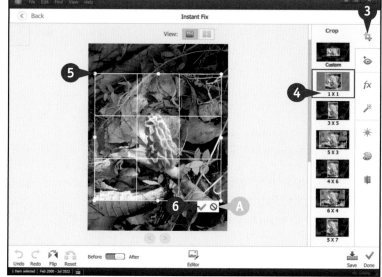

Photoshop Elements crops the photo.

7 Click another instant fix such as **Color**.

8 Click a preset to apply it.

Photoshop Elements fixes the color.

9 Click **Save** to save the changes.

10 Click **Done**.

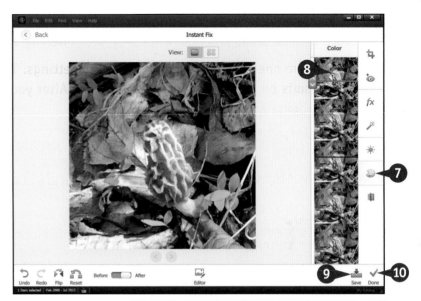

B Photoshop Elements adds the edited photo to a version set and displays the open version set icon (✖).

TIPS

How do I rotate an image in the Organizer?
You can click an image to select it and then click **Rotate Left** on the taskbar to rotate the photo counterclockwise. You can click the Rotate Left button's drop-down list triangle (▼) to display a **Rotate Right** (clockwise) button.

How do I undo Instant Fix changes?
You can click **Undo** on the taskbar before saving the changes. If you performed multiple changes in the Instant Fix panel, you must click **Undo** multiple times to undo them.

Perform Other Organization Tasks

The Organizer provides numerous other tools and techniques for organizing and improving upon image files in your catalogs and albums. The following is a sampling of additional organizational tasks you may want to take on:

To Do This to the Selected File(s)		Use These Steps
Add Keyword tags		Click **Keyword/Info** on the taskbar. With either tab in the panel selected, click in the **Add Custom Keywords** text box under Image tags, type a keyword, and click **Add**.
Add a Rating		Wherever the five rating stars appear (in image details, near the upper-right corner of the screen, in the Information panel), click the desired rating star (one to five).
Add a Caption		Click **Keyword/Info** on the taskbar. Click the **Information** tab. Click in the **Caption** text box under General, and type a caption. Clicking **Edit** and then **Add Caption** also displays a dialog box where you can add a caption.
Add a Location		Click **Add Location** on the taskbar. In the Add a Location dialog box, type a location, click a match in the drop-down list, and then click **OK**.
Add an Event		Click **Add Event** on the taskbar. In the Add New Event pane, type a name in the **Name** text box. Specify a **Start Date**, **End Date**, and **Description** if desired, and then click **Done**.
Add a Person		Right-click (Control +click on a Mac) a thumbnail, and then click **Add a Person**. In the Add a Person dialog box, type a name. If a match appears, click it. Click **Add**.
Create a Project		Near the upper-right corner, click **Create**. Click a project in the menu, and then follow the prompts and make choices as needed to complete it.
Share		Near the upper-right corner, click **Share**. Click a sharing method in the menu, and then follow the prompts and make choices as needed to finish sharing.
Stack Images		Right-click (Control +click on a Mac) one of the selected photos, click **Stack**, and then click **Stack Selected Photos**.
View Tagged Images		Click **Keyword/Info** on the taskbar. Click **Tags** at the top. Click a category to expand it, and then click a choice to mark it.

Index

D